UNDERSTANDING
CLOSE-UP PHOTOGRAPHY

UNDERSTANDING
CLOSE-UP PHOTOGRAPHY

CREATIVE CLOSE ENCOUNTERS WITH OR WITHOUT A MACRO LENS

Bryan Peterson

AMPHOTO BOOKS

AN IMPRINT OF WATSON-GUPTILL PUBLICATIONS/NEW YORK

ACKNOWLEDGMENTS

This book would not be what it is without the greatest editor in the world, Alisa Palazzo, who really makes me think! Without Victoria Craven, I wouldn't have any books at all. And of course, no one is better at book design than Bob Fillie. I will never be able to thank all three of you enough!

Editorial Director: Victoria Craven
Senior Development Editor: Alisa Palazzo
Creative Director: Marysarah Quinn
Art Director: Jess Morphew
Designer: Bob Fillie
Production Manager: Alyn Evans
Typeset in DIN

Library of Congress Cataloging-in-Publication Data
Peterson, Bryan F.
 Understanding close-up photography : creative close encounters
 with or without a macro Lens / Bryan Peterson. — 1st ed.
 p. cm.
 Includes index.
 ISBN-13: 978-0-8174-2719-1 (pbk.)
 ISBN-10: 0-8174-2719-8 (pbk.)
 1. Photography, Close-up. I. Title.

 TR683.P48 2009
 778.3'24—dc22
 2008036031

ISBN 978-0-8174-2719-1

Printed in Malaysia

10 9 8 7 6 5 4 3 2 1

First Edition

Papillon—No one is as close to my heart as you.

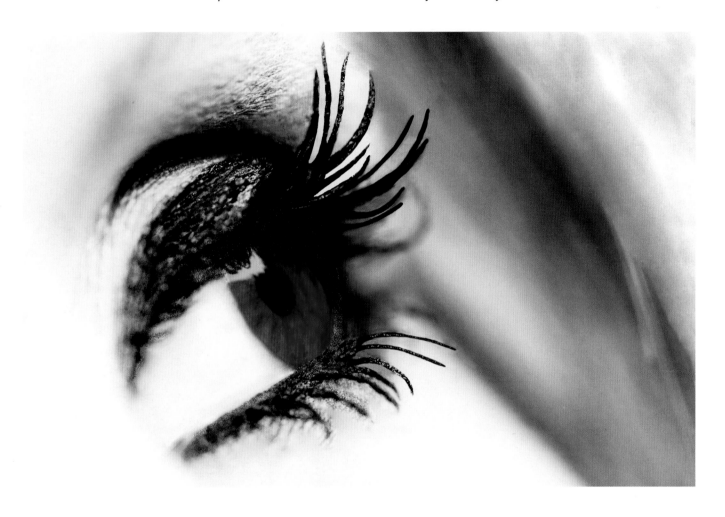

CONTENTS

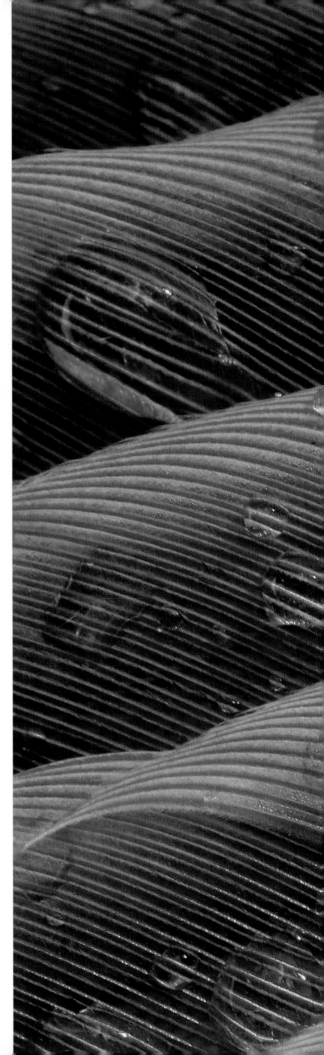

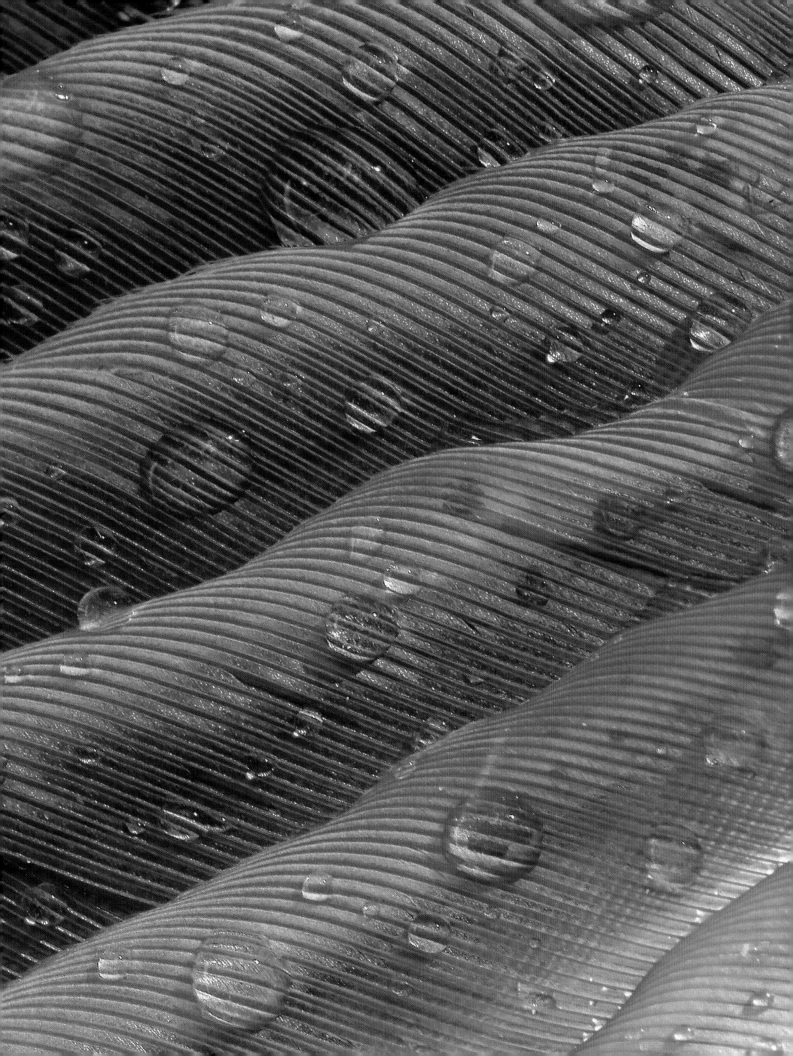

INTRODUCTION

O YOU REMEMBER your first time? I do. My first time—my first intimate encounter with a photographic subject—was with Daisy, a white Shasta daisy to be exact, and it happened on a hot August day in Oregon while looking through the viewfinder of my brother's Nikon F. And, I confess, I have been a close-up photography addict ever since.

If there is any constant in the world of close-up photography, it is this: Flowers are like snowflakes; no two are exactly the same when viewed through any combination of close-up photography equipment. The closer you focus on a given subject, the more that is revealed, and it is with these revelations that the "drug" that is close-up photography maintains its constant and unrelenting hold. You begin to consider adopting a belief in reincarnation or reaffirming your lapsed reincarnation beliefs as you soon realize that your appetite, your hunger, your insatiable desire for more "intimate encounters" is truly vast and deep and that "there can't possibly be just one lifetime, because I need to come back for more—much more!"

I've often been asked by students in my workshops, at my seminar presentations, and in my online photography school how I define an intimate encounter in photography. My answer hasn't changed a whole lot since the first time this question came up, way back in 1978. In my mind, an intimate encounter was then and continues to be an "in your face" experience, one with an emotional charge so great that it is best described as a low-voltage electrical shock to all five of your senses, especially sight, touch, and smell. The world of close-up photography does serve up a bounty of texture-filled images: feathers, human skin, animal fur, wood, rocks, sand, leaves, thorns, berries, broken glass, ice, frost, and even pond scum. It is often the texture within a close-up photograph that awakens our senses the most, whether that texture is "felt" as soft or hard, rough or smooth, dull or sharp, or hot or cold.

To convey that texture—so that the subject is "felt" by the viewer—we must toss aside the old adage "Less is more" in exchange for a new motto: More is more. Intimate encounters are all about getting close, in many cases closer than you ever thought possible. When our loved ones are away for extended periods, we ache for their touch. We've had enough of "less is more," and we want them to return now so that we can get back to "more

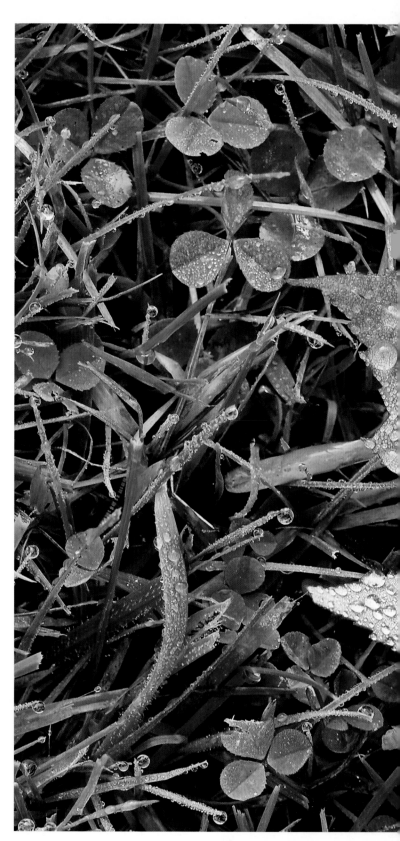

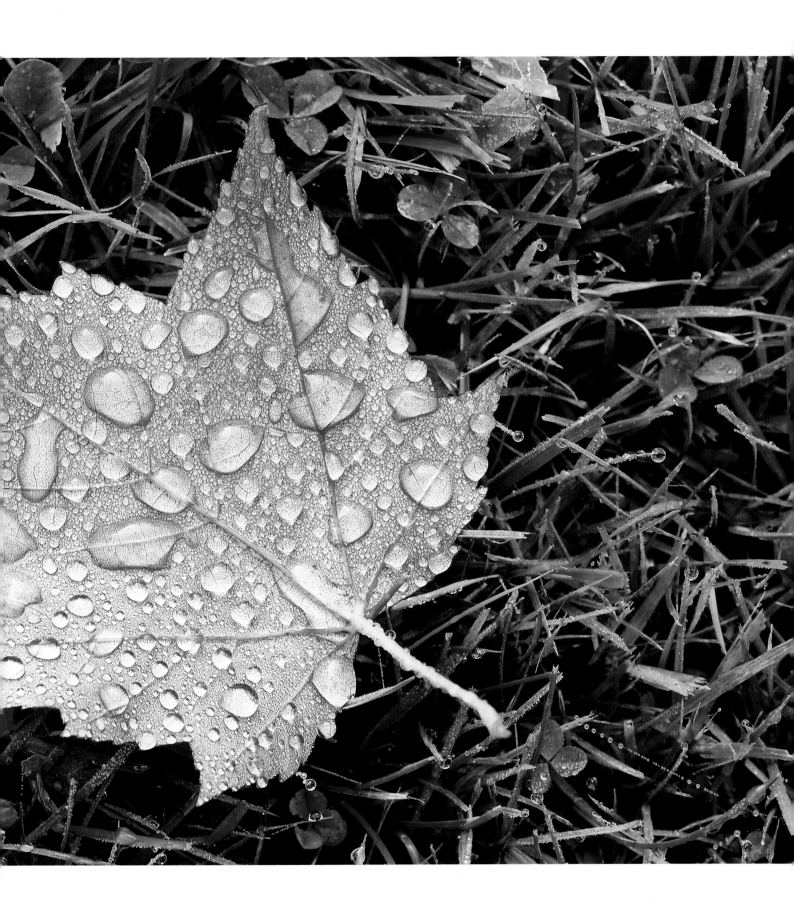

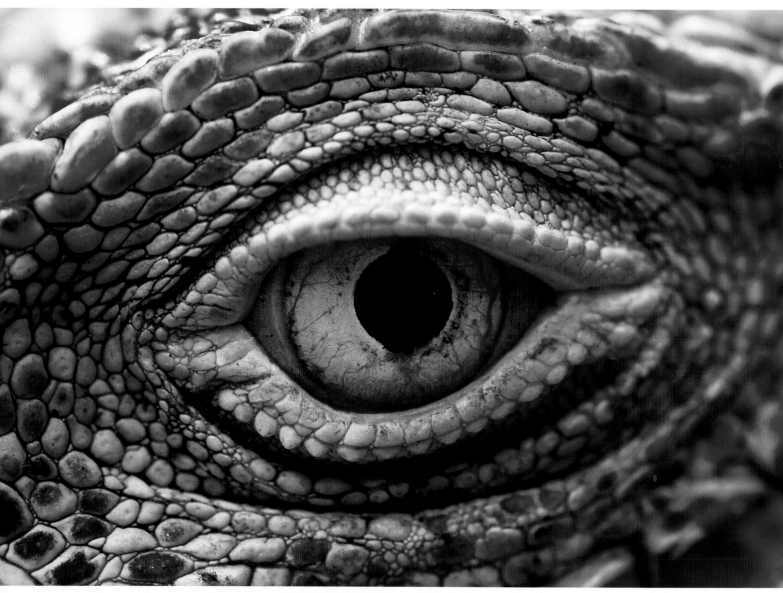

is more." It's hard to be intimate when we are miles away from the ones we love, and it's just as hard to be intimate with any photographic subject when you're "miles away" from it, as well. Just as the only way to feel a person's touch—to feel alive—is to be right there, the only way you can evoke a tactile experience with your photography is to be right on top of, next to, in front of, or underneath your subject at a very intimate distance.

The human need and drive for intimacy is very strong. It is, for some, a lifelong need. It is all about connecting, about feeling we are a part of something outside of ourselves, and it is in close-up photography that we can, if only for a moment, be a part of something that most

people have otherwise not noticed. This is what makes it so special. You may ask, for example, "What intimacy could possibly be found in the gutters of our streets?" A lot, actually, as you will soon see for yourself.

My first intimate encounter with that daisy was, in all likelihood, no different from the first encounters of 99 percent of all photographers, since it is the flower that is the *most* photographed subject in the world, outside of pictures of family and friends. Of course, it isn't long after that first flower photograph that you begin to realize that close-up photography needs to be precise in many cases and can be very demanding of your patience. If it's not just the slightest shift in the camera's position,

then it will be the wind; and if it's not the wind, then it will be the absence of the right light falling on your subject; and if it's not the lack of proper light, then it will be the wrong background; and if it's not the wrong background, then it's that missing piece of equipment you're still saving up for, and on it goes.

Yet despite the demands placed on us by close-up photography, we addicts seem to dig our heels in even deeper. Once we feel the joy of succeeding with one great close-up shot, we're hooked. We see so much potential, so many possible intimate encounters, in a world that most people are too busy to notice or simply never thought was worth the look. But we know different, and we want to not only connect with the close-up world but share that world with the greater world at large, as well.

So, as much as this book is about conventional close-up photography (i.e., the flowers), it is certainly also about *unconventional* close-up photography. In my mind, close-up photography *must* include *anything* that isn't normally experienced up close. Familiarity can breed contempt but *not* when looking for opportunities to shoot close-ups. This whole subject of making discoveries in close-up photography is so far from reaching its end because *nothing* is ever familiar—at the slightest twist or turn, a new image is revealed! It is truly a lifelong journey, and like most journeys, there are many stops along the way and any number of paths to our destination.

Regardless of the equipment, lighting, locations, and viewpoints you choose, you are at the controls. So, no matter where you are in your journey, you always have the option of stopping, surveying the scene before you, and making the decision as to how and when to preserve what you see. We've all heard of and seen, either in pictures or in person, the Seven Wonders of the World, but the photographer armed with any amount of close-up equipment will soon see the Seven *Million* Wonders of the World.

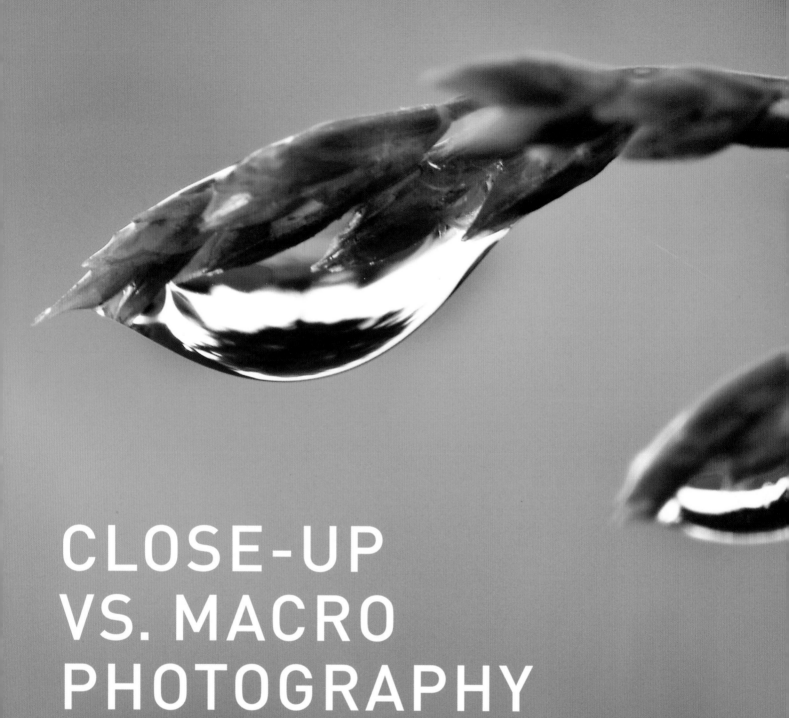

CLOSE-UP VS. MACRO PHOTOGRAPHY

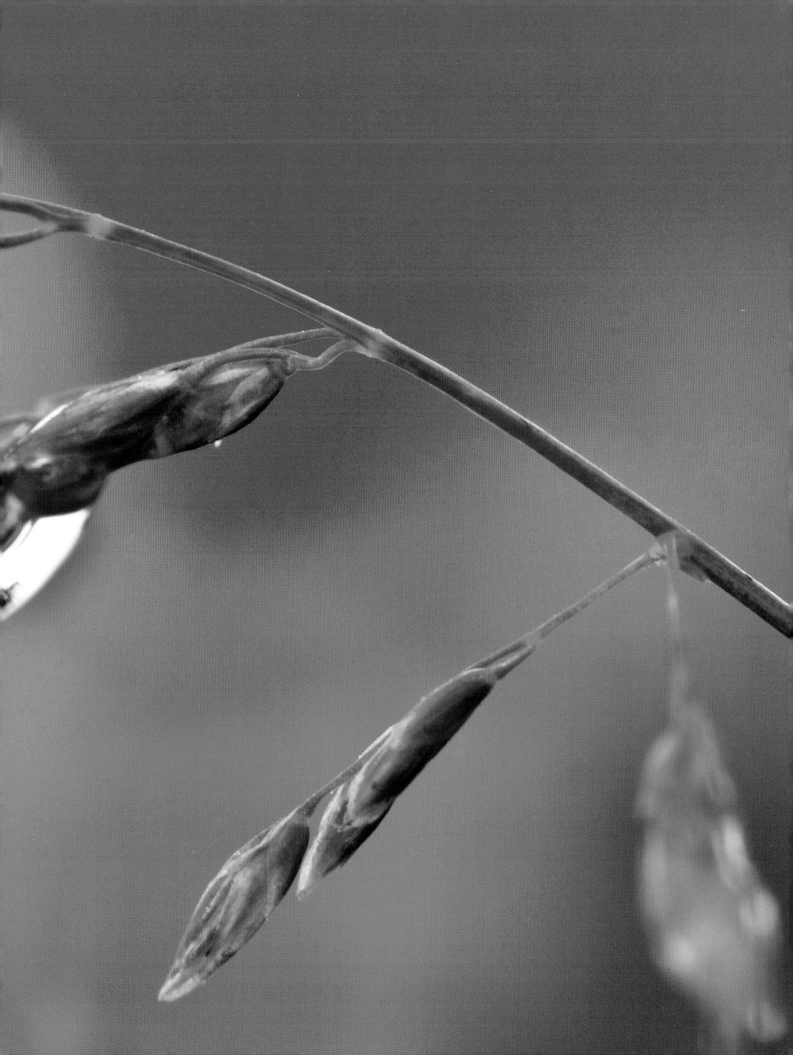

What Does *Macro* Mean?

ID YOU NOTICE that the word *macro* is missing from the title of this book? There's a very good reason why! First of all, let's define *macro*, since there seems to be a lot of confusion about this one very important word. The word itself is derived from the Greek word *makros*, which means *large* or *long*.

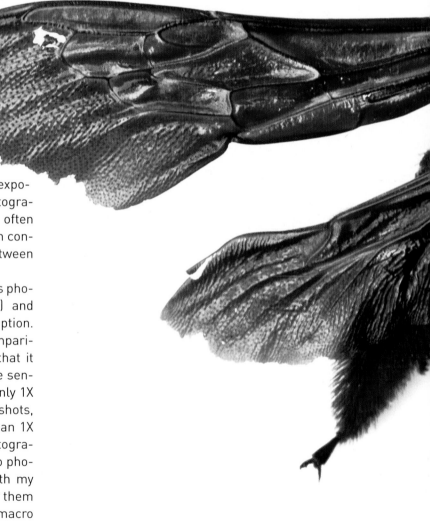

Think about that for a moment. Does that make perfect sense or what?! It does, considering that the images normally shot with a macro lens appear on the CCD (charge-coupled device) or film as "large" subjects—a dragonfly, for example—and more often than not take a long time to shoot. By *long*, I'm not referring to the setup times or the time spent waiting for the wind to die down or the dragonfly to return to that same tall grassy reed where you've set up camera and lens. Rather, I'm referring to the long exposures (long when compared to conventional photography). Exposure times of 1/15 sec. to 1 second are often the norm when shooting macro images, whereas in conventional photography, exposure times average between 1/60 sec. and 1/250 sec.

The technical definition for macro photography is photography that is at 1X magnification (life size) and greater, and I couldn't agree more with that description. So, this simply means that, in a side-by-side comparison, the actual size of the subject and the size that it appears on the piece of film or the CCD (where the sensors are in a digital camera) is *exactly the same*. Only 1X magnifications and greater qualify as true macro shots, and I must emphatically add that anything less than 1X should be, and is, defined (by me and other photographers, as well) as *close-up* photography, *not* macro photography. Sure, I've shot a number of images with my Nikon Micro-Nikkor lenses, but that doesn't qualify them as macro images. (Note that Nikon names their macro lenses *Micro*, which can be somewhat confusing.)

A 1X magnification is often indicated as 1:1, meaning a one-to-one ratio. As an example of "life size," an ordinary honeybee is approximately half an inch, so when photographed on film at life size, it will take up a 1/2-inch-long space on a piece of 35mm film (which measures 1⅜ x 7/8" by the way). And now here's where it gets

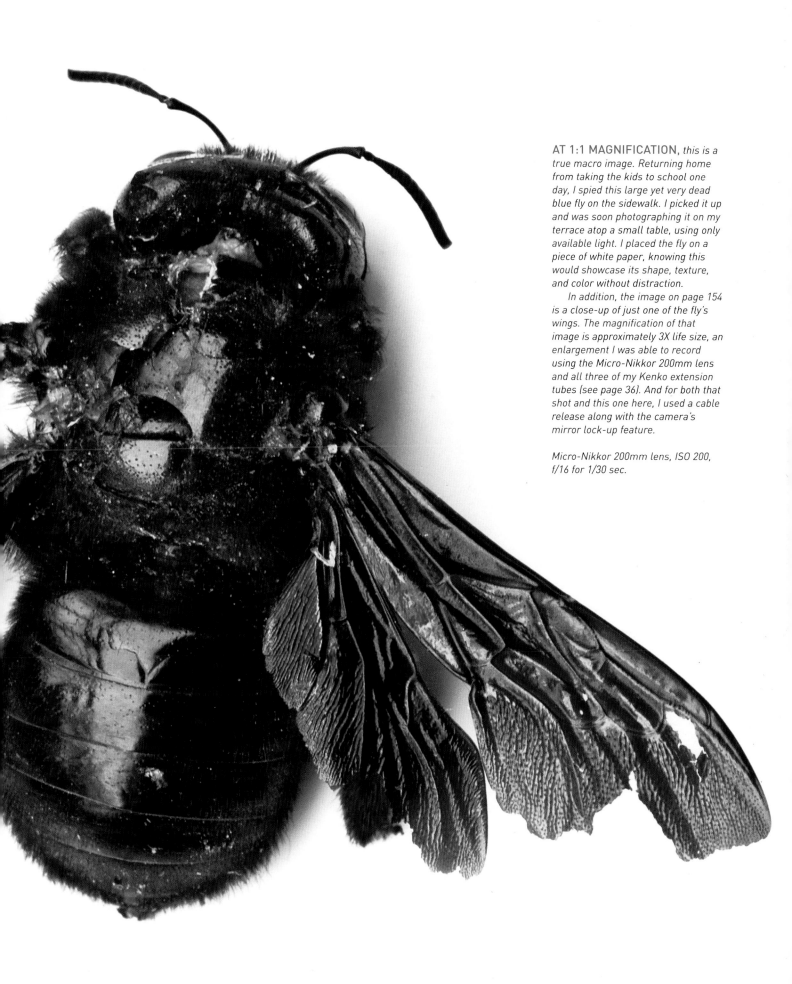

AT 1:1 MAGNIFICATION, *this is a true macro image. Returning home from taking the kids to school one day, I spied this large yet very dead blue fly on the sidewalk. I picked it up and was soon photographing it on my terrace atop a small table, using only available light. I placed the fly on a piece of white paper, knowing this would showcase its shape, texture, and color without distraction.*

In addition, the image on page 154 is a close-up of just one of the fly's wings. The magnification of that image is approximately 3X life size, an enlargement I was able to record using the Micro-Nikkor 200mm lens and all three of my Kenko extension tubes (see page 36). And for both that shot and this one here, I used a cable release along with the camera's mirror lock-up feature.

Micro-Nikkor 200mm lens, ISO 200, f/16 for 1/30 sec.

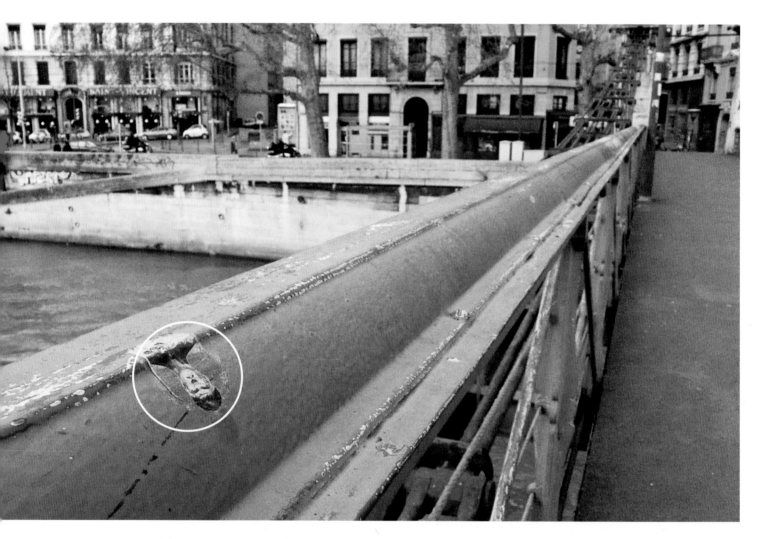

interesting for us digital shooters. When you shoot with a true macro lens (a lens that will render 1X magnification), you can, in theory, not only shoot macro images at 1:1 (life size) but at up to 1.5 times life size. Why? Because the CCD is smaller than a piece of 35mm film. The CCD on my Nikon D300 is roughly 5/8 x 1", and when I use any one of my three Micro-Nikkor lenses (105mm, 200mm, or 70–180mm), that same honeybee photographed with a true macro lens focused all the way to its normal 1:1 life-size reproduction ratio will, in fact, be recorded at 1.5X life size. At least, that's what's many people think. Truth be told, the 1.5X life-size image of your honeybee is nothing more than a cropped-in-tighter version of the same honeybee photographed at 1:1 on 35mm film.

Let me put it another way. When seated in a standard-size airplane seat, you hopefully have a bit of room to maneuver. But when you climb aboard those smaller commuter airlines and take your seat, the fit is often a bit tighter. What the heck? Did you bloat up somehow? Of course not! You haven't gotten bigger at all. The seat just got smaller! Again, the CCD on my Nikon D300 is a bit smaller than the standard 35mm film format; so, that same honeybee, when photographed with the Nikon D300, appears larger *only* because its "seat" got smaller, too.

So again, keep in mind, for an image to truly be considered macro photography, the magnification must be 1X or greater.

YEARS AGO, *it would have been hard to imagine that I would one day begin to see numerous "portrait" opportunities with my macro lens. Back then, I directed my macro most often at nature subjects, namely flowers. But over the past ten years, my macro world has extended far beyond the backyard flower garden, and on more than one occasion, I have stumbled upon "faces," both literal and figurative versions, as was the case with this miniscule face on a bridge railing in Lyon. (My daughter later explained that this was actually a stick-on tattoo that comes free with a piece of bubblegum.)*

What drew me to this face were the textures found upon it. As you'll discover, it's textures that are often the center of interest in macro or close-up work. With my camera and Micro-Nikkor 105mm lens mounted to my tripod, I made certain to choose an almost-straight-down point of view, and due to the subtle curve in the railing, I also made sure to set the aperture to f/22 to achieve the necessary depth of field for top-to-bottom sharpness. With my camera set to Aperture Priority mode, I simply fired the shutter with my cable release, allowing the camera to set the shutter speed for me since the light levels were even throughout.

The 1:1, or life-size, magnification of this "portrait" was a direct result of using the Micro-Nikkor lens, but it's safe to say that I could have also achieved a life-size magnification combining extension tubes with a "street zoom" (18–70mm, 24–105mm, or 17–55mm lenses, for example). Achieving 1:1 magnifications is simply much easier with a macro lens, since most true macro lenses offer the ability to focus from infinity all the way down to life size without the need to add extension tubes or close-up lenses.

Micro-Nikkor 105mm lens

If It's Not Macro, It's Close-up Photography

OST OF THE IMAGES in this book are not true macro images. Most are between 1/2 and 1/10 life size, while a few others are as little as 1/20 life size! So, they are *close-up* images. This is the main reason I didn't use the word *macro* in the book title. Close-up photography encompasses a much broader range of work.

Of course, adding to the confusion of the terminology in this area are camera manufacturers, who have led many consumers to believe that they're getting a macro lens when they buy zoom lenses that have a "macro" setting on them. It's marketing at its finest, for sure, and it obviously works, as countless shooters have walked out the door of many a camera store beaming about their newly purchased all-purpose lenses. Many photographers have said, "It's not only a really nice telephoto zoom but also includes macro! It's like getting two lenses in one!"

But here again, the "macro" functions on all of these zooms (whether they are 24–85mm, 80–200mm, or any number of other variable-zoom lenses being sold) offer up about a 1:4 ratio of magnification, and that means our 1/2-inch honeybee will appear to be about 1/8 of an inch in size when photographed at a 1:4 magnification. You'll need to make no less than a 4 x 6–inch print to get back to the original 1/2-inch life-size subject, and then, before you can really impress your friends, you might want to grab a pair of scissors and cut the 1/2-inch honeybee out of the 4 x 6–inch print to make it into a 1/2-inch print to show off as a life-size image of a honeybee. Yeah, right. Now, I'm not suggesting that the zoom lens with macro that you bought is a useless tool. Heck, not at all! It's a great lens and can be used in countless situations when you wish to record some terrific shots, but these shots will not be *macro* shots; they will be *close-ups*.

FOCUS MANUALLY—EVERY TIME

One very important note: When shooting any close-up or macro composition, turn off your autofocus function and manually focus every shot! If you don't, you will lose far too many shots. Your autofocus lens will seem to experience "seizures" when it's asked to focus on close-up subjects; this is because it can't seem to differentiate between the front or back of that flower, for example, and it sure can't tell if you wanted that bee in the middle of the flower in sharp focus either. If you absolutely must rely on autofocus due to poor vision, then get ready to have your patience tested, or resign yourself to shooting only close-up subjects that are 100 percent parallel, from edge to edge, top to bottom, to your film plane or CCD.

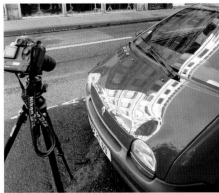

AS I MENTIONED, *and you may have already discovered, your telephoto zoom with macro is not really a true macro lens, but that certainly doesn't mean you can't shoot some close-ups with it. In fact, a telephoto zoom lens with a macro feature does allow you to focus closer than a telephoto zoom without one. The trick is to find subjects that are large enough to fill the frame, since with most close-up and macro compositions, filling the frame is paramount.*

An early Sunday morning found me out and about the quiet streets of Lyon, France, and it wasn't too long into my journey that I came upon one of many telephoto "macro" opportunities I had that morning. With my Nikkor 75–300mm macro zoom, I was able to focus within 3 feet of the reflection on the hood of this small car. To achieve maximum impact, I moved a bit right, left, up, and down until the reflection was filling my frame in the most pleasing way. Not a true macro shot, but certainly an eye-catching close-up!

With my aperture set to f/22 to assure top-to-bottom sharpness, I simply adjusted the shutter speed until 1/8 sec. indicated a correct exposure and then fired off several frames, tripping the camera's shutter with my self-timer to eliminate any possible camera vibrations that could have resulted from pressing the shutter release with my finger.

Nikkor 75–300mm macro zoom lens, f/22 for 1/8 sec.

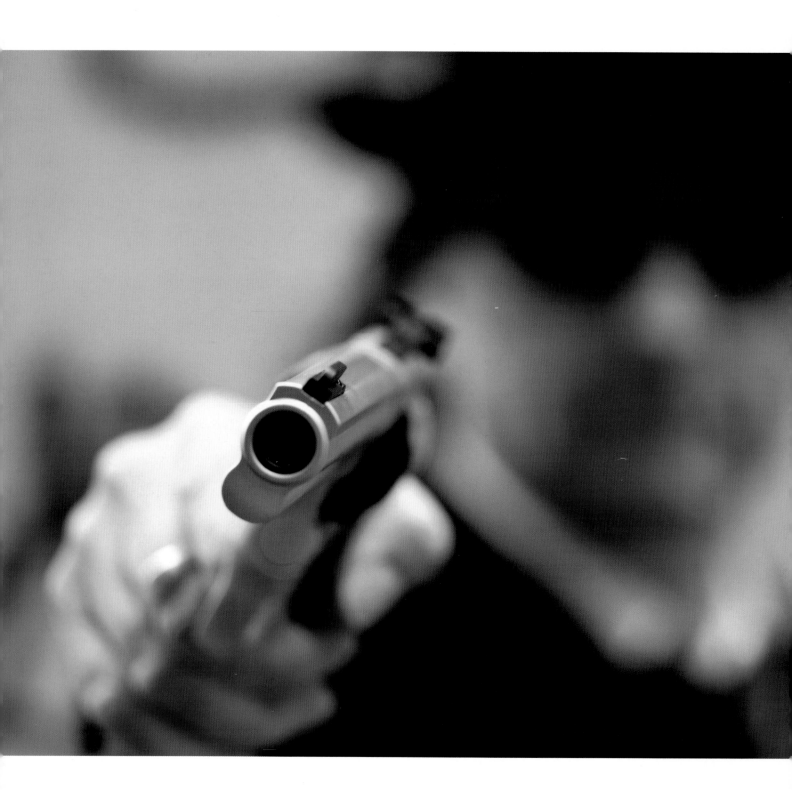

HAVE YOU EVER FOUND
yourself looking down the barrel of a gun? If not, then it's safe to say, you are now! Not a welcome sight, I'm sure. Note the differences in these close-up compositions. Clearly, both show that the visual weight (indicated by the limited area of focus) is on the end of the barrel. Yet, it's also clear that both of these backgrounds tell a different story, and the lenses have something to do with that. The one at right has more of a ghetto, ganglike feel, revealing not only more of the graffiti background but my model's suit, which looks like something out of Reservoir Dogs. The other has what could be considered a more neutral background. For the image at right, I used a 35–70mm zoom lens at the 35mm focal length; for the more neutral shot, I used a 105mm lens. The exposure was the same for both.

In this case, one photograph is not better than the other, but clearly, the photograph taken with the wider-angled 35mm simply conveys more information. When you take the time to know the "visions" of every piece of close-up gear you own, the amount of close-up opportunities available to you does become truly unlimited.

Right: Micro-Nikkor 35–70mm lens at 35mm, f/5.6 for 1/160 sec.; left: Micro-Nikkor 105mm lens, f/5.6 for 1/160 sec.

HE OTHER REASON you won't find the word *macro* in this book's title is because I include an extensive section on shooting close-ups with a wide-angle lens. I can hear the question now: Did Bryan just say "shooting close-ups with a wide-angle lens"? Yes, I did! Shooting close-ups with a wide-angle is a worthy investigation into the reasons why most shooters don't—and why most shooters *should* begin to embrace their wide-angle as a close-up lens with fervor. The world of wide-angle close-ups provides, in many respects, even more fertile ground, more as-yet-unexplored territory than the world we normally associate with "normal" close-up photography.

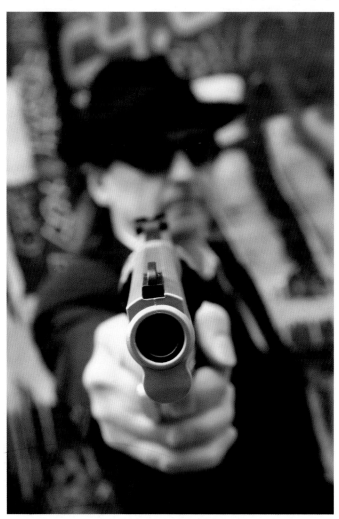

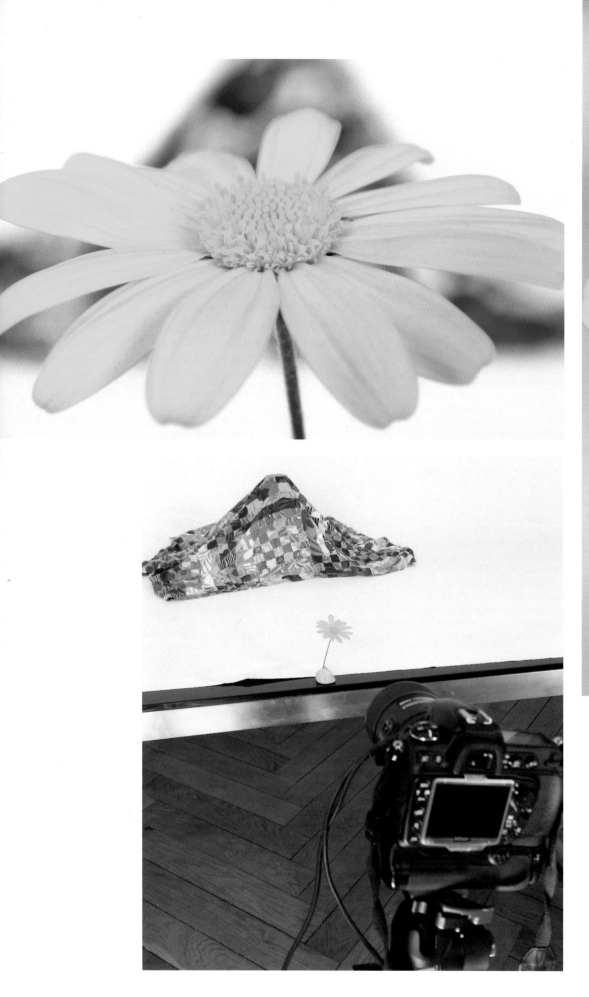

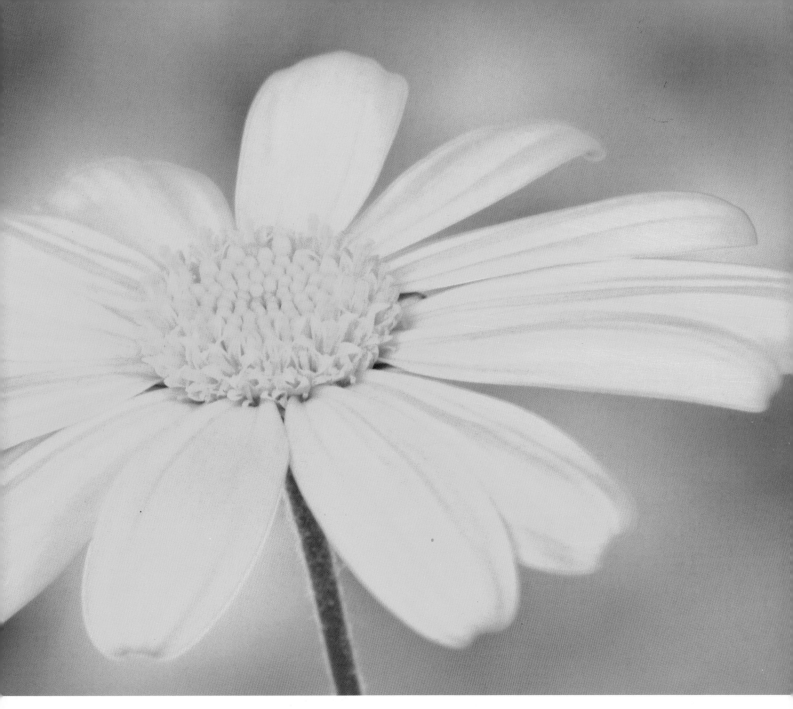

WHEN YOU OPT TO USE *a wide-angle lens for close-up work, do so wisely. Wide-angles are not the best choices for all close-up compositions. As you'll discover, there are many equipment options for achieving a close-up photograph: wide-angle, telephoto, and close-up lenses; extension tubes; reversing rings; and of course, actual macro lenses. When it comes to developing your "macro vision," it is, first and foremost, vitally important that you know—really know—the "vision" of the many combinations of lenses and accessories that are available. Understanding the vision of your equipment will not only enable you to make the often quick decisions necessary when a close-up opportunity presents itself (a butterfly just landed on that flower 3 feet away from you!) but will help you to understand which combination of close-up equipment will offer the right angle of view. More often than not, it is the angle of view that has a tremendous impact on the background, and if there's one area that's in constant need of your attention in close-up photography, it's the background.*

Consider this example. It's a simple setup for sure: a single flower anchored in a piece of putty, with a very colorful shirt draped over an

object (a lens, in this case) in the background. Notice that in both compositions the flower is the same size; it clearly fills the frame in both cases, yet it's obviously clear that the backgrounds are radically different. What happened? I made the image opposite with a 35–70mm macro zoom set at 35mm. I made the image above with a 105mm lens. Since the angle of view is greater with the 35mm wide-angle lens (62 degrees) than with the 105mm (27 degrees), I recorded a wider background in that image. And in this case, that wider background does nothing to visually help the flower. It's simply a distraction, an eyesore, an interruption to what is an otherwise simple and clean shot of a lone flower.

So this was not the place to pull out a moderately wide-angle lens and shoot a close-up, but it was the right place to choose the moderate telephoto lens, which rendered the colorful background as an out-of-focus complement to the flower due to its narrower angle of view.

Opposite: Nikkor 35–70mm macro zoom lens at 35mm, f/8 for 1/30 sec.; above: Micro-Nikkor 105mm lens, f/8 for 1/30 sec.

EQUIPMENT

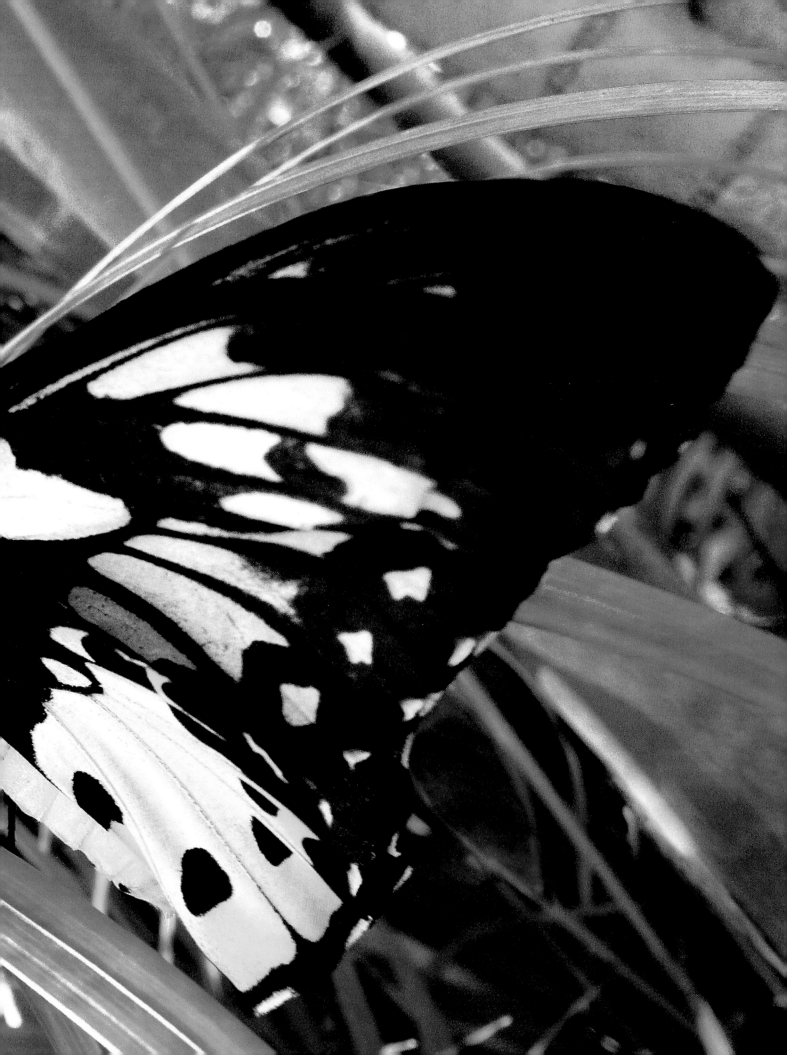

Macro Lenses

ONESTLY, THE AMOUNT of close-up and macro gear available for purchase is a testament to the interest in this area of photography. You can buy inexpensive close-up lenses or expensive close-up lenses (aka close-up filters). You can buy a single extension tube or a set of three. You can buy a reversing ring or bellows, and these purchases are soon followed by the need for a much more versatile tripod, a focusing rail (or focusing stage, as Nikon calls it). And yes, I do know that, for all of you married folks out there, buying more gear may put a strain on your marriage. But hey, look at it this way: The money you spend on equipment will save you thousands of dollars in marriage counseling. Who needs counseling when you're a happy spouse?

If shooting life-size images and beyond is really your passion, then a true 1:1 macro lens will, in all likelihood, be part of your future in photography—perhaps even the amazing Canon 65mm macro lens that offers up 1X–5X magnification. Today's macro lenses, without the aid of additional equipment, allow you to focus from infinity all the way down to that honeybee, recording it as a life-size image. Or in the case of the Canon 65mm macro lens, you can get a full-frame view of the honeybee's eyeball.

Macro lenses are commonly available in the 50–60mm, 90–105mm, and 180–200mm focal lengths. Plus, Nikon used to make a terrific 70–180mm macro lens, but it's now discontinued; if you should ever come across a used one through eBay or KEH Camera Brokers in Atlanta, you'll have to put on your Speed Racer costume and act accordingly to increase your odds of becoming the lucky buyer.

WHAT DO I USE?

Often, the size of the subject I'm photographing will determine what lens I need to bring it "up close and personal." It's true that, more often than not, I will be reaching for a telephoto lens or a macro lens or some combination of either with an extension tube. Other times, I may reach for my digital point-and-shoot, the Leica D-Lux, with its amazing close-focusing (up to 2 inches) wide-angle lens. And as you'll see, I'll also reach for my 12–24mm and even my full-frame fish-eye lens, with its amazing ability to focus as close as 4 inches and yet offer up an almost 180-degree angle of view!

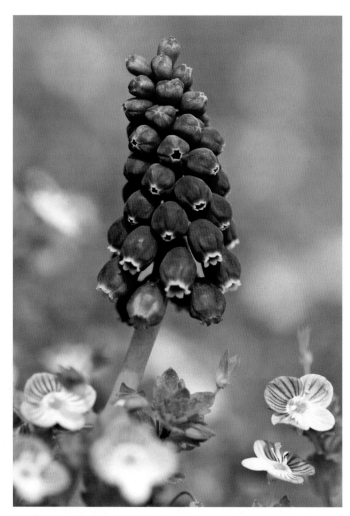

THE WORLD AS WE KNOW IT *would be a hostile place if not for flowers. Not only are flowers a sign of the seasons, a reason for hope, but they are often fragrant and, no doubt, a welcome spot or splash of color in the landscape, a garden, or a vase on the dining-room table. And not surprisingly, they are one of the most photographed close-up subjects, by amateur and professional photographers alike.*

Springtime blooms are reason enough to get out and shoot. This small wild grape hyacinth was one of many along a slope in the countryside of the south of France. I was quick to place my Micro-Nikkor 200mm lens on the camera and isolate this one flower. After checking my depth-of-field preview, I concluded that an aperture of f/8 best rendered the background out of focus while still recording a sufficient area of sharpness on the flower. It was a few moments later that I felt compelled to add some contrast to the background, and I didn't have to look far, as to my left were several dandelions. Yellow has always been a great contrasting color to the purple hues, and it didn't disappoint this time either. I took the picked dandelion and simply placed it approximately 8 inches behind the grape hyacinth. As you can see, this spot of yellow really livens up the overall composition.

Micro-Nikkor 200mm lens, f/8 for 1/160 sec.

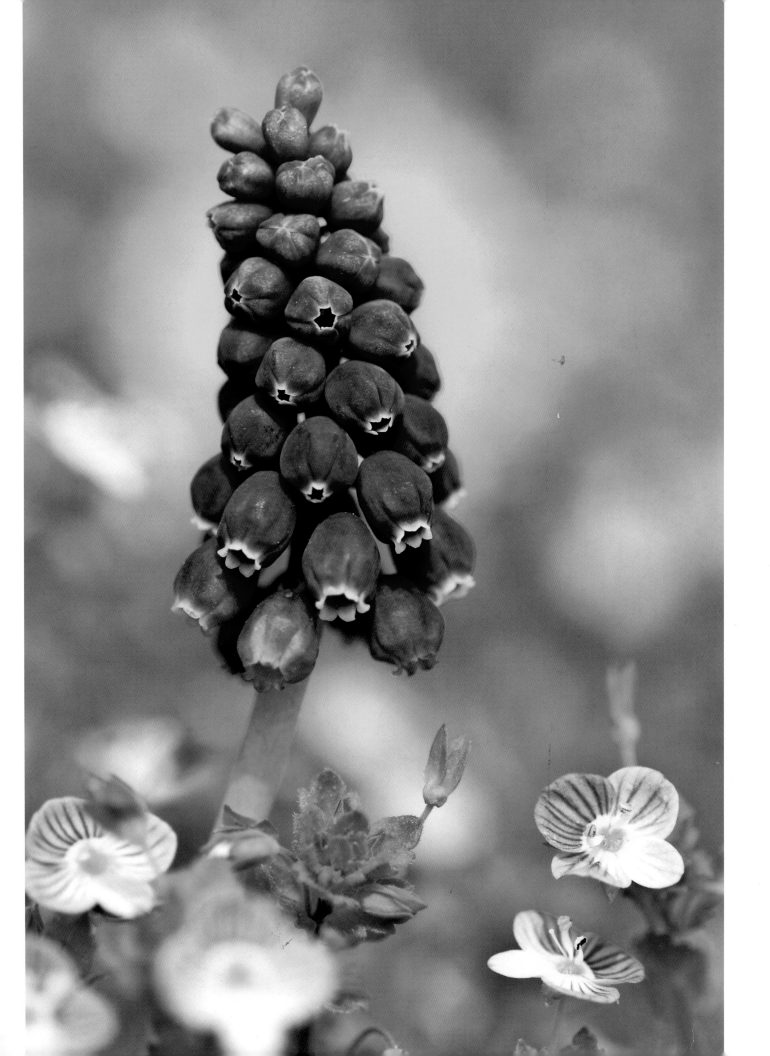

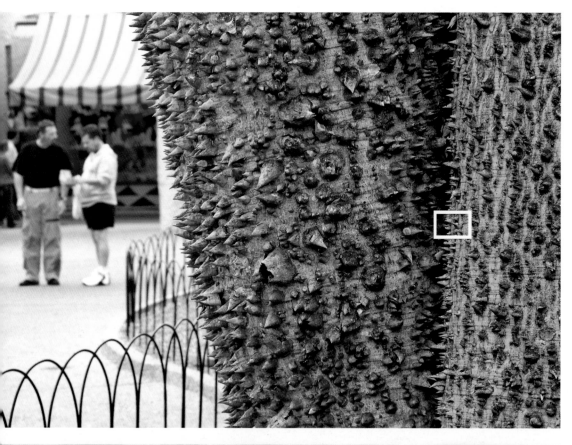

horticulturists to be one of the top five blooming trees in the world, the silk floss gets my vote, as well. Every September it puts on quite a show with its large crimson blooms and the daily activity of the hummingbirds that nest in it. But just like the rose, the silk floss tree is not without its thorns or, shall I say, spikes, as in yikes!

It was the spikes of the silk floss tree, however, that compelled me to take a much closer look. Within minutes, I was all set up with my camera, Micro-Nikkor 200mm lens, and tripod, having sought out the composition you see inside the white box in the image to the left. Not surprisingly, and to my delight I might add, this macro shot generates a host of varied responses from students when I rotate it 90 degrees clockwise (opposite) and ask, "Any idea what this is?" The most common response is, "Some kind of cave with stalagmites?" Of course, having the benefit of the larger view, we know it's not a cave of stalagmites. (The original, horizontal orientation is the lower shot on this page.)

Micro-Nikkor 200mm lens, f/16 for 1/60 sec.

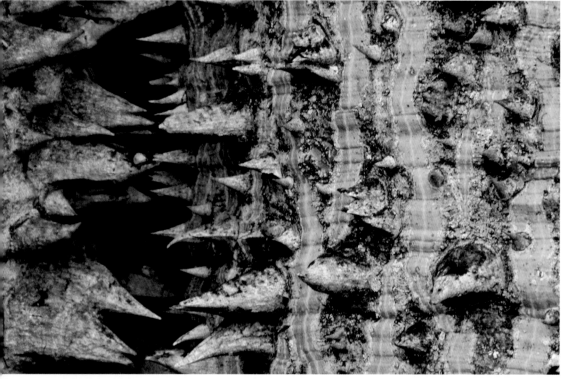

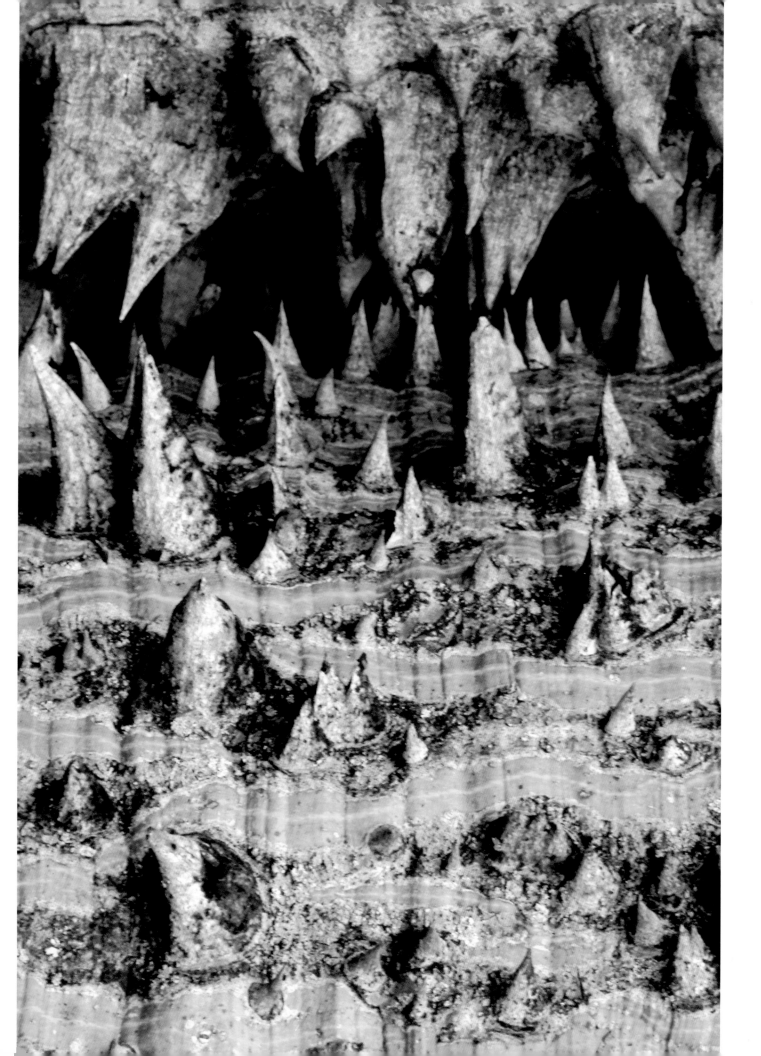

Of the three macro focal lengths available, and assuming you are going to buy only one macro lens, I would *strongly* recommend that you buy a lens in the 180–200mm focal length range—but *only* if you're going to use it primarily in the great outdoors. Manufacturers of macro lenses in this focal length include the majors, Canon and Nikon, and the two aftermarket giants Tamron and Sigma. Canon's 180mm is, of course, made to fit only Canon camera bodies, and Nikon's 200mm is made to fit only Nikons. Tamron and Sigma both offer up the 180mm macro lens for Pentax, as well as the 180mm for Nikon and Canon. And, of course, they do so at a much cheaper cost—almost half, in fact, which is some serious cash savings and no doubt worthy of your consideration. Does this lower price indicate a major loss in image quality (for example, contrast and sharpness)? Not according to the countless field tests that these lenses have been put through by the likes of *Popular Photography* and *Shutterbug* magazines, to name just two.

So, back to the 180mm. There are several reasons I'm so keen on using this focal length in the field: Your lens-to-subject distance is greater without sacrificing image magnification. You can record life-size magnifications and still have roughly 12 inches of space between you and your subject versus having only 2–3 inches of space between you and your subject when working with the macro lenses in the 50–105mm range. In other words, you'll be able to record a life-size image of that butterfly or salamander or garter snake from a safe distance. You can go about your business and they can go about theirs, and nobody's getting all stressed out.

In addition, after photographing that salamander, you can just as easily turn your attention to the rustle in the bushes behind you and focus on that white-crowned sparrow without having to stop and remove an extension tube or close-up lens, since all macros have continuous focus from infinity down to life-size magnifications. And because of that continuous-focus feature, this same lens doubles as your primary portrait lens (for all those times you get called upon to make head shots of the wannabe models living on your street).

And although these are good arguments for the 180–200mm macros, the best argument, to my mind at least, is this: Macro lenses in the 180–200mm focal length all come with tripod collars, and if you currently own a zoom lens with a tripod collar, you already know

how easy and seamless it is to change from landscape mode to portrait mode (i.e., from horizontal to vertical orientation). Just loosen the collar, rotate the camera, and voilà, you've changed modes. Considering the often tedious task of most macro shots (we do want to be precise, after all), imagine the hassle that awaits you without the benefit of a tripod collar, when you now wish to shoot a vertical composition of that same horizontal close-up: *Yikes* and *ugh*, along with a few swear words, are the norm!

Of course, I would be remiss if I didn't also address another unique feature of all macro lenses. Optically, a macro lens is "corrected" for flat-field viewing, allowing one to record sharper-than-normal images at all apertures. In simple tech-speak, you'll record edge-to-edge tack-sharp images of any and all objects that lie within that plane of focus without the normal edge "falloff" found when shooting that same subject with a single focal length or zoom lens in combination with extension tubes and/or close-up filters (close-up lenses).

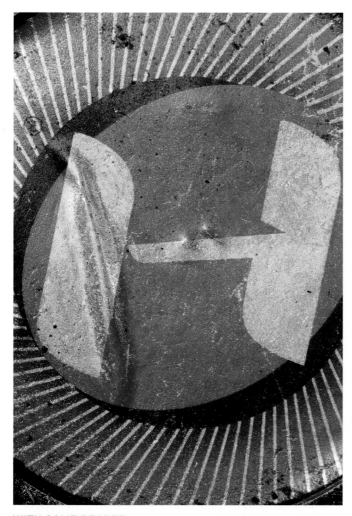

WITH SOME DEGREE of prodding, most macro/close-up shooters will eventually allow their own curiosity to take hold, and they will turn their macro lenses away from flowers and nature subjects and toward the man-made world. Years ago, after several years of shooting mostly flowers, butterflies, and bees, in fact, I had an epiphany. I was involved in one of those really minor fender benders in a mall parking lot, and as luck would have it, my camera and Micro-Nikkor 55mm were in the trunk. I say luck because the accident was not my fault, and I wanted to be sure to take a picture of the small but still noticeable damage to the right front fender of my bright red Volkswagon Jetta. I had intended to only take one shot, but I was soon immersed in the "beauty" of the damage, small as it was. Not only was some new texture revealed (the shiny metal now exposed by the paint that had been scraped off) but some nice added color appeared (a deep yellow color from the other car, which had left its mark atop what red paint remained in the area of my damaged fender).

Later that evening, I began to think more about other macro possibilities beyond the natural world, and within a few days I paid what would become a number of visits to local junkyards and wrecking yards. Thus began my constant journey of always placing these locations on my annual list of places to shoot. Several years ago, a handful of students and I came across a wrecking yard in Petaluma, California. After seeking permission from the owner to enter, all of us were soon immersed in the joy of shooting "industrial abstracts."

I came upon an emblem, a hologram in fact, from a Honda. Soon, I was over the top of it with my camera and Micro-Nikkor 105mm lens, focusing as close as necessary to record the letter H. Since I was parallel to the emblem, I had no depth-of-field concerns, so I chose the critical aperture of f/11 and simply adjusted my shutter speed until the camera indicated a correct exposure of 1/160 sec.

What happened next is vitally important. I knew when photographing the letter H that I had yet to focus as close as my lens would allow. I knew I could still focus even closer and perhaps record another close-up image, one that would be far more abstract than the letter H. I mention this for one good reason: Most amateur and even professional shooters get so excited when they get their first macro lens that they fail to fully realize its close-focusing potential. In countless workshops, I've been invited by students to check out a close-up image in their viewfinder. More often than not, I like what they've done, but when I ask if they've considered looking at that subject even closer, they remark, "How can I do that?" I simply reply, "Keep focusing until you can focus no more." To their surprise, they discover just how close—really close—they can focus, and thus opens up the real world of macro.

So in my second shot, I simply focused as close as I could get, which in turn rendered a much more abstract image of this Honda emblem. Since my point of view was still parallel to the emblem, I again chose an aperture of f/11, but now my light meter indicated the need to change my shutter speed from 1/160 sec. to 1/100 sec. The reason for this is simple: The lens was now extended farther; the light that would be traveling down the lens and onto the film or CCD took longer to arrive, so a slower shutter speed was in order.

Left: Micro-Nikkor 105mm lens, f/11 for 1/160 sec.; right: Micro-Nikkor 105mm lens, f/11 for 1/100 sec.

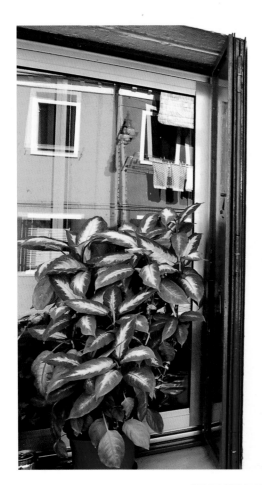

ONCE YOU'VE MADE THE DISCOVERY *that most any subject is worth at least taking a look at with your macro lens, you can expect to garner an odd stare or two when shooting in areas where people are out and about. Such was the case when I came upon this downspout between two houses on the most colorful island in the world, Burano, Italy. If you've been to Burano, you can understand why my interest in a silly old downspout would cause some unusual glances if not outright stares. For sure, there's so much more that one can find to photograph in Burano, but obviously, at least on this morning, I couldn't move on until I had framed up what were some of the most colorful reflections found on this downspout.*

Due to the height of the subject I had in mind, I had to extend the center column of my tripod, which is something I don't recommend or like to do because it has the potential to introduce "wobble" since the camera is no longer as secure as it is when the center column is not extended. Fortunately, the concrete sidewalk underneath the tripod was as stable as any concrete sidewalk could ever be. There was also no wind, and to be safe, I chose to use the mirror lock-up feature on my Nikon D2X, thus further reducing the possibility of any vibrations. Due to the pipe's cylindrical nature, I needed to use a really small aperture to achieve sharpness throughout, especially near the side edges, where the downspout curved away from the plane of focus. With my aperture set at f/32, I adjusted my shutter speed until 1/4 sec. indicated a correct exposure. With my camera's self-timer engaged to fire the shutter 10 seconds after I tripped the shutter release, I felt I had done all that I could to assure a tack-sharp image, and sure enough, I was happy with the results.

Nikon D2X, Micro-Nikkor 105mm lens, f/32 for 1/4 sec.

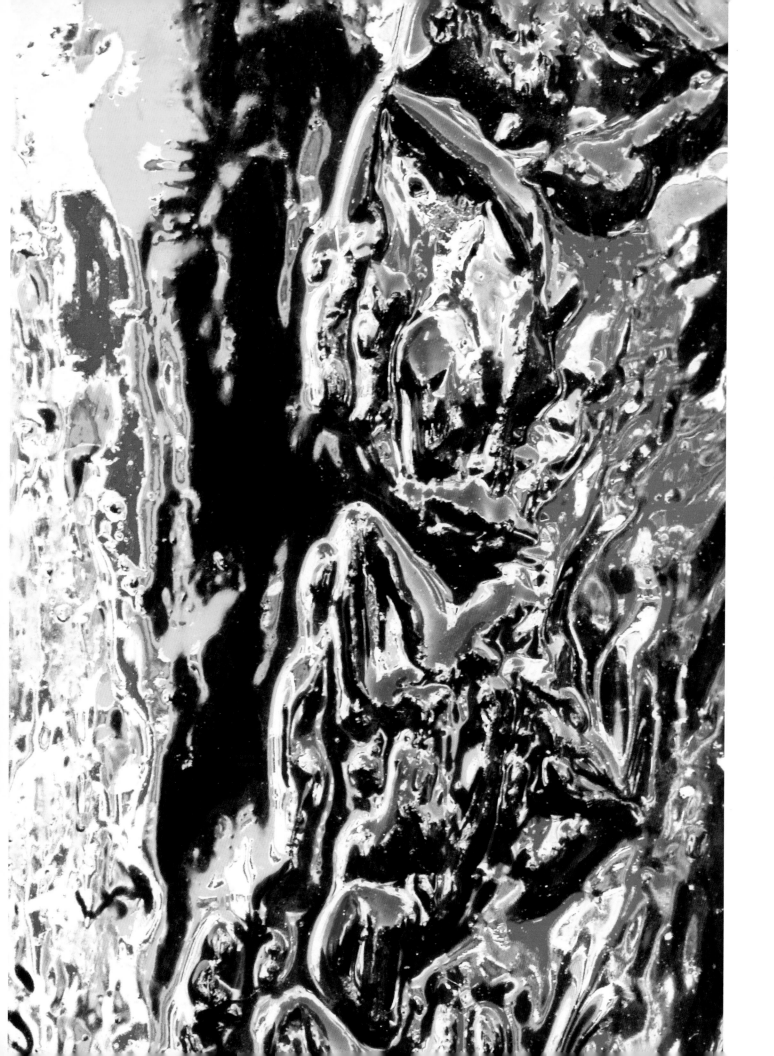

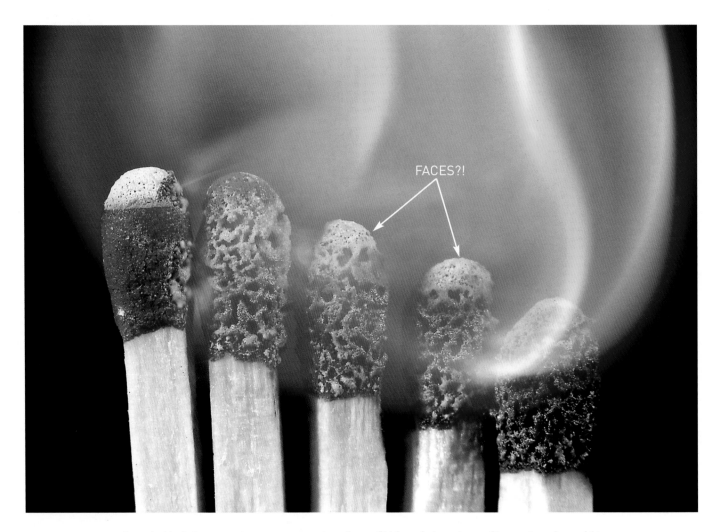

A child is not a vase to be filled but a fire to be lit.
—FRANÇOIS RABELAIS

Just as a candle cannot burn without fire,
man cannot live without a spiritual life.
—BUDDHA

Genius is initiative on fire.
—HOLBROOK JACKSON

Love is the fire of life; it either consumes or purifies.
—UNKNOWN

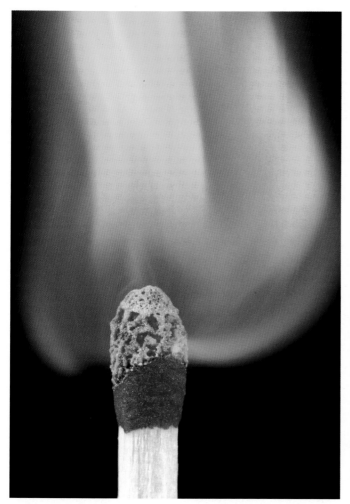

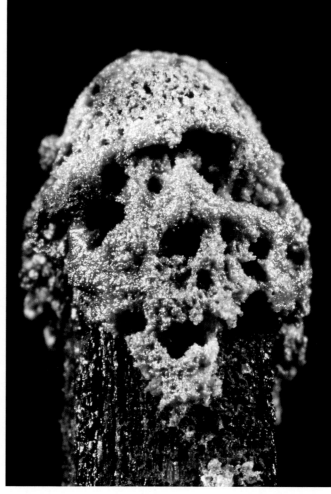

SO MUCH HAS BEEN WRITTEN ABOUT FIRE, and its use as a metaphor endures, as the quotes on the facing page show.

I remember the movie Quest for Fire, as well, and although the dialogue was limited to grunts, groans, and screams, the message of fire's importance was made clear. And of course, without fire (the sun) we would not have the most essential ingredient for image-making: light. So what better way to pay tribute to fire than with a single wooden match and a macro lens?

With my camera and Micro-Nikkor 105mm lens mounted on a tripod, I lined up a row of matches stuck in a small mound of putty. The idea behind shooting a row of matches was to convey the idea of "catching fire," but it just wasn't coming together to my liking. I soon realized that once again, in art, less is more, and soon I was shooting a single lit match.

I also noticed, while reviewing the row of matches, that the extinguished match tips looked like the remnants of skulls. So this time, with my camera, 105mm lens, and the addition of three extension tubes,

I was soon making a 3X magnification of a burnt match head. Heck, who knows? If you can sell a Frosted Flake in the shape of Illinois on eBay, maybe there's a market for burnt matches that look like skulls!

In terms of lighting, I used two Alien Bees from the company White Lightning, one on each side of me and pointed at 45-degree angles to the match. First, without benefit of strobes and with my camera in Shutter Priority mode set to 1/125 sec., I lit a match and noticed that the camera indicated f/11 as a correct exposure. Keep in mind, however, that this was the exposure just for the flame and not for the wood of the match itself. I then turned on the strobes and took a flash meter reading, setting the power on both strobes in order for the flash meter to indicate a correct exposure at f/11. When the flashes fired, this enabled me to record a correct exposure of both the flame and the wooden matches.

Left: Micro-Nikkor 105 mm lens; right: Micro-Nikkor 105mm lens, three extension tubes

Extension Tubes

XTENSION TUBES are accessories that you place in between the camera body and the lens to gain magnification. They are hollow tubes, meaning you aren't adding any additional glass elements that could adversely affect image quality. They come in a range of sizes—12mm, 20mm, 25mm, and 36mm—and can be stacked together or used singly. And yes, even those of you who have bought an actual macro lens should still buy at least one extension tube—if not a set of three extension tubes. You can, of course, buy just one. Just ask Canon or Nikon, and they'll be happy to sell it to you, but where's the logic in that? Why buy Canon's single 25mm extension tube when you can buy a set of three extension tubes from Kenko for about only forty bucks more? With Kenko, you'll get 12mm, 20mm, and 36mm extension tubes, and all of the "pins" (the contacts, see below) are there, so it matches up with the Canon body and lens it's used with, and you don't have to worry about "losing" your metering. This same set of three extension tubes is also available for Nikon and Pentax shooters at the same price. When you use all three tubes together, you have a total of 68mm of extension available, and that's roughly three times more extension than one Canon 25mm extension tube. That translates into even greater degrees of magnification.

So, just how does an extension tube work? Simply put, the mechanics of most any lens work as follows: The farther away the rear element of a lens from the CCD or film plane, the closer the lens will focus. So, in theory, when you focus on something close—let's say, your daughter sitting in her high chair eating her oat-

meal—the rear element of your lens has moved farther away from the CCD or film plane. So it stands to reason that if you could place some kind of spacer between your lens and camera body, you should be able to focus closer. This is why you could take that toilet paper core and, with an ample amount of duct tape, secure it between your lens and camera body and fashion an instant super-close-up lens!

The drawbacks to this are, however, far greater than the advantages: Although extremely lightweight, a toilet paper core doesn't hold up well in the rain, for example. It also is much lighter in color than the black camera body and lens; this is enough contrast to scare away macro subjects. And a toilet paper core is missing the pins (the contacts on extension tubes that are necessary to maintain wide-open viewing), so when you stop the lens down to increase your depth of field, the image in your viewfinder gets really dark. So the long and the short of it is, forget the toilet paper core and go with the heavy metal look of extension tubes, which are impervious to rain and do have the necessary pins that allow you to maintain wide-open metering.

Okay, so now you place just one extension tube between your camera and lens and you "push" the rear element of the lens farther away from the film plane; this affords you a closer view, a greater magnification, of what lies before you. And when you stack extension tubes, adding one on top of the other, your subject becomes even larger, since you're afforded an even closer view. Extension tubes are wonderful, and must-have, additions to that telephoto zoom "with macro" that you already bought. An 36mm extension tube (or multiple extension tubes) in combination with your street zoom or telephoto zoom with macro allows you to record an extreme close-up—if not a macro shot (See page 158 for more on magnification ratios and extension tubes.)

The only drawback to extension tubes is the decrease in light that comes with their use, which in turn affects viewfinder brightness and exposure times (requiring slower shutter speeds). Yet even these two very minor drawbacks are *not* reason enough to forgo buying extension tubes.

A NOTE ABOUT EXTENSION TUBES AND WIDE-ANGLE LENSES

A wide-angle lens for a digital camera (such as the 12–24mm range) or a wide-angle lens meant for a 35mm film camera (the 17–28mm range, for example) will not be able to focus with any extension tube because the focus point is now so close that you would literally have to climb inside the lens to find it.

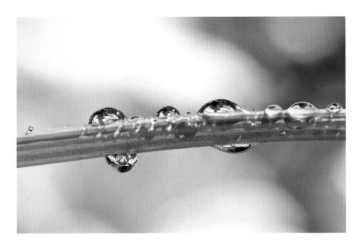

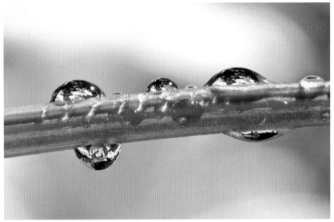

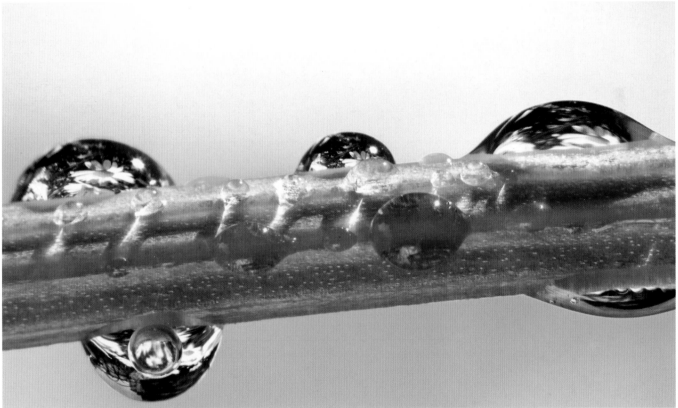

LET'S ASSUME YOU HAVE a street or telephoto zoom lens with a macro function. Chances are good that you can record an image at 1/6 to 1/4 life size, and chances are even better that you've already done so and made the discovery that many times you can't get as close as you want. All that's missing is a set of extension tubes! Dewdrops on blades of grass or flower stems continue to be subjects that many shooters eventually migrate toward, but often, the results are far from fulfilling as the photographer quickly learns the macro feature on these zoom lenses is hardly macro at all. With the aid of some extension tubes, however, a macro shot is just a few twists away.

For these examples, I was shooting at 50mm. (If you're shooting digitally, set the focal length of your street zoom to 35mm, which will be the rough equivalent of a 50mm lens, and if you're shooting with a film camera, set the focal length to 50mm.) With my 18–70mm street zoom at a focal length of 50mm and with one 12mm extension tube, I was able to record dewdrops on a lone flower stem but was still too far away for my taste (top left). This image is at about a 1:4 magnification ratio, or 1/4 life size. When I combined the 12mm extension tube with the 20mm tube, I approached a life-size magnification and got closer to a far more

fulfilling composition. But it wasn't until I placed three extension tubes (a 12mm, a 20mm, and a 36mm) between the camera and lens that I went beyond life size (since the extension of 68mm exceeded the focal length of 50mm) and fully realized a frame-filling composition. The third image is at about 1.3X life size. In fact, the dewdrops are so close that you can see within the droplets the landscape that lies behind them. Note that for all exposures I used a tripod and the camera's mirror lock-up feature with an electronic cable release.

Let's consider just how big this is in terms of magnification: Focal length "over" mm length of extension tubes equals magnification size. If 50mm "over" 50mm of extension equals 50/50 or 1 (1:1, or life size), and we have a 50mm focal length "over" 68mm of extension, that gets 50/68 or 1.36:1—just a bit more than 1.3X life size.

Top left: 18–70mm lens at 50mm with 12mm extension tube, ISO 200, f/22 for 1/15 sec.; top right: 18–70mm lens at 50mm with 12mm and 20mm extension tubes, ISO 200, f/22 for 1/10 sec.; above: 18–70mm lens at 50mm with 12mm, 20mm, and 36mm extension tubes, ISO 200, f/22 for 1/6 sec.

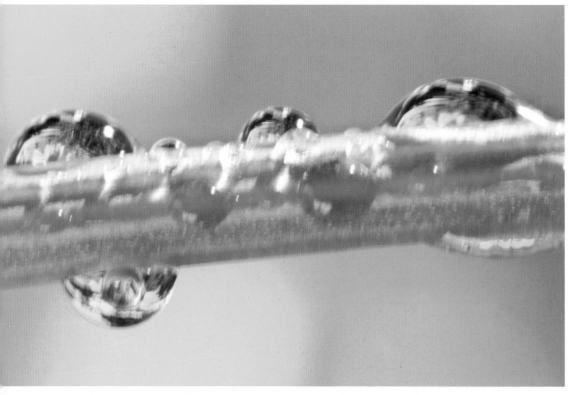

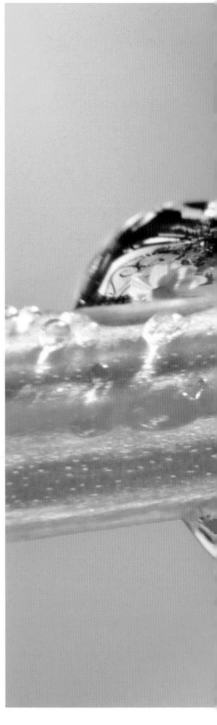

THE DEWDROPS ALSO HELP ILLUSTRATE *the drawback to extension tubes. If you're using all three extension tubes at one time with a moderate zoom or telephoto zoom and, of course, are on a tripod, your camera and lens will experience some serious wobble—or camera shake—if you press the shutter manually. So, if you've ever wanted a great excuse to use a cable release and mirror lock-up, this would be it!*

In the first photograph, I pressed the shutter release with my finger, and that, of course, introduced the wobble factor. Since the shutter fires right away after pressing the shutter release, the exposure records the wobble and not tack-sharp drops of dew on a flower stem. In the second photograph (opposite), I chose to use mirror lock-up and my electronic cable release.

And finally, don't even bother trying to use the depth-of-field preview button, as the length of extension tubes coupled with a moderate or telephoto zoom will now render an exceptionally dark view as you look through the viewfinder—so dark, in fact, that you might think your camera is broken. (See page 98 for more on depth-of-field preview.)

Both photos: 50mm lens, with 12mm, 20mm, and 36mm extension tubes, f/22 for 1/4 sec.

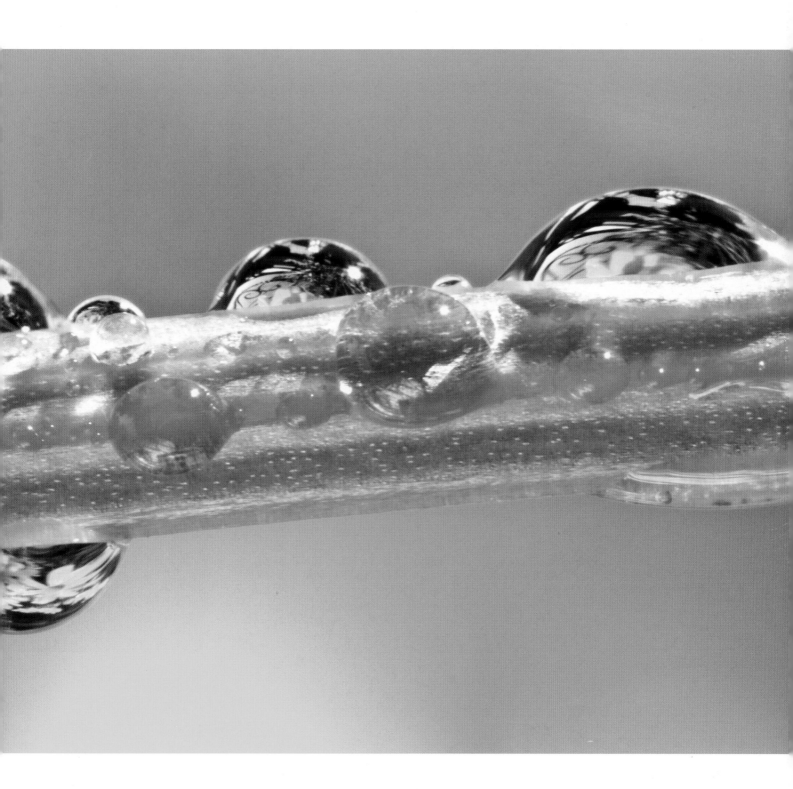

EXTENSION TUBES VS. TELECONVERTERS

Do not confuse extension tubes with 1.4X, 1.7X, or 2X teleconverters, multipliers, or doublers, as they're often called. Unlike a teleconverter, which *does* have optical glass in its construction, an extension tube is *glassless*, as mentioned on page 36. It is nothing more than a piece of metal that places more distance between your camera body and lens (a metal toilet paper core, if you will).

A teleconverter, with its piece of glass, on the other hand, increases the focal length of a given lens by 1.4, 1.7, or 2 times *and* introduces a possible loss of sharpness if the optical quality is not "matched" to the lens in use. That's why, and of course this is just my opinion, you should use only those converters that are designed and built by the same folks who built your lens. If you have a Nikkor lens, then use only a Nikon converter.

So just by way of example, a 2X teleconverter would change a 100mm lens into a 200mm lens.

You should give very serious consideration to using a Nikon TC1.4B or TC1.7B teleconverter (1.4X and 1.7X teleconverters, respectively) with your Nikkor 70–200mm F2.8 zoom lens, along with a 36mm extension tube. You'll begin to see and record some truly beautiful and muted tones of background color when shooting those lone flower compositions in the wild or at the local park, if not in your own backyard. Ditto to Canon, Pentax, Sigma, and Tamron users.

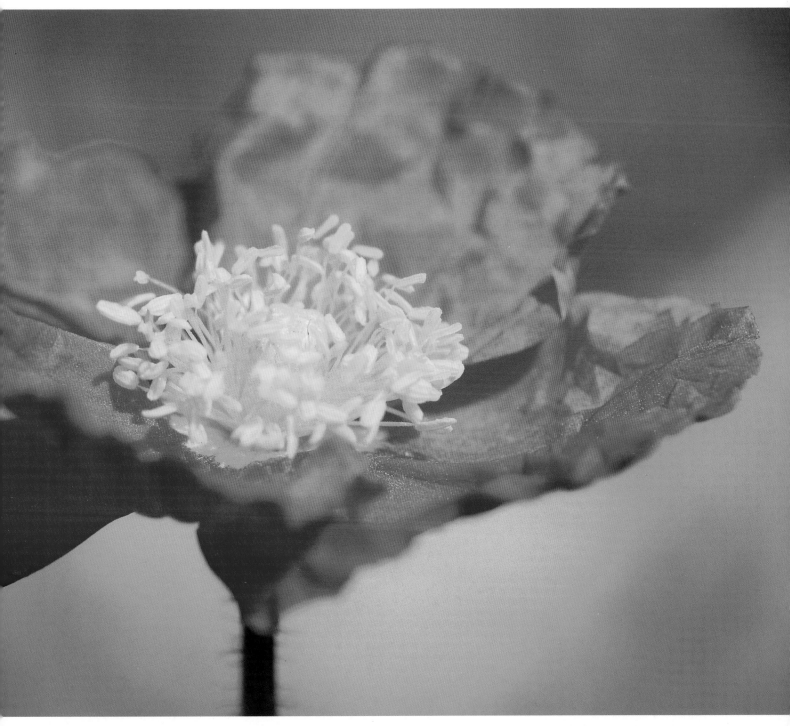

ONE OF THE SITUATIONS *in which I use an extension tube is when shooting flowers with a telephoto lens. For years I had used my 300mm lens with one 36mm extension tube, and this combination would always "knock out" my backgrounds of surrounding flowers into wonderful areas of out-of-focus tones and color. Several years ago, however, I picked up Nikon's truly amazing 200–400mm tele-zoom lens, and it has since replaced the 300mm lens of yesteryear.*

Like most telephoto zooms, the 200–400mm also can focus quite close, rendering a reproduction of roughly 1:4 (or 1/4 life size), and it can do so at all focal lengths. Still, the 200–400mm will seldom fill the frame with that lone flower. But with the addition of that one extension tube (the 36mm), I can once again isolate a lone flower against a background of blurred color. Take a look: With the lens at a 300mm focal length but no extension tube, I was certainly able to isolate this lone

Iceland poppy, but not without also recording some competition both from background flowers and from stems that created some distracting lines. The eye is forever intrigued by line, drawn to it like a moth to flame, as they say. Unfortunately, this image is not about line but about color and texture, and I wanted a frame-filling flower shot.

Adding the 36mm extension tube was the simple solution. This gave me options: I could either leave the lens at 300mm and walk closer to the flower, or I could stay put and shift toward the 400mm focal length to bring the flower closer to me. In this case, I did the latter, and as you can clearly see, the second image is all about a lone Iceland poppy. I shot both images at f/7.1 to maintain a background of tones and shapes, but I adjusted the shutter speed: The first was correctly exposed at 1/320 sec., while the second image, due to the addition of the 36mm extension tube, needed 1/250 sec.

Close-up Lenses vs. the Canon 500D

F ALL THE MANY different tools available to achieve close-up photography, there is but one on my say-no-to list: the silly, useless, optically inferior, and ridiculously cheap—both in price and quality—close-up filter sets that one can find at camera stores all over the world for around $40. Unfortunately, these sets are still a popular item with beginning photographers. How popular? If buying or selling these cheap sets were a crime, they'd need to build even more jails. Their quality is so bad that you're much better off putting that money toward a set of extension tubes or the one and only close-up lens you'll ever need: the Canon 500D, which I'll get to in a minute.

Although I certainly discuss a variety of equipment by different manufacturers, when it comes to close-up lenses, my personal feeling is that Canon is king. It is the only brand to consider when buying a close-up lens. (Nikon, unfortunately, has ceased marketing its T-series close-up lenses, so like it or not, even the most die-hard Nikon fans are going to have to give at least this part of their business to Canon.) As of this printing, Canon offers three close-up lenses (the 250D, the 500, and the 500D) in filter sizes ranging from 52mm to 77mm. The 250D is recommended for focal lengths from 35mm to 150mm, and the 500 and 500D are recommended for focal lengths between 70mm and 300mm. Since most shooters own a telephoto zoom that offers up at least 200mm, I recommend the purchase of the 500D only. (The 500 is a single-element, glass-constructed lens, and the 500D is a double-element, glass-constructed lens, which translates into a wee-bit-sharper image.) The current price difference between the 500 and 500D is only about $20, so why not get the better-quality lens?

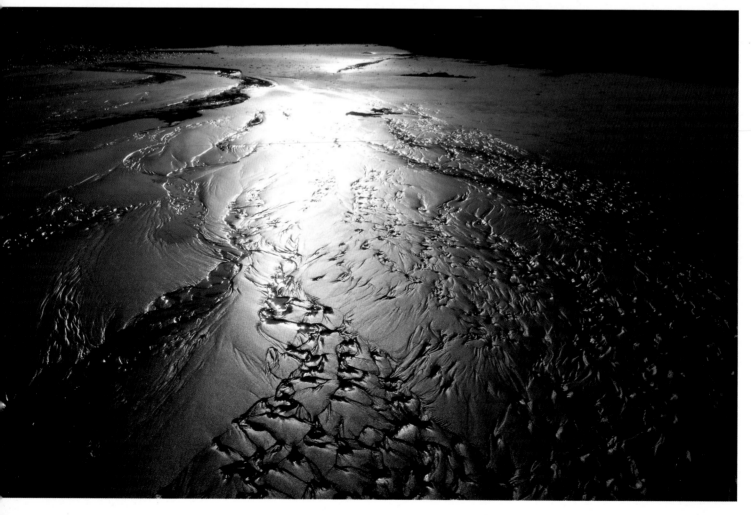

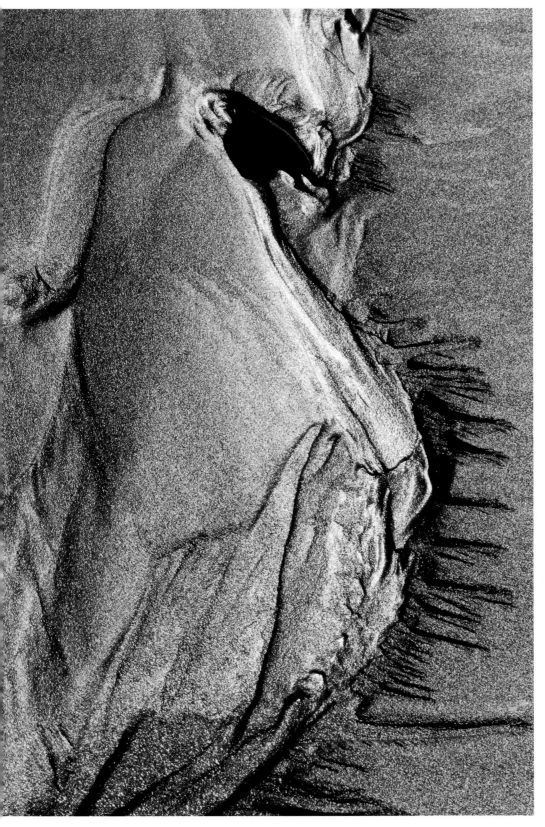

OREGON HAS MANY CLAIMS to fame, not the least of which is that it rains one heck of a lot. As they say, Oregonians don't tan in the summertime, they rust. Yet beneath all that rainfall, Oregon can boast of the longest (350+ miles), the most varied, and the most beautiful coastline in the world. Having spent many years in Oregon, this will always be a huge part of my life, if only in memory, since it was along this coastline that I spent much of my early years honing my craft as a photographer.

Some of my favorite subjects along the Oregon coast were and still are the many "sand drawings." This is a term I use to describe the varied designs in the sand caused by really small inland streams that flow onto the beach and into the awaiting surf. These streams of water cut through the sandy beaches, leaving behind a wealth of patterns, and are most prevalent at low tide, since the streams have greater distances to travel before reaching the surf. Sand drawings are best photographed when they are backlit, which occurs in early morning as you shoot against the rising sun or in late afternoon as you shoot against the setting sun. This low-angled backlighting not only renders these wonderful designs stark silhouttes, but it also emphasizes their sandy textures.

On one particular morning a few years back, I was in one of those "traveling light" moods and had just my Nikkor 70–200mm zoom lens and the Canon 500D close-up filter. I spent no more than an hour, just after sunrise, shooting in and around Beverly Beach State Park, and of the many close-up discoveries I made in that one hour, none was more rewarding than this. Due to the strong backlight, I had no trouble handholding the camera for this shot, despite finding myself using an aperture of f/22. Since I was shooting at a slight angle, I needed the depth of field of f/22 to give me sharpness top to bottom. With this aperture setting, I simply adjusted the shutter speed until 1/200 sec. indicated a correct exposure.

Left: Nikkor 70–200mm zoom lens, Canon 500D close-up filter, f/22 for 1/200 sec.

Just like many other discerning professional shooters, I, too, use the Canon 500D (77mm filter size) on my Nikkor 70–200mm F2.8 zooms. A few years back, and after spending but a few hours in the garden with my 500D close-up filter and my 70–200mm F2.8 Nikkor lens, I was hooked on the practicality of owning this close-up lens. Once I sat down in front of the computer, I could see sharpness that easily compared to the sharpness normally obtained with my Micro-Nikkor 200mm lens. The one drawback that I could find was that the 500D renders only a 1/3 life-size magnification, and that's when the 70–200mm lens is set to 200mm. But hey, if you're not all about the itty-bitty crittters and are primarily a flower and butterfly photographer, this is one option to seriously consider in lieu of buying the much more expensive Micro-Nikkor 200mm lens or the Canon 180mm macro lens.

Add into this equation the size and weight of this filter (pocket size and about the weight of a pack of smokes) and you're quick to arrive at the same conclusion that I did and order one right away. When I find myself heading out the door in one of my "traveling light" moods, I am quick to grab the 500D and put it in my front pants pocket. Then I'm ready for all the butterflies that might come my way, gladly leaving behind the weight (2.5 pounds) of my Micro-Nikkor 200mm lens.

Also, focus is continuous with this filter, meaning that when you find yourself shooting at a 200mm focal length at a distance of 7 inches, you can zoom back toward 70mm and the focus distance is still the same (7 inches away), unlike with extension tubes, which will find you needing to constantly readjust the focus every time you zoom to a different focal length.

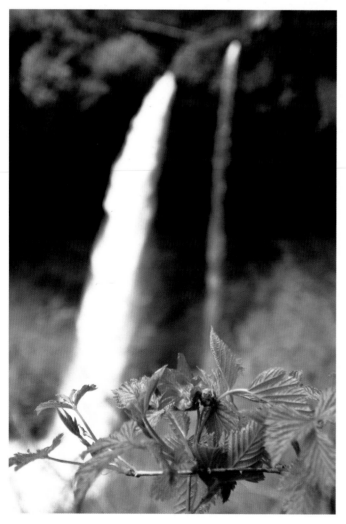

SILVER FALLS STATE PARK *continues to be one of Oregon's best-kept secrets. It is Oregon's largest state park, yet most outdoor enthusiasts prefer to trek farther north in and around the famous Columbia River Gorge. That's fine with me, too, since then I don't have to deal with any crowds along the 9 miles of hiking trails in Silver Falls. Plus, I don't have to worry about being in people's way, or them getting in my way, when I stop to shoot any of the eleven very impressive waterfalls.*

Springtime is the ideal season to visit Silver Creek if you want to see the waterfalls flowing at their peak. The snowmelt from the Cascade Mountain Range causes the rivers to swell, and the resulting water flow fills the canyons of Silver Falls State Park with thunderous roars. As the trail meanders down more than fifty stone steps, you arrive at a somewhat level dirt trail, and just around the corner, you're met with the impressive roar of the 160-foot-tall North Falls. It's one of those obvious wide-angle shots where you can record the waterfalls top to bottom, along with the surrounding forest; but on this day, I was determined to record an up-close-and-personal landscape, and I found just the right subject: a salmon berry bush that was growing within inches of the trail.

As you can see in the first example—and at the focal length of 18mm—my attempt at creating an up-close composition with focus on the salmon berry bloom fell a wee bit short of the goal: With my aperture set wide open (f/4) and the focus on the flower itself, I did get the visual weight on the flower, but it was still too small inside the frame. The solution was an easy one: to place the Canon 500D close-up filter on my Nikkor 12–24mm lens. Voilà! I was able to place the emphasis on the flower yet do so within the much wider angle of view of 18mm. This isn't just a close-up of a salmon berry bloom; rather, it's a close-up of a salmon berry bloom in the forest near a large waterfall. This kind of close-up photography in my mind is akin to having your cake and eating it, too, since you not only record an intimate encounter with the flower but also record "the story behind it." It's a way of looking at the world that is still very new, and the possibilites are, not surprisingly, endless.

Left: Nikkor 12–24mm lens at 18mm; opposite: Nikkor 12–24mm lens at 18mm, Canon 500D close-up filter

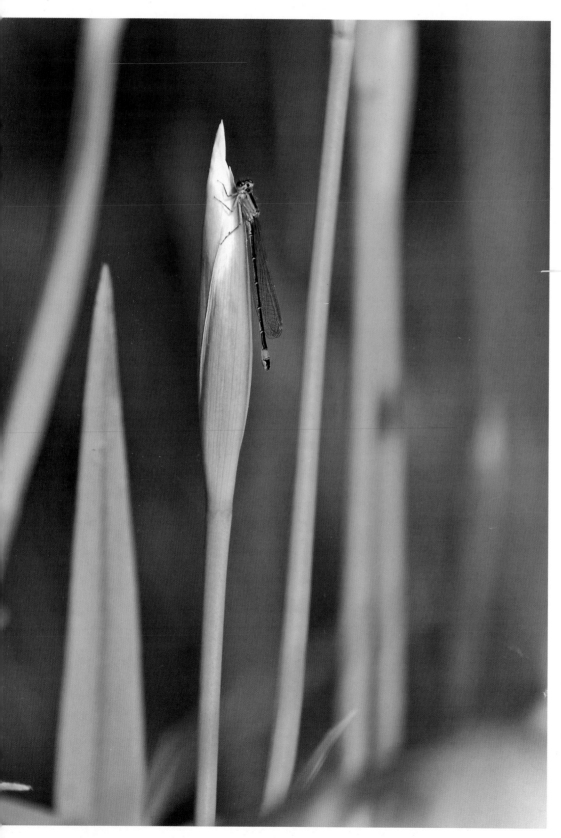

THERE ARE, OF COURSE, *many signs of spring, not the least of which is the return of flowers, bees, and butterflies. And along many a swampy riverbank or pond, the dragonfly hatch is well on its way, to the delight of frogs everywhere. Lyon boasts the largest urban park in all of France—one that even comes close to rivaling New York City's Central Park in size. There's an abundance of critters every spring at Parc de la Tête d'Or, including the dragonflies that live on the edges of the several large ponds that encompass the flower gardens. Seated comfortably on the green grass that runs up to the edge of one small pond, I spied several baby dragonflies basking in the warm glow of the morning sunshine. Dawn had just arrived, and at that hour, many insects are a bit slow to wake up, allowing the photographer to work at rather close ranges without fear of the critters flying away. Like many humans I know, even bugs and insects are slow to wake up.*

Handholding my camera and Nikkor 70–200mm VR lens at the 200mm focal length, and with my aperture set to f/8, I focused as close as I could, adjusted the shutter speed until 1/320 sec. indicated a correct exposure, and fired off several frames. Needless to say, I needed to get closer and fill that frame! The composition to the left is much like sitting in the last row of the fourth level at a Lakers basketball game.

Since I had left the house in one of my "light moods," I had but one option to get closer, and it was right inside my pants pocket: the Canon 500D close-up filter. After threading on the close-up lens, I picked up and moved forward until the lens was now focusing at its closest focusing point of 3 feet. With the focal length still set to 200mm, I got the composition as it was really meant to be.

Left: Nikkor 70–200mm VR lens at 200mm, f/8 for 1/320 sec.; opposite: Nikkor 70–200mm VR lens at 200mm, Canon 500D close-up filter, f/8 for 1/320 sec.

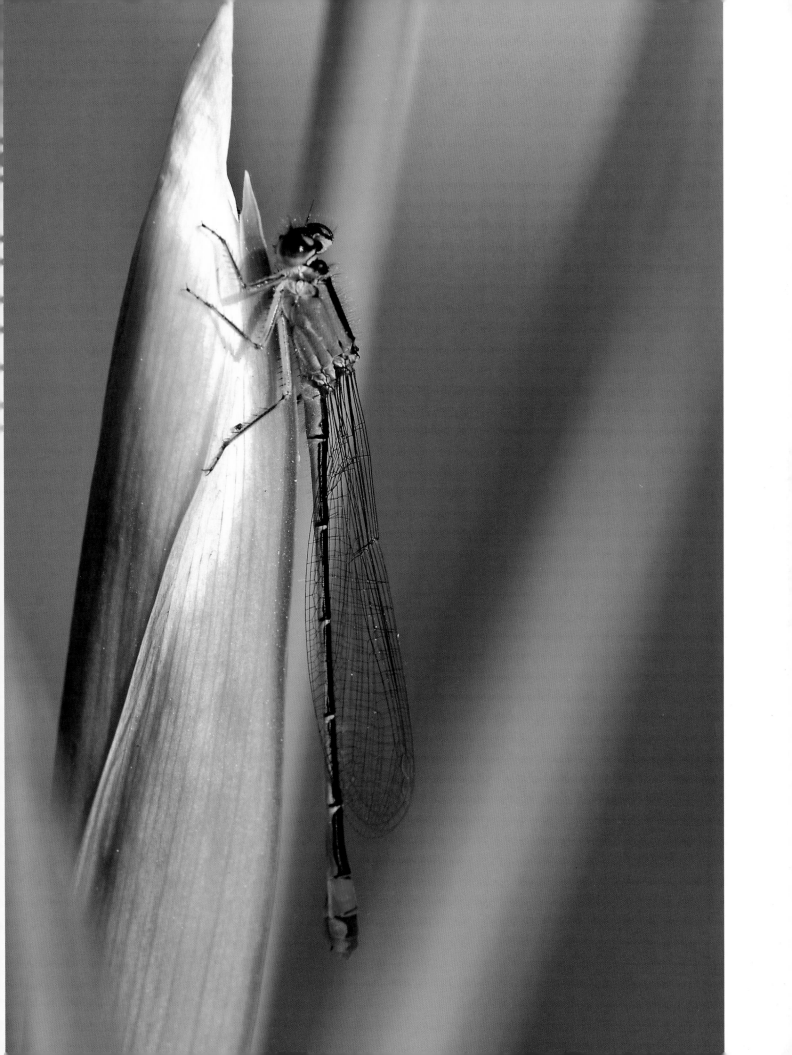

Canon 500D and the Wide-Angle

 LTHOUGH THE 500D is intended for use with a telephoto lens (as it says in Canon tech-spec sheets), I discovered one of my students, Donna Eaton, using it on her wide-angle lens! When Donna explained that she used it all the time on her wide-angle, I couldn't help but ask, "Is it sharp?" And she was quick to reply, "Oh yeah!" Personally—in one of the rare occurrences of me actually following a manufacturer's advice—I had only used the Canon 500D with my telephoto lens, but no more. The 500D in combination with a super-wide, such as Nikon's 12–24mm lens, allows for some wonderful up-close-and-personal compositions; and, due to the wide-angle of view of that 12–24mm lens, I can tell stories that are even closer and more personal. (See page 64 for more on wide-angle lenses.)

The one and only word of caution that I can offer when using the 500D on a wide-angle lens is this: First remove your UV or skylight filter, as the combination of the protective filter and the 500D will cause vignetting in the corners of your composition. In fact, the addition of any other filter, such as a polarizing filter, will also cause vignetting at the wider angles, such as the 12–18mm range, and that limits you to viewpoints of close-up subjects that are either frontlit, backlit, or under the umbrella of an overcast sky. (Since the best polarization effect is *always* found when the sun is at a 90-degree angle to you, sidelit subjects are always photographed with a polarizing filter—again, except when using the Canon 500D.)

A LOW TIDE ALONG *Oregon's coastline is always a great excuse to shoot wide-angle close-ups—if you're willing to create your own composition. The reason I say* create *your own composition is simple: The shot you see here is not one you'll ever stumble upon when walking along the more than 350 miles of Oregon coastline. Oh sure, you'll see your share of small rocks in the sand as low tide drifts even farther out, but a feather on any of these small rocks? Not on your life! I've never hesitated in arranging, or rearranging, as necessary what Mother Nature has bestowed upon us in order to convey an idea or create a shot. Placing this feather on this rock was just me doing what Mother Nature would have done in a perfect world.*

Of course, I used a wide-angle lens to make this shot—but not without the aid of the Canon 500D close-up filter. My Nikkor 12–24mm lens can only focus down to 9 inches, and at the wide-angle view of 16mm, 9 inches away from this feather looks like 3 feet! With the addition of the 500D filter, I was able to focus as close as 3 inches. With my camera mounted on my tripod, and with the aperture set to f/22 and my focus at 3 inches, I had only to adjust the shutter speed until a correct exposure was indicated. I might add that in a perfect world, one would also see a lone seagull or two about 15 feet into this composition, perhaps looking back toward the camera, but until I become truly proficient in Photoshop, I will be resigned to doing most of my arranging and rearranging in-camera.

Nikkor 12–24mm lens, Canon 500D close-up filter, f/22 for 1/60 sec.

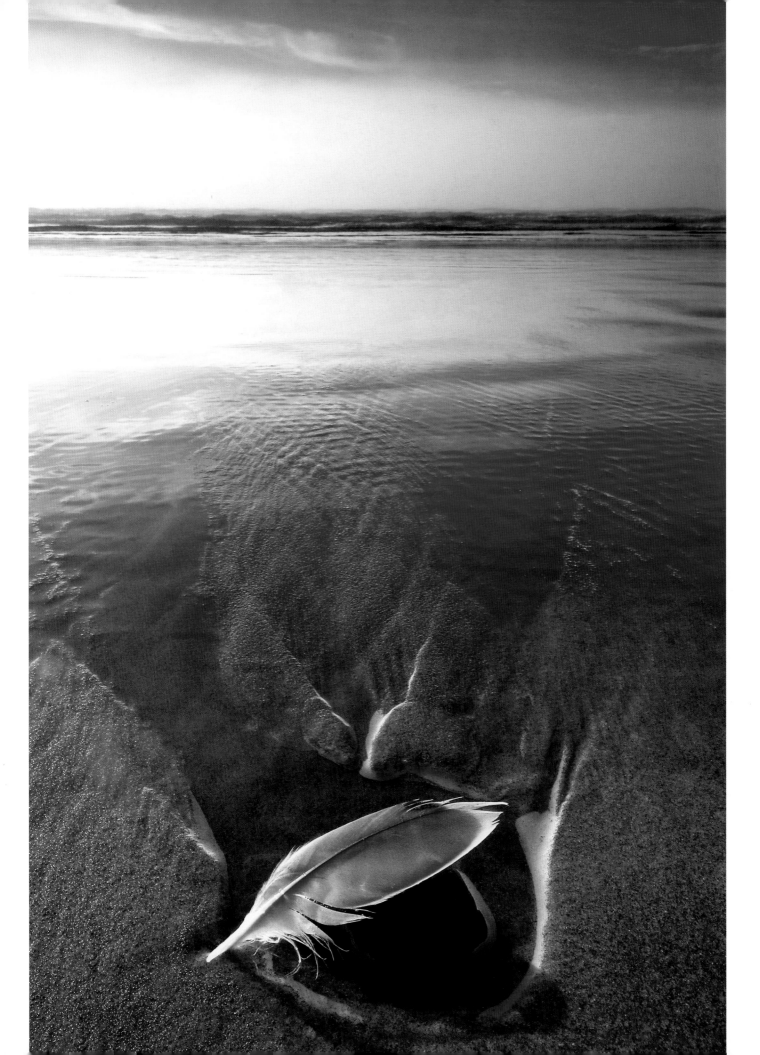

Reversing Rings

OTS OF THINGS have changed in the world of photography since my first encounter with a real camera. Back in 1970, I was using my brother's Nikon F and three lenses: the 28mm F3.5, the 50mm F1.4, and the 200mm F4. When it came to shooting close-ups, I of course always opted to use the 200mm lens, because simply enough, I seemed to be able to fill up more of my frame with the flowers in the garden. A few weeks later in that fateful summer of 1970, I was visiting my brother and he took me out to his garden to "show me a really neat trick." He took the 50mm lens off the camera and said, "Place the lens backward against the camera body and hold it tight and hold the camera with your other hand, and now take a look through the viewfinder and look at that daisy in front of you." Well, I did as he suggested, and when I saw the magnification, the rest was history, as the saying goes!

A few weeks after this life-changing, mind-altering event in my brother's backyard, I was anxious to share my discovery with another photographer, a photographer far more experienced than my brother and I combined. After I had shared my joy-filled discovery with him, he told me that what I had just told him was day-old news. He said, "Where have you been living, kid? Mars? Heck, everyone knows about that trick!"

At this point, I had two choices: go back to Mars or glean as much information as possible from this guy. Since I was as hungry for information back then as a bone-dry sponge is for water in the Mojave Desert, I exclaimed, "You're the man! Tell me more, 'cause I want to learn as much as I can!" Thanks to this guy, I got a lot of my darkroom questions answered that day (I was shooting black-and-white film back then and making prints in my home darkroom in the bathroom), but most important of all, he told me that Nikon made an actual *reversing ring* that would allow me to reverse-mount my 50mm lens on the Nikon camera body, freeing up both of my hands and making it much easier to hold the camera and work the controls. Within a week, I had bought my first reversing ring.

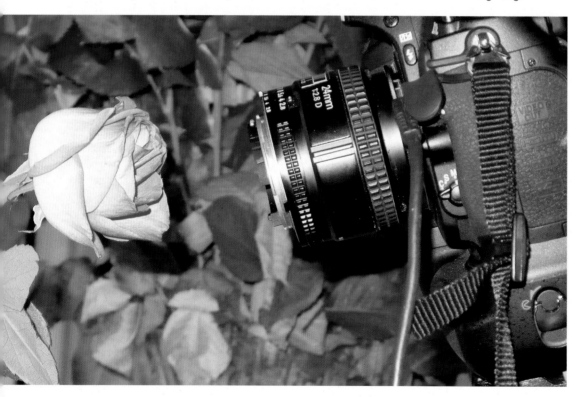

IF YOU WANT TO ENJOY *hours of unlimited discoveries that will result in some of the most fluid compositions found anywhere, then order up a reversing ring and thread it onto the front of a single-focal-length wide-angle lens (a 28mm, 24mm, or 20mm, for example). Reverse-mounting a lens to your camera will start you on one of the most sensual journeys you will ever make as you go inside a blooming rose.*

Shots like these ask very little of you but give so much in return. Shoot at or near wide open to keep the depth of field limited to basically zero. This will definitely generate a host of beautiful imagery. Opposite is my favorite of a series of eighteen images I made with one pink rose in a small vase, natural light, my tripod, and a reversed lens.

24mm reversed wide-angle lens, ISO 200, f/2.8 for 1/30 sec.

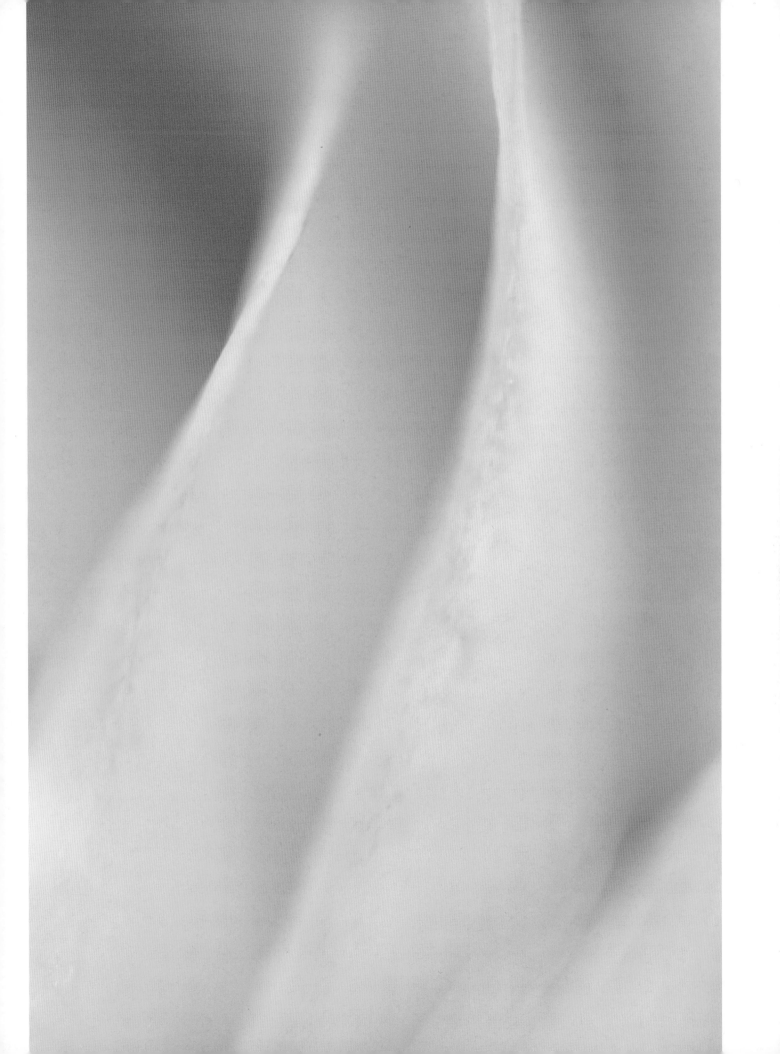

Reversing rings allow you to attach a lens to a camera body in reverse, and when you do this you can often get up to 4X magnification with standard (not specially designed for macro) lenses. Nikon and Canon both still make reversing rings, and my good friends at Adorama Camera also make their own brand of reversing rings for the likes of Pentax and Minolta. Obviously, they are still a popular item and a wonderful and much less expensive entry into the world of close-up photography.

Note that reversing rings are not intended to work with zoom lenses; rather, they are intended for use with single-focal-length lenses when that single focal length is less than 100mm. And here is something else to consider: When you reverse-mount a wide-angle lens, the magnification increases dramatically. The wider the better, I say, so if you have a single-focal-length wide-angle lens lying around—for example, a 35mm, 28mm, 24mm, or 20mm—consider getting a reversing ring. Call it a cheap thrill if you want, but I have yet to tire of looking at a rose at 3X life size when I combine my reversing ring with my old 20mm wide-angle lens. So, reach back into that closet of yours or head up to the attic and blow the dust off that single-focal-length lens that you thought you'd never use again—you got work to do!

THE CLOSE-UP POSSIBILITIES
with just one simple floral subject and four basic pieces of equipment (camera, lens, reversing ring, and tripod) are endless. Although similar in content to the image on the previous spread, this interpretation of the subject has a different feel.

24mm reversed wide-angle lens, ISO 200, f/2.8 for 1/15 sec.

Digital Point-and-Shoot Cameras

 BET YOU DIDN'T THINK a digital point-and-shoot camera would be a piece of equipment deserving of consideration for close-up photography. I know I never entertained the idea either, until it was brought to my attention a few years back that some of these cameras can and do shoot at an amazingly close 1 to 2 inches from the subject.

With the recent upgrades in the digital point-and-shoot arena—namely, the ability to shoot raw files and at over 10 megapixels—I was one of many photographers standing in line for the Leica D-Lux 3 digital point-and-shoot. This camera is amazing for a number of reasons: (1) It comes with what is, effectively, a 28–105mm lens (its 6.3–25.2mm lens is the equivalent of a 28–112mm lens on a 35mm camera) Then (2), it offers rear curtain sync with flash. And (3), it has live view (display of the image on the LCD screen as the sensor sees it), full manual override, and the Aperture and Shutter Priority modes found on most digital point-and-shoots. But most of all, I fell in love with this camera's ability to focus down to an amazing 2 inches when at an effective focal length of 28mm. This is a dream come true for me, as I now have a really super-lightweight 10MP camera that shoots great close-ups in raw format.

Anybody who has shot with a digital point-and-shoot camera has already experienced, if not knowingly, some amazing depth of field with exposure times at which the camera is still easily handholdable. Due to the digital point-and-shoot camera's smaller sensor size, the depth of field at its usual smallest aperture of $f/8$ is actually close to $f/32$ on a 35mm camera. In "exposurespeak," that's a gain of almost 4 stops, which simply means that for those times when you want massive depth of field with your digital SLR (DSLR), you would find yourself shooting at $f/32$ at a shutter speed 4 stops slower than if you were making that same image with your digital point-and-shoot, for which you would be at $f/8$ in that situation.

This means that with the point-and-shoot not only do you get to record some amazing depth of field but you can do so at relatively fast shutter speeds! If you've ever wanted an excuse to shoot some amazing close-ups, I can think of no better reason than this bit of news. So, if a particular digital point-and-shoot model offers close-up capabilities, you might consider buying it for this reason.

DIGITAL POINT-AND-SHOOT CAMERAS *have made great strides in the past few years, namely in their ability to offer up a larger image size and to shoot raw files. Plus, along with its 10MP raw file size, the Leica D-Lux 3 that I love so much has a 75-degree angle of view. It's a camera that's permanently attached to my side, hanging from my belt in its case. On more than one occasion, I've used this camera to record a number of really exciting close-ups, including this one of a "salmon." After walking my daughter to school one morning, I came upon a dry and fairly large paint spill, which I surmised was the handiwork of someone who got a bit careless at a nearby construction site. The red reminded me of a bright red salmon—a coho, in fact—and I reached for my Leica. With the camera in Aperture Priority mode and the aperture set to f/5.6, I simply held the camera, squatted down, and focused on the red paint.*

Leica D-Lux 3, f/5.6 for 1/250 sec.

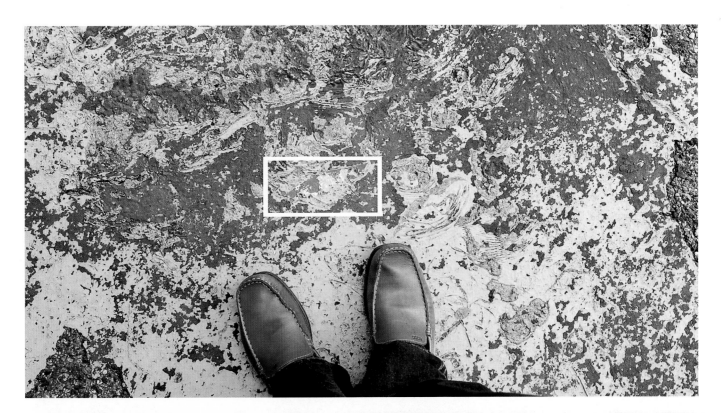

IF YOU DO HAVE *a digital point-and-shoot camera that can take close-ups but you don't have a local outdoor fruit and vegetable market nearby, consider heading off to your local grocery store to capture some truly great close-up shots in the produce section. Compositions made in these locations can add some vibrant splashes of color to those kitchen walls! Due to the small size of most digital point-and-shoots, you'll soon find that no one pays attention to you and what you're shooting the way they might when you stroll through the markets or produce department with your big black Lowepro camera bag and that big black DSLR hanging around your neck! In addition, just like a DSLR, these point-and-shoot cameras all offer various white balance (WB) settings, and in some cases, you can even shoot raw, as I did here with my Leica D-Lux 3; so, even if you don't get the WB quite right when shooting in the supermarket, you can always make the corrections in postprocessing.*

Leica D-Lux 3 with lens at 6.3mm (equivalent of 28mm), ISO 400, f/4 for 1/25 sec., Aperture Priority mode

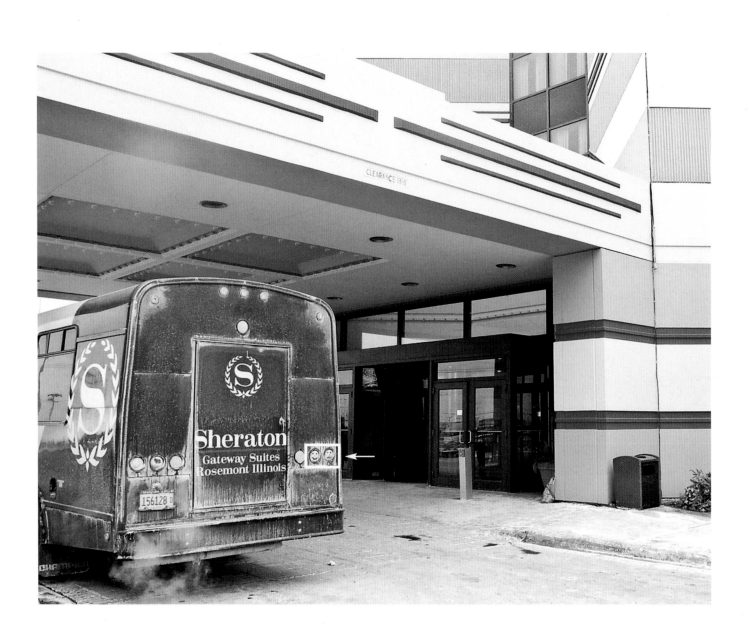

RECENTLY, IN THE PARKING LOT of a hotel near Chicago's O'Hare Airport, I noticed that someone had paid homage to the two masks that have come to symbolize the theater and its two major categories—comedy and tragedy—on a shuttle bus's taillights (see boxed area opposite). It is close-up opportunities like these that remind me why I'm glad I take my Leica point-and-shoot with me just about everywhere. Being able to shoot close-ups from a distance of 2 inches and at the wide-angle focal length has allowed me to capture images that I wouldn't ordinarily be able to shoot with such spontaneity. Considering the overcast wintry conditions, this was one very simple Aperture Priority exposure; once I set the aperture to f/5.6, I just framed the image and pressed the shutter release.

Leica D-Lux 3, f/5.6 for 1/125 sec.

PERHAPS YOU'VE ALREADY NOTICED, *but if not, texture is a very important part of close-up photography, and you can count on me being in your corner if all you want to do is fill your frame with close-ups of textures. Textures ignite our sense of touch. They tempt us and add visual appeal to an image.*

On a wintry, rainy day in Lyon, France, I came upon what was once a blue fruit carton that housed red apples at the market. Handholding my Leica D-Lux 3 and with the camera set in Aperture Priority mode, I chose f/4, hunched over the smashed carton, and pressed the shutter release, allowing the camera to select the correct shutter speed of 1/60 sec. You could say that this is truly a simple image; yet due to its textures, it's an image about "feelings."

Leica D-Lux 3 with lens at 6.3mm (equivalent of 28mm), ISO 200, f/4 for 1/60 sec., Aperture Priority mode

VARIATIONS ON A THEME

Sometimes, within the variety of close-up subjects you find, a particular subject calls out to you for continued exploration. For me, it is individual letters and portions of words that are getting most of my attention of late. Attesting to this interest are the indvidual letters introducing the text for most of the topics in this book. These are all close-up photos I've taken over the years, many with my Leica D-Lux 3 point-and-shoot.

My fascination with letters has enabled me to put together five complete alphabets, with each letter in each alphabet being entirely different. Some may ask, "Why would anyone need not one but five complete alphabets?" Strictly speaking as a commercial photographer, these letters do have value in the marketplace, particularly in the graphic design community. But hey, if nothing else, at least I'm ready should the need ever arise to put together one heck of a ransom note!

Focusing on one subject in greater depth is a good exercise visually and photographically, and it can lead to a more complete appreciation of the subject. This journey of being on the constant lookout for new letters has really opened up my eyes to the importance of communication and language itself. Where would man be without an alphabet?! And then there's the "art" in the letters themselves. As any graphic designer or typesetter knows, letters come in a host of styles, designs, and colors, and one could easily argue that each letter has its own language. The letter A, with its two converging sides, is a letter of movement but is also stable (as evidenced by the "bridge" connecting its two sides). The inspiration for the A-frame house, it is a cozy letter in which one can take refuge. The letter C is open, unlike the letter O, which is closed. The letter S is snakelike. It meanders, without worry; it is carefree, it throws caution to the wind, it is the rivers and streams. The letter Z is simply a very decisive S; it wastes no one's time, it is matter of fact, it is what it is. Of course, I'm just having fun with the symbolism of line here.

George Eastman loved the letter K, considering it "such a strong and decisive letter" that when it came time to name his new company, he simply told his fellow board members that he didn't care what they named the company —as long as the name began and ended with the letter K. Thus was born a name known the world over: Kodak.

For me, letters provide a lifelong photographic opportunity! And I would encourage you to explore, in depth, a subject you love—even if it is just using your point-and-shoot camera. It will heighten your awareness of your surroundings, challenge your eye, and improve your photographic skills overall. In fact, using the point-and-shoot may give you a bit more flexibility in capturing unexpected subjects.

Above: Nikon D2X, 105mm lens, ISO 100, f/13 for 1/160 sec., Aperture Priority mode; opposite: Leica D-Lux 3 with lens at 6.3mm (equivalent to 28mm), ISO 100, f/2.8 for 1/500 sec., Aperture Priority mode

Wide-Angle Lenses

 ERTAINLY, I CAN'T SERIOUSLY be suggesting that *great* close-ups await any photographer who pulls out his or her wide-angle lens, can I? You bet I can—and I'd go even further by stating that the wider the angle, the better the close-up! I recommend the 12–16mm range; for this, a 12–24 zoom lens is most common. With fill-the-frame SLRs and DSLRs, I recommend the 15–24mm range, for which a 17–35mm zoom lens is the best.

One of the biggest hurdles all photographers will have to overcome is their aversion to the wide-angle lens and, more precisely, the misunderstood vision of the wide-angle lens. Most shooters have this reaction to their wide-angle lenses: "What's up with my wide-angle lens? All it seems to do is make everything small and distant!" All the more reason why my suggestion that the wide-angle lens is good for close-ups is met with such surprise. But hear me out; after you do, you may not make it your number one choice for close-up work, but I do believe you will look at the world with a whole new appreciation of how wonderful the wide-angle lens is. You just need to embrace and begin to see—really *see*—the tremendous potential of this lens for close-up photography use.

One of the biggest advantages wide-angle lenses have over telephoto and macro lenses is the ability to capture a much, much wider angle of view yet still render an up-close-and-personal interpretation of the subject. Depending on the lens and manufacturer, a wide-angle lens may focus down to 9, 7, or even 4 inches. It is story-telling imagery at its most intimate! A *storytelling* image is simply one with a great opening line (main subject) along with the rest of the story (the background). What a wide-angle does is offer up this immediate and sometimes much larger foreground, with a bit more depth of field than you would ever get with a telephoto lens, and this is worthy of your consideration when you want your close-up subject to have a sense of place—for example, a mushroom against a background of surrounding forest as opposed to just the mushroom.

Developing a vision for the wide-angle lens isn't as hard as you might think. It involves truly understanding *why* wide-angle lenses "make everything small and distant"—the often-heard complaint. The reason these lenses do this is the very reason you should use them for close-up photography. Wide-angle lenses do push everything in a scene to the background, so to speak, because they expect *you* to place something of great importance in that now empty and immediate foreground—and I can't stress *immediate* foreground enough, since therein lies the key.

Imagine for a moment that you're getting your living room ready for a party, a party that will find everyone dancing on your living-room floor. What do you do with all of the furniture? You push it all to the back wall, which in turn opens up the floor so that now there is lots of room for everyone to dance. It is initially an empty floor, and I'll be the first to admit it looks wrong; the empty floor does call attention to the fact that no one is dancing. But here comes one couple, followed by another and another, and before you know it, the floor is filled with dancing feet and looks like a fun place to be! Start thinking of your wide-angle lens in the same way. The "vision" of the wide-angle will push everything back solely because you are planning on having a dance party in what is initially an empty foreground—but not for long, of course!

AS YOU MAY RECALL *from earlier photos, Silver Falls State Park is one of my favorite haunts when I find myself out west. That's particularly true in the fall when the big-leaf maple trees that line Silver Creek put on their colorful show. Their multihued display is a welcomed contrast to the many Douglas fir trees that grow there. On one such visit, I found myself once again getting down low and up close and personal with numerous maple leaves that had fallen upon the slippery rocks below. With my camera and 12–24mm lens on tripod, I set my focal length to 14mm and my aperture at f/22. I also aligned my focus of 3 feet directly above the distance marker. (Found on every lens, the distance marker is the white mark just in front of the feet/meter indicator.) I was then able to create a composition of immediate foreground textures and color. (See page 66 for my depth-of-field focusing tip.)*

I should also mention that I did use a polarizing filter here, which knocked down a considerable amount of gray glare that was being reflected off the wet leaves and was the result of the cloudy and rainy sky overhead. With the polarizing filter in place, I adjusted my shutter speed until 1/2 sec. indicated a correct exposure and shot several frames.

12–24mm lens at 14mm, f/22 for 1/2 sec.

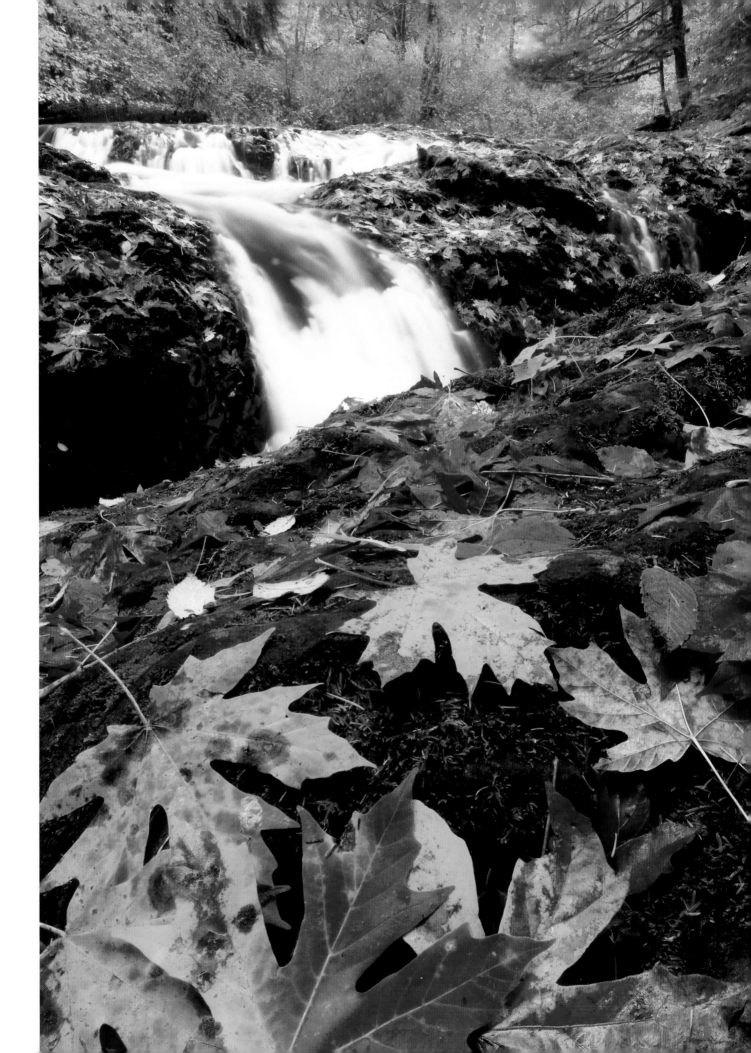

DEPTH-OF-FIELD TIP

Depth of field is covered more completely starting on page 94, but for now, here's a tip. When shooting storytelling compositions in which you want as much front-to-back sharpness as possible and are wondering where you should focus, follow this foolproof "formula" that's guaranteed to work each and every time: If you're using a lens with a 75-degree angle of view (18mm on the digital 18–55mm zoom), first set the aperture to *f*/22 and then focus on something that's approximately 5 feet from the lens. Then, if you're shooting in manual exposure mode, adjust your shutter speed until a correct exposure is indicated by the camera's meter, and take the shot. If you're shooting in Aperture Priority mode, simply shoot after setting the aperture, since the camera will set the shutter speed for you. Your resulting depth of field will be approximately 3 feet to infinity.

If you're using a 12–24mm digital wide-angle zoom, and you're at focal lengths between 12–16mm, set the lens to *f*/22,

focus on something 3 feet away, and follow the remaining step as mentioned above. Your resulting depth of field will be approximately 2 feet to infinity. You *must* turn off autofocus when you do this.

It's very important to note that once you've set the distance to either 3 feet or 5 feet (depending on your focal length), most of the image you see through your viewfinder will appear out of focus. You will be tempted to refocus, but *don't*! The reason the image in the viewfinder looks out of focus is because you're viewing this scene at a wide-open aperture, and at the wide-open aperture you will see *only* what you've focused on. Since you've focused the lens at either 3 feet or 5 feet, everything else in the viewfinder *should* appear out of focus. But—and this is the important point to remember—once you press the shutter release, the lens will stop down to the aperture of *f*/22, and at that point, and not before, the promised depth of field will be recorded.

DEVON, ENGLAND, is the home to Buckfast Abbey. It is also a major stop on the tourist routes, as evidenced by the many cars in the parking lot. Assuming you, too, are one of these tourists, how can you come away with a truly compelling shot of the abbey, a shot that would suggest that the abbey was visited by you and you alone? Keeping in mind the idea of "pushing all the furniture to the back wall in the living room," you can then ask the important question: Whose "feet" will be dancing in the foreground? To my mind, the geraniums were the perfect subject—the feet, if you will. I got down low, and voilà, the low point of view and the immense foreground of geraniums all but turned a humdrum view of Buckfast Abbey into a postcard shot of a pristine spot with no tourists.

To get this low view, I lay on the ground and handheld my camera. I preset my focus, aligning 3 feet directly above the distance marker, and with my aperture set to f/22, I was assured of recording a depth of field from 2 feet to infinity, as this image clearly shows. Once my aperture was set, I merely adjusted my shutter speed until 1/60 sec. indicated a correct exposure and pressed the shutter release.

20mm lens, f/22 for 1/60 sec.

SO, HOW DOES HDR SOFTWARE WORK?

What high dynamic range (HDR) software does behind the scenes, while you sip coffee and stare at the computer, is generate a single exposure by taking only that area that's correctly exposed from each of the multiple shots you load into the program and then combining these pieces of correct exposure into a single image. There's much more to learn about HDR, of course, and this is not the book for that, but if you are interested in learning more about it, consider buying Michael Freeman's book *Mastering HDR Photography*.

MY FIRST TIME TO NEW YORK CITY *still remains a very vivid memory, and it was during this trip that I photographed the New York City skyline from the once "dangerous" Brooklyn side of the East River. The year was 1983, and a great deal has changed since then, both in the skyline and the crime rate. The Twin Towers are, of course, no longer part of the skyline, and the once-burned-out and "condemned" Brooklyn warehouses are now refurbished loft apartments fetching an easy million dollars—and there is no shortage of buyers. There are friendly waterfront promenades, complete with outdoor concerts, playgrounds for the many families that have moved to the neighborhood, and paths for joggers and bicyclists.*

I returned to this area recently, and as I looked out across the East River toward Manhattan, I was struck with an idea intended to hint at global warming. What if the East River just evaporated? As you can clearly see in the first photograph, there's a large bed of river rock leading up the river itself. It wasn't long before I found myself digging a small hole in the rocks where I could place my camera and 12–24mm lens. This assured me of two things: (1) a low viewpoint that would hide the river and (2) a close-up composition of the varied rock textures and tones. With my lens at a 14mm focal length and my aperture set to f/22, I aligned 3 feet directly above the distance marker and was almost ready to shoot. I say almost because in this particular instance I was going to shoot an image that would later be processed as an HDR image (meaning multiple exposures would be combined in postprocessing to achieve the full range of tones that the human eye sees in a scene, without over- or underexposure).

HDR stands for high dynamic range. *When shooting a given composition with the intent of making an HDR image, you will, in all likelihood, shoot at least five exposures, if not seven; in some extreme cases, you may even shoot nine. What this simply means is that you will bracket each exposure normally by a full stop, both in the plus/+ (or overexposure) and the minus/- (or underexposure) categories. For example, in this shot, my meter indicated a correct exposure of 1/125 sec. I knew this would not be a correct exposure, however, because I was shooting into some very bright clouds that the sun was behind. My foreground rocks were not going to be correctly exposed because there was far less light on them than what was in the sky. The same was true for the backlit buildings and the Brooklyn Bridge, which would all require a different exposure time to record as a correct exposure.*

So with HDR in mind, I did the following bracket: I shot my first exposure at the indicated meter reading of f/22 for 1/125 sec. I then took three additional exposures on the minus (underexposure) side: f/22 for 1/250 sec., f/22 for 1/500 sec., and f/22 for 1/1000 sec. Next, I took three more exposures on the plus (overexposure) side: f/22 for 1/60 sec., f/22 for 1/30 sec., and f/22 for 1/15 second. Once I returned home, I loaded all seven exposures into a software program called Photomatix (www.hdrsoft.com), and within 10 minutes and after following a few very simple prompts, they were merged into the "single" final exposure of the Manhattan skyline you see at left.

Some of you are no doubt wondering why I didn't bracket my exposures simply by changing my aperture. The reason is that since I wanted the greatest depth of field possible (2 feet to infinity), I didn't dare bracket with my aperture. If you find yourself in situations where bracketing is a must, consider bracketing with your aperture only *if depth of field is of no concern at all,* otherwise always bracket with your *shutter speed.*

12–24mm lens at 14mm, f/22

WILDLIFE: DO NOT DISTURB

There is a tremendous responsibility that I feel at times in writing a photography book, not the least of which is that I have to have my facts right so that no one is misled into believing something that just isn't true. If you've read any of my other books, or have just discovered me now, you know that I'm a big believer in "moving" my subject, or adding or taking away an element or two, if it means getting a better shot—as long as it does *not* change the *truth* of the photograph. For example, if I came upon a perfectly colored autumn leaf sitting on a log, I would have no problem moving that leaf farther up the log if I felt that its placement there would result in a much more compelling composition. In the case of the starfish composition opposite, I had no reluctance at all in moving the starfish a few inches to the left, placing it where you see it here. *But* had this starfish been clinging to any of the distant rocks, where they are normally found, I would have done my best to make do with a composition from that area—never entertaining the thought that I could just rip if off the rocks and place it wherever I chose. Getting a shot "at all costs" is not an option when photographing live subjects.

If you want to get that wide-angle close-up of a mother robin feeding her babies in the nest, make the effort to build a small blind and make the investment to fire the camera with a radio remote trigger release from 30 feet away. Certainly, you would not take kindly to someone walking onto your property and grabbing your kids and photographing them down at the local park. My rule is really quite simple: If it has a heartbeat—or, at the least, is a living subject—*don't* evict it from its home or move it to the other side of town. Challenge yourself instead to find points of view and lens choices that can still convey compelling compositions. If none exist, move on, and save the "if only" story for your next roundtable discussion on the morality of image-making.

SEAL ROCK, OREGON, *is home to numerous sea lions, and it is also a great place to capture coastal landscapes that seem like you shot them at 1 million years B.C., with their prehistoric-looking rocky outcroppings. Following a really low tide one morning several years ago at Seal Rock, I discovered one purple starfish sitting somewhat listlessly in the shallows of a large tidal pool. I must admit, I picked it out from the tidal pool and, for several minutes, placed it in various nearby locations in and around the sandy beach, as you see here. (But please read the information in the box to the left, and always approach and treat wildlife logically and with great respect.)*

With my camera and 12–24mm lens on tripod, I chose a low viewpoint and also a vertical composition to place greater emphasis on the starfish. With my lens at 16mm and my aperture at f/22, I aligned my focus 3 feet directly above the distance marker. I was almost ready to shoot, but since I was shooting a sidelit scene, I needed to call upon my polarizing filter. Due to the strong early-morning sidelight coming in from the left, I knew the right sides of my starfish would record too dark, since they were in shadow, but the solution was an easy one: I popped open my 36-inch collapsible silver/gold reflector that I keep in my camera bag and held it just out of camera range to the right of the starfish. This added gold fill light that easily "filled in" the darker sides of the starfish. (See page 78 for more on reflectors.) Finally, I was ready to shoot, so I adjusted my shutter speed until 1/30 sec. indicated a correct exposure.

12–24mm lens at 16mm, f/22 for 1/30 sec.

The Fish-Eye

ERHAPS THE MOST surprising thing about the full-frame fish-eye lens is its ability to focus as close as 4 inches from the subject. Equally surprising for the first-time user is the bending of the horizon line that occurs with this lens. And the bending is further magnified when one tilts the lens at angles of 30 to 45 degrees to the horizon. In my mind, it's a welcome "global" view that this lens provides of up-close-and-personal subjects while still rendering the whole scene in exacting sharpness. The only caution I would offer is to really check the edges of your viewfinder before shooting, as you may discover your own feet or other unwanted elements showing up near the bottom or sides of the frame. It truly is a *wide* angle of view.

IT'S ALWAYS WITH ME, *my fish-eye lens, and I embrace its vision with great enthusiasm when the right landscape presents itself—or when I wish to distort, to "fatten up," a normally familiar subject. When seeking out landscapes, I'm almost always looking for those scenes that are almost devoid of any "living-room furniture": deserts, prairies, plains, and of course coastlines. Imagine my joy at coming upon a dead rockfish, washed ashore from what I surmised was a meal (if only a bite or two) for the many sea lions that live out on the rocks adjacent to Oregon's Yaquina Head Lighthouse.*

A full-frame fish-eye composition of a fish? Who would have thought? Crouching down low and moving close, I set the lens to its smallest aperture (f/22), focused on the fish, and adjusted the shutter speed until 1/30 sec. indicated a correct exposure. As the waves came in, I fired off several frames each time.

Fish-eye lens, f/22 for 1/30 sec.

THERE ARE MANY NATURE PARKS *in Florida's Everglades, and one such location provided another opportunity to put the full-frame fish-eye to work. On this particular afternoon, there were a number of cormorants drying out their feathers while sitting atop a small fence bordering the main path that ran throughout the park. I was amazed at how close these birds would let me get, so close in fact that I was soon reaching for my fish-eye lens.*

The bird on the facing page allowed me all the time in the world to shoot this close-up, whimsical portrait. Handholding the camera, I set the aperture to f/22 and focused as close as I could—4 inches, in fact. After that, I simply adjusted the shutter speed until 1/60 sec. indicated a correct exposure and fired off far too many frames (a total of seventy-seven exposures, to be exact). Sometimes, when the situation before me just seems too unreal, I get caught up in it, a bit more enthusiastic than the scene really warrants, to the point where I just start firing off shot after shot without stopping to ask myself, "Is this really necessary?" In this case, it certainly wasn't, since this was hardly an action-filled subject. Heck, the bird just sat there the entire time! It had no plans to move, fly, or do anything but keep its eye on me. And seventy-seven exposures later, what did I have to show for my efforts? Some seventy-six additional shots that are 99.9 percent exactly like the one you see here.

Fish-eye lens, f/22 for 1/60 sec.

Not only does the fish-eye lens allow for some fresh close-up views of the world in which we live but it can also offer up any number of "what does the world look like from the point of view of . . ." possibilities. Again, due to its really wide and sweeping vision, along with its close-focusing (4-inch) capabilities, this lens can go just about anywhere and offer up that reversed point of view. You know what that mailbox looks like, but if you could squeeze *into the mailbox*, what view would be offered up when the postman delivers your mail? What is the mailbox's view, if you will? If you could crawl inside a very large shoe, what would you see when the foot enters the shoe? If you could sit way back on the refrigerator shelf, what view would you see when someone shows up for a 2:00 AM feeding? If you could sit on the end of the spoon, what view would you have when your daughter takes her cough syrup? What view would you see if you were the end of a needle about to give someone a shot of novocaine? What does the office garbage can see when you throw a wad of paper into it?

If your camera has a self-timer and rear curtain sync (when you need it), you can find out. You can re-create my pizza setup at left in any number of situations. Ask lots of questions. Use your imagination.

IF YOU COULD CRAWL *inside your oven, what view would you have when someone takes out a cooked pizza? Before resting my camera and full-frame fish-eye lens on the bottom rack at the back of the oven, I engaged the camera's built-in flash, setting it to rear curtain sync, and put the camera in Aperture Priority mode. I chose an aperture of f/16 for maximum depth of field and prefocused the camera to its shortest focus point of 4 inches. (Autofocus was turned off, as usual.) In addition, I engaged the camera's self-timer to fire 5 seconds after I first pressed the shutter release. All that remained was to explain to the model that he needed to just stand there for a few seconds, acting as if he were about to take the fresh-baked pizza out of the oven. Getting my model to do exactly as I directed was the easiest part of the shoot, since the model in this case was me! Holding the pizza with one hand and firing the shutter release with the other, I held the pose you see here for 5 seconds, and voilà.*

For those who don't know about rear curtain sync, here's a brief explanation of how it works: Instead of the flash firing at the beginning of the exposure, rear curtain sync triggers the flash to fire at the end of the exposure. With the camera in Aperture Priority mode, the initial exposure took into account the light outside the oven in my well-lit kitchen, which was the available light on me. Then at the end of the exposure time, the flash went off and illuminated the interior of the oven, along with the pizza and my hand in the oven mitt. Easy stuff—really, it is! (P.S. Never put your camera in a hot oven. This oven may appear hot, but trust me, it was at room temperature—in fact, it wasn't even turned on. The glowing red coils were achieved in Photoshop via an adjustment layer and shifting the red in the Color Balance menu.)

Fish-eye lens, f/16 for 1 second

Reflectors

ECENTLY, I'VE BEGUN TO embrace and trust Nikon's in-camera matrix metering system with a greater fervor than ever before. As you may have noticed, I shot many of the photographs in this book in Aperture Priority mode (for which the photographer picks the aperture and the camera/light meter picks the shutter speed). But even though my dependence on manual metering has lessened, I still find that it's necessary to meter in manual exposure mode when I'm presented with "difficult" exposures.

Difficult exposures aren't difficult because I can't decide how much or how little depth of field I need or because I can't decide if I should freeze or imply motion, but rather because of the *light*! Sometimes, despite Nikon's famous matrix or Canon's reliable five-point metering, the light meter will still be fooled and render an exposure that's either too light or too dark. (When postprocessing my raw images, I can sometimes get the help I need when I really blow an exposure, but again, I have to ask myself, "Why not get it right in-camera rather than spend all the time needed to correct it in Photoshop?")

A classic example of a difficult exposure is the backlit flower. Backlit flowers can produce some powerful and emotion-filled imagery—if you know where to take your meter reading, if you know where to "place the sun" compositionally speaking, *and* if you are willing to use a reflector. I say *willing* because reflectors are a necessary evil. Granted, they're really lightweight and easy to attach to, and carry along with, your camera bag; but just like a tripod, a reflector is one more thing that you have to fiddle around with before you can take the image, and to the frustration of many first-time shooters, getting the once small and compact reflector back into its neat little pouch becomes a daunting task. (Get out the video camera and photograph one of your fellow photographers struggling to return the reflector to its compact size, and I'm confident you will win a top prize on *America's Funniest Home Videos*!)

So, what exactly is a reflector? It's a circular piece of highly reflective fabric stretched tightly over a collapsible metal ring. The fabric is either shiny gold, shiny silver, or a sheer white material. Sizes can range from 12 inches in diameter to up to 3 feet. When pointed toward the light source (the sun, in most outdoor cases), the reflector acts likes a dull mirror, reflecting back much of the ambient light onto the subject. Of the many reflectors on the market, my personal favorite, both for its size and functionality, is Adorama Camera's Flashpoint 22" 5-in-1 Collapsible Disc Reflector, which offers translucent, white, black, silver, and soft gold surfaces.

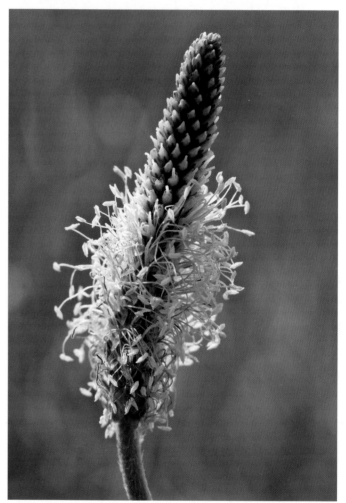

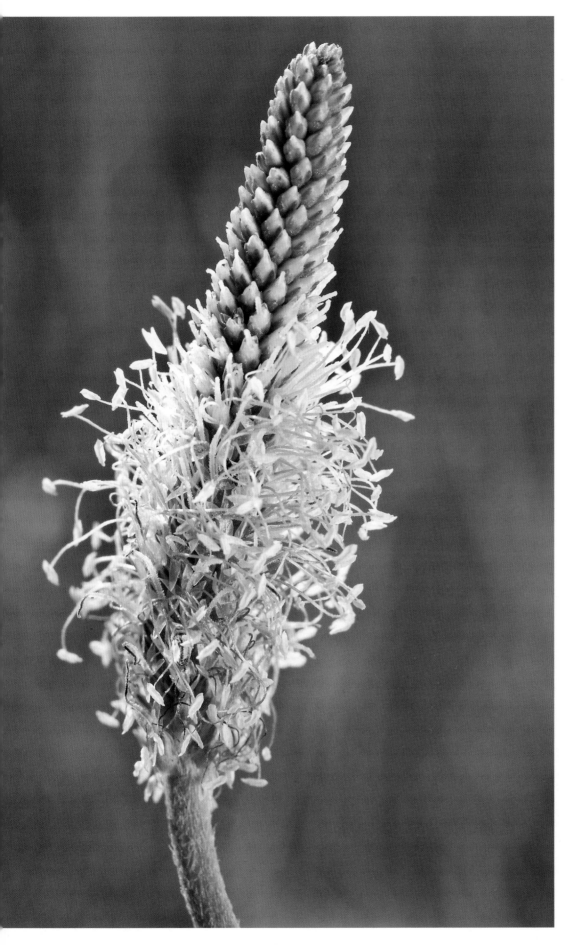

SOME YEARS AGO, photographer Dewitt Jones came out with a book entitled What the Road Passes By. It inspired me in many ways, not the least of which was by showing me the riches that one could find in any number of roadside ditches. Whether it be the quiet ditch of a country road or the noisy and sometimes breezy ditch of an interstate highway, I have never been disappointed by the images I've made in a ditch with the aid of a macro lens. This is one such example, but it did require the use of a reflector.

With my camera on tripod and set to manual exposure mode, I determined, with the aid of my depth-of-field preview button (see page 98), that an aperture of f/11 would render the needed sharpness in the subject yet still keep the background in relative obscurity. In addition, my experience with green tones has taught me to set an exposure at -2/3 from what the meter indicates when green is a dominant factor. So, although the meter told me that at f/11 I could record the exposure at 1/200 sec., I chose to shoot it at -2/3, which was 1/320 sec. As you can see opposite, the subtle backlight created rim light around the edges of the subject. By comparison, with the silver side of my reflector in place I was able to better illuminate the somewhat darker front side of the backlit subject. The exposure was the same in both examples.

Both photos: 200mm macro lens, f/11 for 1/320 sec.

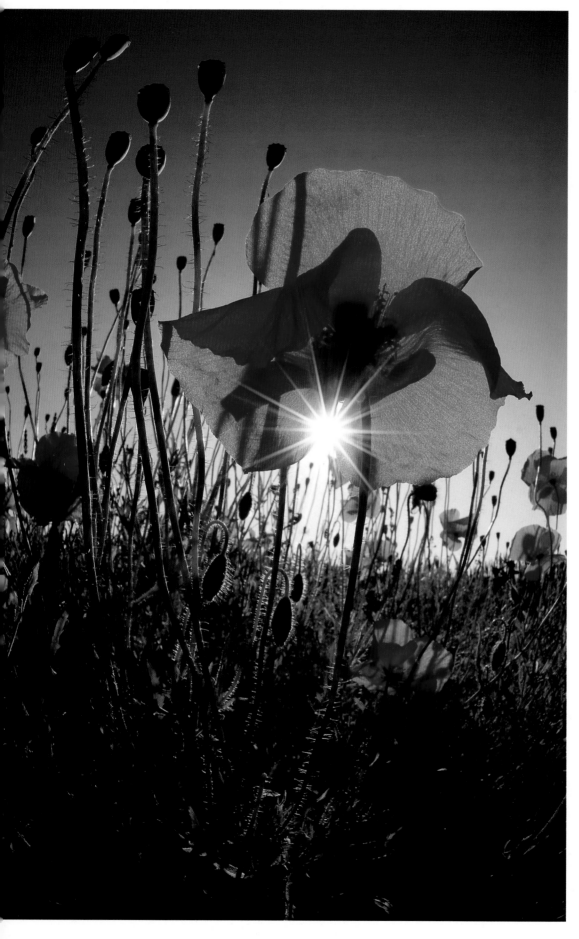

THE CLAIM TO FAME *of low-angled backlight is that it illuminates the flowers before you with a glow that only backlight can produce. It's vital to stress the words* low-angled *here, since most shots like these are only possible shortly after sunrise or just before sunset—when the sun is low in the sky (and when most shooters prefer to be sleeping or eating dinner). But if you choose to head out and shoot at these times of day, not only will you come back with some dynamic images, but you won't have to jockey for position since you'll have the entire meadow or public garden to yourself!*

Backlight can lead to silhouetting, which might not always complement your subject. When I made these images, I mounted my Nikon D300 and 12–24mm lens on tripod, with things set to manual exposure mode. I chose an aperture of f/16 and adjusted the shutter speed until 1/500 sec. indicated a correct exposure. The first attempt was a fairly dynamic exposure of the backlit, translucent poppies and blue sky, with that portion of sun that I allowed to "sneak" into the shot by simply choosing a point of view that blocked most of the sun behind the main flower.

The second attempt is the same exposure but is stronger due to the addition of the reflector. With it, I was able to add some fill light into the foreground and record an image in which both frontlight and backlight are present. The main flower still glows with backlighting, but it is not obstructed by silhouetting; and the color and all the interesting details in the surrounding flower stems are now visible.

Both photos: Nikon D300 and 12–24mm lens, f/16 for 1/500 sec.

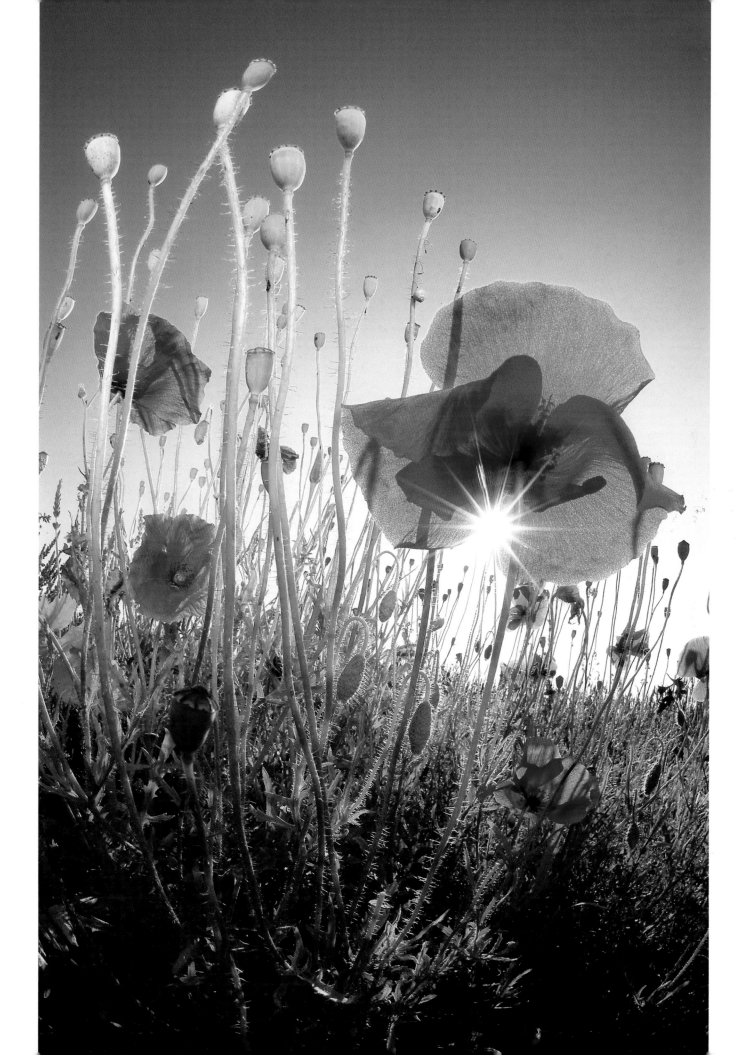

SHOULD YOU FIND YOURSELF *shooting close-ups of flora or fauna or even non-nature abstracts at or around midday on sunny days, you'll be dealing with a lot of light and shadow, and sometimes, this contrast is not welcome. You'll wish you could tone things down a bit, and you can with the aid of that 5-in-1 reflector. You would use the translucent surface, which will diffuse the light, softening the shadows and, in effect, mimicking the light of a bright overcast day. That's what happened here. I placed the colored pencils on a table near a western-facing window and discovered that the midday light was somewhat harsh. When I positioned the translucent reflector directly overhead, thus blocking the sunlight, the light became much softer. Note that in addition to the reflector, I also used a tripod.*

Above: Nikon D2X, Micro-Nikkor 105mm lens, f/22 for 1/60 sec.; right: Nikon D2X, Micro-Nikkor 105mm lens, f/22 for 1/20 sec.

Ring Flash

EARS AGO THERE WAS a full-page ad that showed up in a number of magazines and newspapers with the following headline: A Lazy Man's Way to Riches. The ad promised that for a mere $29.95 (or perhaps it was a bit more) "millionaire secrets" would be sent immediately to you, and that if you followed them, step by step, you too would soon be a millionaire. Since I never responded to the ad's offer, I cannot attest to the secrets' success, but I can attest to something else: If you head out the door with a ring flash at the ready, you will quickly discover the lazy man's way to riches, photographically speaking. The riches to which I refer are freedom and some really beautiful light.

Imagine being freed up from using a tripod because your shutter speeds are closer to those safe and hand-holdable speeds of 1/125 or 1/250 sec., all the while using apertures as small as f/16 to f/32 with ISO 200! Imagine being freed up from having to find a way to get your diffuser in position so that you can soften the light! Imagine sleeping in for a change and planning your flower shots at midday! Unheard-of, right?

These are just a few of the "riches" to be discovered when shooting macro shots with a ring flash. Unlike your camera's built-in or shoe-mounted flash, the ring flash itself is normally comprised of two half-circle flash tubes that are embedded in a hard plastic circular housing. This hard housing threads onto the front of your lens, while the power source with its single power cord is mounted on the camera's hot shoe. The ring flash was originally invented by a dentist for dental photography, but as with most inventions, one thing led to another, and now the ring flash has become one of the more popular macro accessories, if not a must-have.

As many of my readers already know from my prior books, I've never been a big fan of electronic flash, and truth be told, it wasn't until the fall of 2007 that I actually took the time to discover just how "rich" I could become from the use of a simple ring flash. I've spent many a day and evening since that time reflecting on what is now a very passionate relationship with my ring flash, and there is this sense of loss that I feel at having waited as long as I did to embrace its use. It is really that important, that vital, that good! Needless to say, I do suggest that you consider picking one up for yourself, and the good news is that, as of this printing, you can find one for under $100. Recently, I've been using a brand called Phoenix, which I picked up at Adorama Camera in New York for $88, and it continues to serve me really well.

Every ring flash provides even illumination—shadowless, in other words—and this is particularly important when shooting contrasty macro subjects, because the flash will evenly light things, doing away with harsh contrast. Additionally, because the flash is literally wrapped around the front of the lens, it is amazingly close to the macro subject, and this in turn allows you to shoot at some really small apertures (f/16 to f/32). The result is some great depth of field. And the best part of all is that, since you're using flash, you'll find yourself shooting at the fast flash sync shutter speed of at least 1/125 sec., if not 1/250 sec., depending on your camera. At these shutter speeds, who needs a tripod?!

LATE ONE AFTERNOON, *I came upon a dead blackbird. How it died I have no idea, but the flies had arrived in force, and it was the stark green and bluish flies that caught my attention. With the ring flash mounted to my 105mm lens, my aperture set to f/22, and my shutter speed set to the flash sync speed of 1/250 sec., I moved in as close as I could focus, rendering 1.5X magnification, and fired off several shots.*

A shot like this would be next to impossible to record without ring flash. Why? Because, in this case, natural light levels were really low; the dead bird was under the shade of a tree, and it was about 7:00 PM. If I had had my tripod and if I were going to shoot in only available light, I would still have had to rely on this fly to sit very still for what would have been f/22 at 1/4 sec. Considering the feast this fly was sitting on, that wasn't going to happen.

Micro-Nikkor 105mm lens, f/22 for 1/250 sec.

RING FLASH: MY PERSONAL CAVEAT

I do find one drawback with the ring flash in low light, and I'll be the first to admit that it's strictly a personal one: I don't like unnatural black backgrounds, but they can't be avoided when shooting with the ring flash in low light. A simple law of using flash is the following: Correct exposure is based on the flash-to-subject distance, *not* camera/lens-to-subject distance. Since the ring flash is mounted right at the end of the lens, it is, at times, a mere 2 to 3 inches from the subject. This is particularly true when my Micro-Nikkor 105mm is rendering a subject at 1:1 or greater magnification; at these close distances, the aperture opening must be quite small (f/16, f/22, or even f/32) to maintain a correct exposure of this very close flash-to-subject distance. Sure, it's good news most of the time, since most of us would prefer greater depth of field, not less; but when shooting at these small apertures in low light, and due to the limited distance that most ring flashes can reach, the background is quick to fall off into underexposure—and this underexposure is simply recorded as a black background.

Again, it's strictly personal taste, as I know of other photographers who go out of their way to shoot in low light to make sure they *do* record a dark, if not black, underexposed background. They love the contrast of their well-lit subject against this black ground, but for me, although the flash output from the strobe is really a soft light, it is still "flash" light, and when seen against these black backgrounds, it is a look that's just a wee bit too artificial. To be clear, I'm all for black backgrounds, and I've shot my share of black backgrounds under available light, but these subjects have either been sidelit or backlit with the golden light of early morning, and they simply look far more natural.

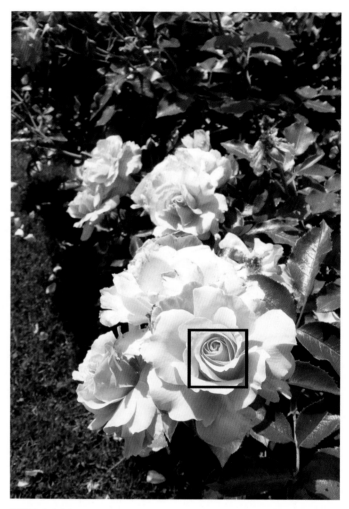

TAKE A LOOK AT THE LIGHT IN THIS SCENE. *One glance at those shadows and you'll recognize it as midday light. And with midday light come those often-harsh shadows that can quickly spoil a macro shot. Normally, in my pre–ring flash days, I would find myself on tripod, holding my small diffuser disk over the rose to reduce the harshness of the sun's light. I'm sure, however, that I won't be reaching for my diffuser nearly as often now that I've discovered the benefits of the ring flash.*

It should be easy to see the change in lighting in these two close-ups. In the top image, there clearly are both light and shadow, yet in the bottom shot, the light is even and soft. The difference: ring flash. Without ring flash, I chose f/22 to allow for maximum depth of field. Since I was in Aperture Priority mode, the camera selected 1/100 sec. I framed the shot without a tripod and fired off several exposures. With ring flash on my lens and the power source atop my hot shoe, I had the same f/22 aperture and the shutter speed set to a sync speed of 1/250 sec. Due to the flash, the shadows were all but eliminated, rendering a much softer, kinder rose. Is this easy or what?

Opposite top: Micro-Nikkor 105mm lens, f/22 for 1/100 sec., Aperture Priority mode; opposite bottom: Micro-Nikkor 105mm lens, Phoenix ring flash, f/22 for 1/250 sec.

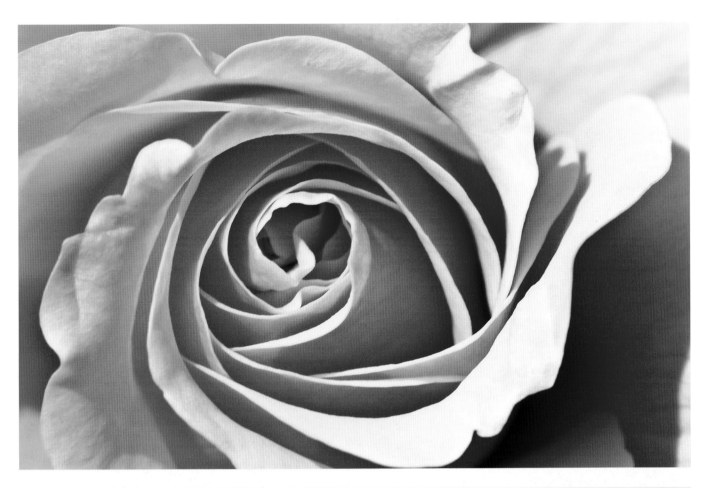

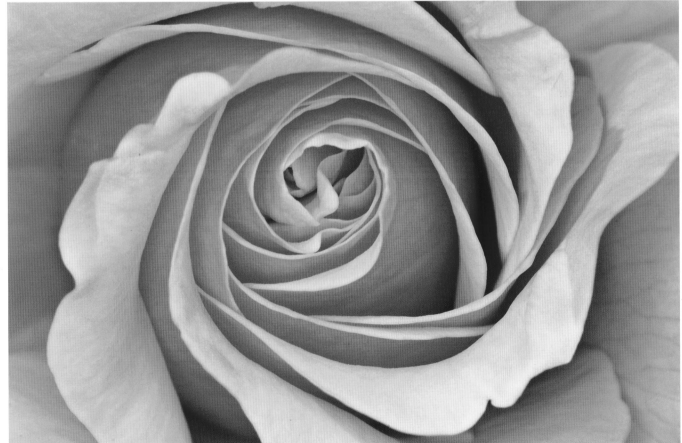

Tripods

ASICALLY, DESPITE the recent addition of a ring flash to my close-up system, there's still much close-up photography that almost always demands the use of a tripod. More often than not, close-up work requires exacting sharpness and crystal-clear details, and that means that one should strive to use the lowest ISO possible, to keep noise levels (grain) to the absolute minimum. (Granted, technology has advanced, and one can now get some truly low-noise images even at ISO 1600 with Nikon's D3X—but at a cost of $5,000 as of this printing. Until this technology finds its way into the $1,000 digital cameras, I'm using ISO 200 on my Nikon D300.)

In addition, since so much close-up photography involves incredibly short working distances, depth of field is at a premium. The "massive" depth of field here is often no greater than 1 inch front to back, and this is with an aperture of f/22! The combination of a low ISO and small lens opening means that exposure times between 1/30 sec. and 1 second are the norm—and are far too slow to handhold.

I've learned many valuable lessons from my own photographic experiences over the last thirty years, and there's one thing that stands out with absolute certainty: Don't go cheap when it comes to buying a tripod. Cheap is anything less than $300 for a tripod and its related head. Believe it or not, tripod/head combos that cost under $300 will only perform for about two to three years with normal use. You are better off buying one tripod that costs you more up front, because in the long run, you'll be money ahead. I have students who are on their fifth tripod because they were trying to "save money." Better to do it right the first time.

Of the many tripods out there, you should give serious consideration to ones with carbon fiber legs. Carbon fiber is much lighter in weight than steel, and if you plan to use your tripod religiously, the last thing you want is to be weighted down more than necessary. In addition, consider the height of the tripod. You'll want it to be sitting at chest level when all three legs are extended. You'll also want a tripod with legs that "click out," allowing the tripod to go almost down to the ground.

As far as tripod heads, you'll want a ball-head model that offers a quick-release mounting system. A ball head (sometimes seen as *ballhead*) is the only type of head capable of allowing the camera and lens to move freely to get the often difficult and precise points of view required in close-up photography. There are several well-known ball-head manufacturers, including Kirk Enterprises, Really Right Stuff, and my favorite, Arcatech.

I RECENTLY PURCHASED *a Canon 5D along with the Canon 65mm F2.8 macro lens, which—are you ready for this?—can capture 1X to 5X image magnification. The 65mm has proven to be a very challenging lens to work with for several reasons: You must have absolute dead calm—no wobbles, bumps, breezes, or vibrations allowed! In addition, since depth of field at f/16 and 1X magnification is at a maximum of 1/4-inch, can you imagine what the depth of field must be at f/16 and 5X magnification? Darn near nonexistent, which further demands not only precise focusing but an equally precise point of view, and the only way you'll ever get both of these necessary components is with a really solid tripod head in combination with a focusing rail (see page 90). Then there is one other consideration: a ring flash or something along the lines of Nikon's dual-strobe macro lighting setup, the R1C1. Trust me, at magnifications between 2X and 5X, the available light levels are extremely low.*

For this shot, I made use of all this equipment. Here's how it worked: With my focusing rail on the tripod head, I mounted the Canon 5D body and Canon 65mm 1X–5X macro lens with my Phoenix ring flash attached. With the aperture at f/16 and shutter speed set to a flash sync speed of 1/200 sec., I was almost ready to shoot. I just had to make sure that I was exactly parallel to the subject and that my focus was precise, both of which I achieved by adjusting the tripod ball head and the focusing rail. With the camera's mirror lock-up engaged, I fired off several frames at a magnification near 4X (four times life size). What looks to some like pieces of raw bacon or prosciutto are, in fact, the whole-wheat flakes found in some granola.

Canon 5D, Canon 65mm macro lens, f/16 for 1/200 sec.

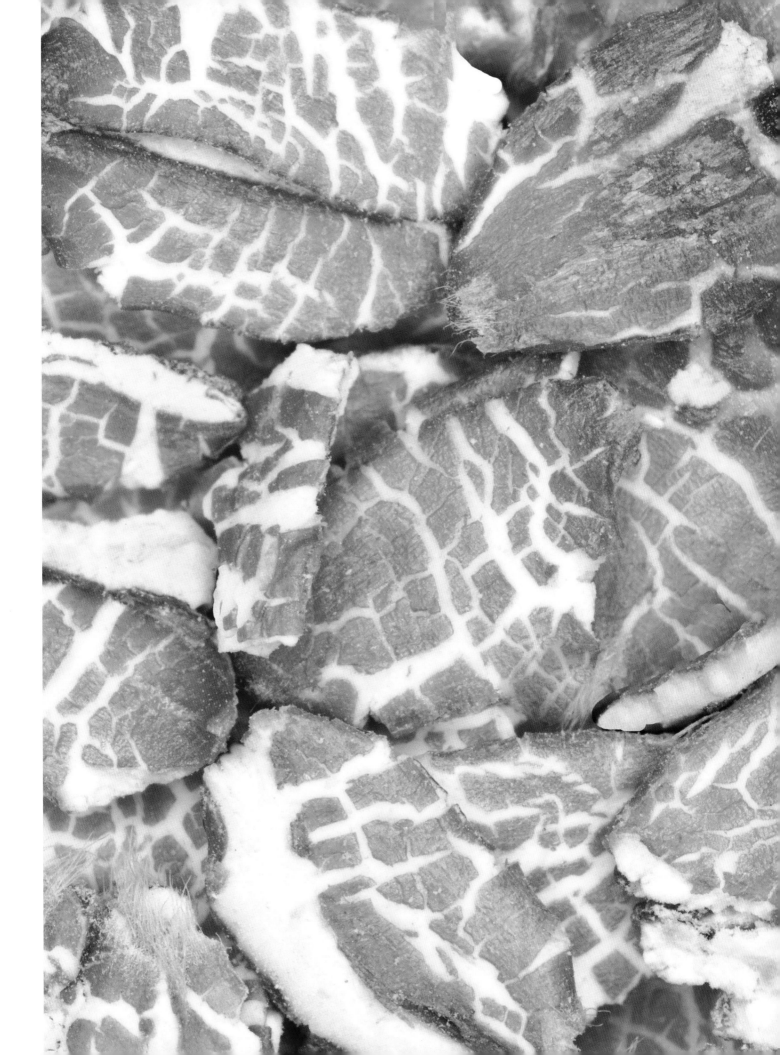

Small Things

HAT I'VE FOUND is that, in addition to the tripod, there are, of course and very appropriately, those "smaller things" that come into play if you want to improve your odds of achieving razor-sharp close-up images: the camera's built-in self-timer, the camera's mirror lock-up feature (not on all cameras), a cable release, wireless remote triggering devices, and the focusing rail.

Whether or not you use any of these tools will depend, in large measure, on your shutter speed. Obviously, if you're handholding your camera because you feel the shutter speed is fast enough to allow this, then none of these tools will be needed. But there will be many times when your shutter speeds will be far too slow for you to handhold your camera and may even be slow enough to require the use of a cable release and mirror lock-up. As a general guide, if your shutter speed has fallen below 1/60 sec., you *should not* be shooting without a tripod, and if your shutter speed falls below 1/15 sec., you should *always* be using a cable release or the camera's self-timer, along with the camera's mirror lock-up feature if the camera has it.

When there's any wind at all, *do not* use the self-timer. In all likelihood, your subject is being affected by the subtlest of breezes, and when the wind does stop momentarily, you can't afford to have an additional delay of 2 or 5 seconds for the self-timer to fire the shutter release because the wind could easily pick up again—and if it does, it *will* do so right at the moment the exposure is being recorded.

Regarding the focusing rail, this is a truly practical item if most of your close-up work is indoors and/or scientific in nature. It is attached to your ball head, and then the camera and lens are attached to the it. It's like attaching a pair of ice skates to a tripod-mounted camera and sending it out on the ice. You can now easily tweak the position of the camera left, right, back, or forward by the simple twist of several knobs on the focusing rail. With magnifications beyond 1:1, precise focus and the correct point of view are an absolute must, and nothing makes it easier to obtain both of these goals than a focusing rail.

DEPTH OF FIELD
& APERTURE

Depth of Field

UNDENIABLY, working at the close camera-to-subject distances required in macro photography differs greatly from shooting "normal" scenes, particularly in aperture choice and the resultant depth of field (front-to-back sharpness in an image). This brings me to the first optical law you should learn: The closer you focus on a given subject, the larger the subject and the shallower the depth of field. That's both good news and bad. It's great if you want to see something up close, but it's bad if you want to see it *all* in crystal-clear sharpness. When you are close up, depth of field is always shallow, so getting everything in focus is challenging and not always possible.

In addition, the distribution of depth of field in close-up photography differs from that in normal photography: In close-up work, the depth of field extends equally in front of and beyond the subject; in other words, half of the area of front-to-back sharpness will be in front of the subject, and one half will be behind it. In regular photography, depth of field is distributed one-third in front of the subject and two-thirds beyond it. This needs to be taken into account when deciding where to focus.

BUSHES OF LAVENDER
bordered the deck around the swimming pool at my hotel in Provence, and due to the sweet fragrance and perhaps even sweeter nectar, the flowers were abuzz with bees and butterflies. It didn't take long at all to fire off a number of frames of butterflies intent on "filling their cups" and paying no attention to me whatsoever. I simply held my camera, and with the aid of the DOP button (see page 98), I surmised that f/8 was the right aperture and adjusted my shutter speed until 1/250 sec. indicated a correct exposure.

Nikkor 70–200mm lens, Canon 500D close-up filter, ISO 200, f/8 for 1/250 sec.

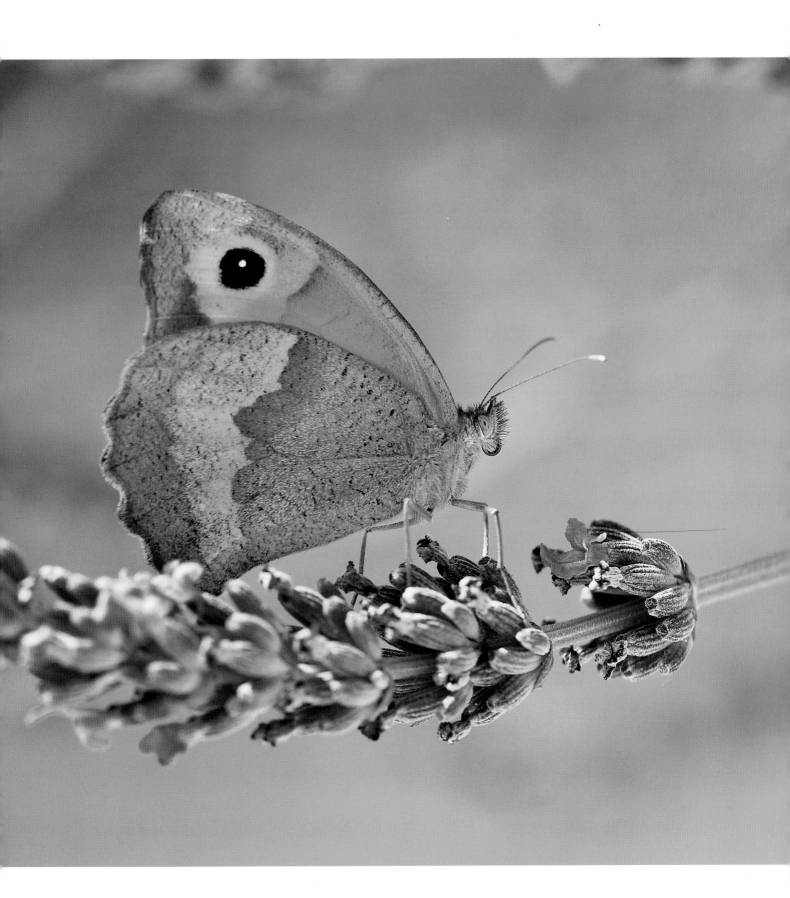

Correct vs. Creatively Correct Exposure

 O DOUBT, you may have already discovered that the slightest shift in point of view can change the point of focus dramatically in macro work. So can the aperture choice. For this reason, I want to make one thing perfectly clear: There is a correct exposure, and then there is the *creatively correct* exposure. Every picture-taking opportunity—whether you're shooting close-ups or not—offers up no less than six possible combinations of apertures and shutter speeds that will result in a technically correct exposure. Yet, more often than not, only one, or possibly two, of these combinations will be the creatively correct exposure.

Is there a way of knowing *before* you take the picture which one exposure is the most creatively correct? Yes, if you use an important feature found on many SLRs and DSLRs: the depth-of-field preview button. I'll get to that on the next few pages, but first take a look at these three images to see how important aperture is.

WHAT'S NOT SHARP IS JUST AS IMPORTANT AS WHAT IS

Distance and aperture play *huge* roles not only in what records as sharp on the charge-coupled device (CCD) or on film but also in what *doesn't* record as sharp. Knowing this, exploit the background when shooting close-ups. A simple change in the sharpness or blurriness of the background can affect the final image in a profound way.

ALL THREE OF THESE IMAGES are exactly the same exposure, meaning the quantitative exposure value of each aperture and shutter speed combo is the same. However, you can clearly see that, visually, they are each different. The first image was taken at f/5.6 for 1/500 sec., the second at f/11 for 1/125 sec., and the third at f/22 for 1/30 sec. Again, their quantitative value is the same, which is to say that the volume of light that hits the sensor (or film) is the same. The difference can be seen in the effect on the background: In the first image, the background is limited to subtle out-of-focus tones and no distinct shapes. In the second, the background begins to offer up a bit more information, and by the third, it's clear that the background consists of other nearby flowers. All three are a correct exposure, but as is often the case, only one or sometimes two are the creatively correct exposure. (Note that I took all three photos with my Nikon D2X and Micro-Nikkor 200mm lens on tripod.)

Opposite: f/5.6 for 1/500 sec.; above: f/11 for 1/125 sec.; right: f/22 for 1/30 sec.

The Depth-of-Field Preview Button

UITE AMAZINGLY, the general consensus on the depth-of-field preview button is that it is a useless tool. I couldn't disagree more! Also known as the DOF button, the depth-of-field preview button is one of the most *useful* tools found on many SLRs and DSLRs, yet you wouldn't know it based on the huge amount of confusion it causes for many amateur photographers. But trust me, if your camera has a DOF button and you actually learn how, where, and when to use it, you'll soon be wondering how you ever lived without it. (If your camera doesn't have a depth-of-field preview button, no worries; there's a way to achieve the same benefit, although it might feel a bit arcane, and I'll get to this in a minute.)

The depth-of-field preview button gets its name from the function it performs. When you press the DOF button and look through your viewfinder, you are able to preview your depth of field. You can use this feature to check whether or not you have chosen the right aperture. Because of this, I refer to it not as the DOF button but as the DIM-TRAC button—as in, Did I Make The Right Aperture Choice? Additionally, I like this nickname because when you press the "DIM-TRAC" button, the image in your viewfinder does go quite *dim* (I'll explain this in a minute) and the feature does allow you to *track* how much or how little depth of field you currently have.

So, let's take a look at these three images to see how the DOF, or DIM-TRAC, button actually works. And keep in mind that this feature is not just for macro work; whether you're shooting up close or with a telephoto or wide-angle lens, the DIM-TRAC button is the tool to embrace!

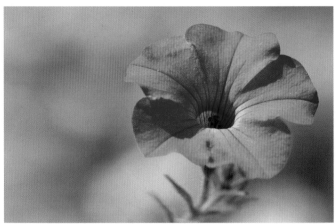

f/22, no DIM-TRAC

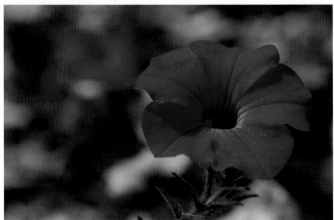

f/22, DIM-TRAC engaged

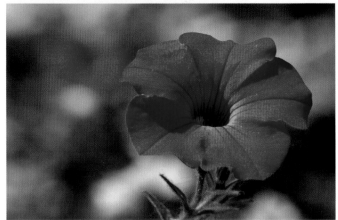

results at f/16

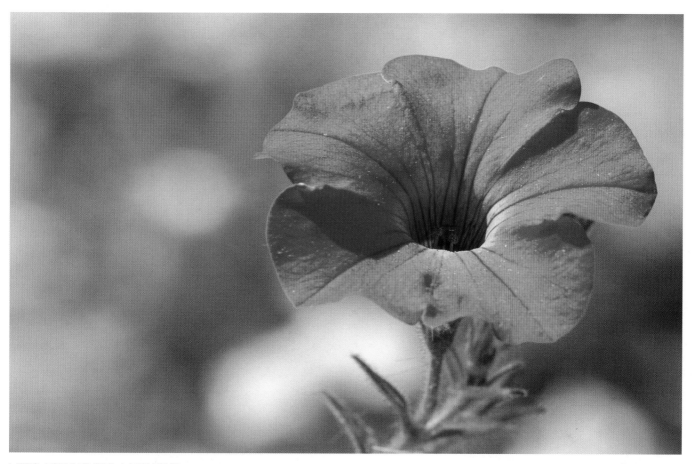

LET'S ASSUME FOR A MOMENT *that you and I are shooting side by side in a flower garden, and we are both uncertain if our aperture should be f/8, f/11, or f/16. We know we want some additional depth of field but are not sure how much. So we begin with f/16, and I suggest that we press our DOF, or DIM-TRAC, buttons. Not surprisingly, the first thing that happens is the image in the viewfinder gets a lot dimmer. (Hence, my nickname, DIM-TRAC.)*

Why does this happen? Let's just review how the camera works for a minute. Every SLR and DSLR offers wide-open viewing, which simply means that no matter which aperture you select, you are always viewing things as though your lens were set at a wide-open aperture. (Remember, large apertures are the smallest f-stop numbers.) Regardless of your chosen aperture, your camera will not stop down to that aperture until you press the shutter release to make the exposure. At that point, two very important things happen: (1) The mirror inside the camera body flips up and out of the way to allow the exposure to be made, causing a momentary "blackout" in the viewfinder, and at this point, the lens stops down to your chosen aperture; and (2) when the light passes through the now-stopped-down aperture, sharpness (depth of field) increases. The amount of added depth of field is directly proportional to the aperture choice: the smaller the aperture, the greater the depth of field.

So, returning to that flower we're trying to shoot, the reason the viewfinder gets dark when you press the DOF button is that you have engaged the same lever that stops down the lens when the actual picture is being made (opposite, middle). Therefore, the diminished light coming through the lens is the result of less light coming through your chosen smaller aperture. (When you don't press the DOF button, you are viewing through a wide-open aperture and, thus, seeing a brighter image in the viewfinder.)

From now on, however, you shouldn't care one iota about the diminished light when pressing the DOF button. Instead, start paying attention to something far more important: the increase in front-to-back sharpness. Trust me, a change in depth of field has taken place, and you will see it, even if it takes a few seconds for your eyes to adjust to the dimmer light. It is these areas that you must study closely so that you can determine whether or not you want this added sharpness and detail. If the sharpness is what you want, then release the preview button and take the picture. If it's not, then with the preview button still engaged, start opening the lens up from f/16 (or whatever your aperture may be), working toward f/11 (for this particular example). As you do this, you'll notice those defined areas begin to diminish. If at f/11 those areas are still too defined, open up the lens even more; go toward f/8, heck, even f/5.6 if you feel it helps. Once you arrive at an aperture that renders the effect you like, adjust your shutter speed until the camera's meter indicates a correct exposure and shoot.

In effect, the depth-of-field preview button on your camera is much like the tuning knob on a radio. You "tune in" your image, eliminating any background "noise and static" before you make the final exposure.

Above: 80–200mm lens, Canon 500D close-up filter, f/11

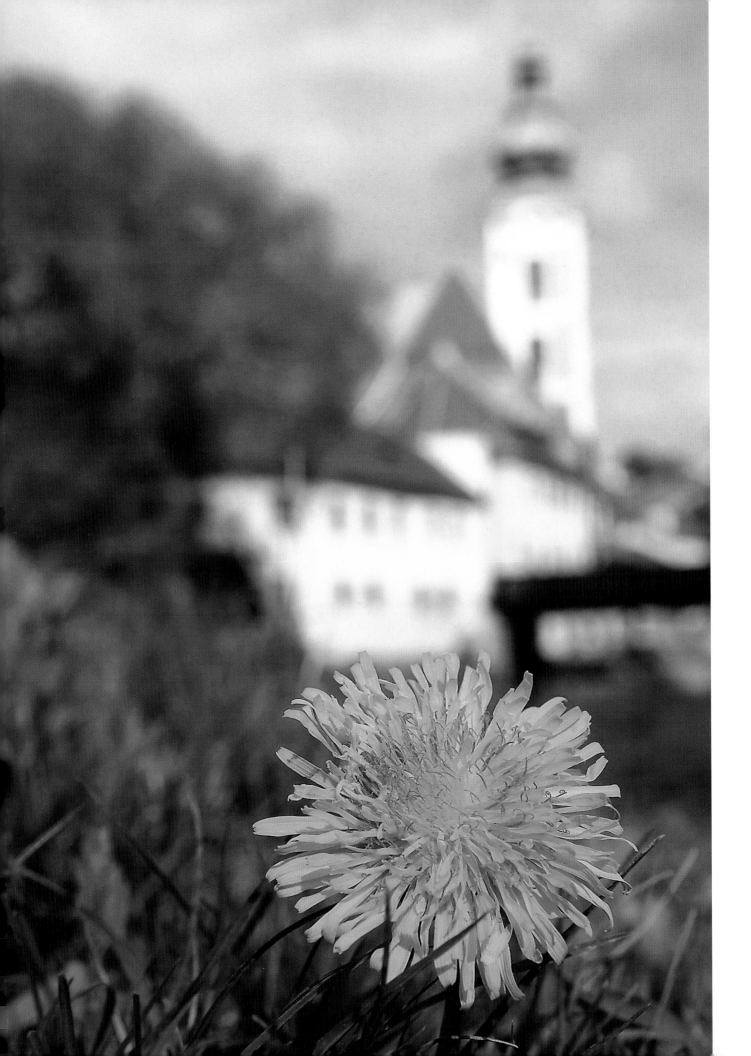

TAKING THIS SHOT *of a lone dandelion in the Czech town of Ceksy Kremluv definitely called for DOF button use. With the right lens, I felt I could shoot a close-up of the dandelion and give it a sense of place by including the distant church in the composition. Lying on my stomach, with the camera and lens at ground level, I framed it all up at 55mm. However, when I initially viewed the scene, the church was not nearly distinct enough (above). With DOF preview engaged, I started by adjusting the aperture to f/16 (too sharp) and then to f/11 (still too sharp) before finally settling on f/9, at which point I felt the church was playing the supporting role it was meant to play—defined but by no means tack sharp.*

Above: Nikkor 17–55mm lens at 55mm, f/2.8; opposite: Nikkor 17–55mm lens at 55mm, f/9

POOR MAN'S DEPTH-OF-FIELD PREVIEW BUTTON

Those of you without a depth-of-field preview button might feel that you're missing out on a valuable tool. You are, but there are ways around it that are much less expensive than buying a whole new camera system just for the DOF button.

OPTION 1

Before shooting a single-theme image (one in which you are featuring a lone subject against a blurry background), pretend to remove your lens from the camera body while still looking through the viewfinder. By *pretend*, I mean turn the lens one-quarter of a turn or so, as if you are about to remove it. When you do this as you look through your viewfinder, you'll see the actual depth of field that your chosen aperture will render. (The viewfinder will also become darker, just as it does when you press an actual DOF preview button.) And voilà, you've just discovered what I like to call the poor man's depth-of-field preview button.

At this point, once you've turned the lens, take note of how much stuff comes into play in front of and behind your subject. If you like what you see, click the lens back into its *On* position and fire away. If not, adjust the aperture and repeat the above technique, "removing" the lens and taking a look.

OPTION 2

Most images that display effective isolation of the subject are made with a combination of the following: a telephoto zoom lens at focal lengths between 200mm and 300mm with a 50mm or 36mm extension or an added close-up filter, such as the Canon 500D. Most of the time for shots like this, the working distance between the photographer and the subject is around 10 to 12 inches. Assuming that you've chosen a point of view that includes a complementary background (i.e., a background about 15 to 30 inches behind the subject) and that you wish to render the background as out-of-focus tines of color, it's a fairly sage bet that the right aperture is somewhere between f/5.6 and f/11.

If your camera offers 1/3-stop brackets, you could shoot a total of seven correct exposures, and certainly one, if not two, of those will end up being the one you'll like. Since there's no film cost for digital shooters, this method of achieving the best exposure may make the most sense. So for example, if you're getting a reading of f/5.6 at 1/320 sec., you would then shoot one each of the following exposures: f/6.3 at 1/250 sec., f/7.1 at 1/160 sec.. f/8 at 1/125 sec., f/9 at 1/100 sec., f/10 at 1/80 sec., and f/11 at 1/60. Keep in mind that all these exposures are the same in quantitative value but different in terms of their respective depths of field. And that is ultimately what you want to look for with shots like these: depth of field that complements the focused subject.

So that there is no confusion, note that the technique I just described is *not* bracketing, since each and every exposure is the same quantitative value. Bracketing is when you shoot a number of *different* exposures. For example, if f/5.6 at 1/500 sec. is a correct exposure, then to bracket, you shoot f/5.6 at 1/250 sec. for a +1 exposure and f/5.6 at 1/1000 sec. for a -1 exposure. These three exposures all have different quantitative values.

Exposure without DOF Preview

UST SO WE'RE CLEAR, succeeding in the world of close-up photography does not depend on your camera having a depth-of-field preview button. There are many close-up opportunities that never require the use of DOF preview. In fact, I can think of at least three situations in which using DOF preview would not only prove useless but even futile.

SITUATION 1: The subject is parallel to the camera. When the subject fills the frame and is parallel to the film plane, there are *no* major depth-of-field concerns. Your choice in aperture could be any of the choices your lens offers up, but here's my feeling: When depth of field is not a real issue, I'd strongly advise using an aperture between *f*/8 and *f*/11. These are, in tech-speak, *critical apertures*. They offer up the best contrast, color, and sharpness, but again, they are to be called upon when depth of field is not a concern, which is almost always the case when the subject is flat and parallel to the CCD or film plane.

SITUATION 2: You're using a wide-open aperture. Keep in mind that the image you see in the viewfinder is always a presentation of how the subject would look if shot through a wide-open aperture (see page 98 for an explanation of this). As you focus on a subject, you might think it looks good just like that (viewed wide open). If that's the case, simply set your aperture wide open, adjust the shutter speed until the camera meter indicates a correct exposure, and shoot. Since you're choosing a wide-open aperture, it would be futile to use the DOF preview button; the lens can't possibly stop down when you've set a wide-open aperture.

SITUATION 3: You want round specular highlights. If you're trying to capture round specular highlights, you will be, once again, choosing a wide-open aperture—the only aperture that can deliver them. (See page 106 for more on specular highlights.)

AUTUMN LEAVES *and a bit of a dusting from Jack Frost offer great close-up opportunities, if you're willing to venture out in the cold. I'm not a fan of cold—never have been, never will be—but as long as I'm a fan of many cold-weather close-up subjects, I will grit my teeth and bear it. And on this particular frosty, foggy morning, it was easy pickings at the local park. There was no shortage of texture-filled opportunities, but it was this one leaf that caught my attention. I could only surmise that this still-somewhat-green leaf got tired of looking down from the tree above at the many other leaves that had already fallen and could wait no more. With all the strength it could muster, I imagine, it managed to rip itself from its branch and was soon enjoying the remaining days of life among friends.*

Using a tripod, I simply framed up the one large leaf, and because I was directly overhead and parallel to it, I chose the critical aperture of f/11. All that remained was to adjust my shutter speed until the camera's meter indicated I had a correct exposure. I did also use the camera's self-timer to ensure sharpness, and so 2 seconds after I pressed the shutter release, the exposure was recorded.

Micro-Nikkor 200mm lens, f/11 for 1/15 sec.

SEVERAL YEARS AGO *while visiting my brother in Seattle, my daughter Sophie screamed out from the living room, "Daddy, a bird just flew into the window!" I jumped to my feet, ran out of the house, and quickly found myself standing above a very dead English sparrow. I realize my reaction may sound a little heartless, but I exclaimed, "A photo-op, for sure!" and got my camera and Micro-Nikkor 105mm lens. I fanned out one of the wings, spritzed it with "dewdrops" using a small spray bottle of water, and was quickly immersed in my subject.*

Since my point of view was parallel to the wing, there were no depth-of-field concerns—and no need to use the DOF preview button. I was free to simply compose, focus, and shoot, using the critical aperture of f/11. And when I was finished with the shoot, Sophie and I gave the bird a proper burial in the corner of my brother's garden.

Micro-Nikkor 105mm lens, f/11 for 1/250 sec.

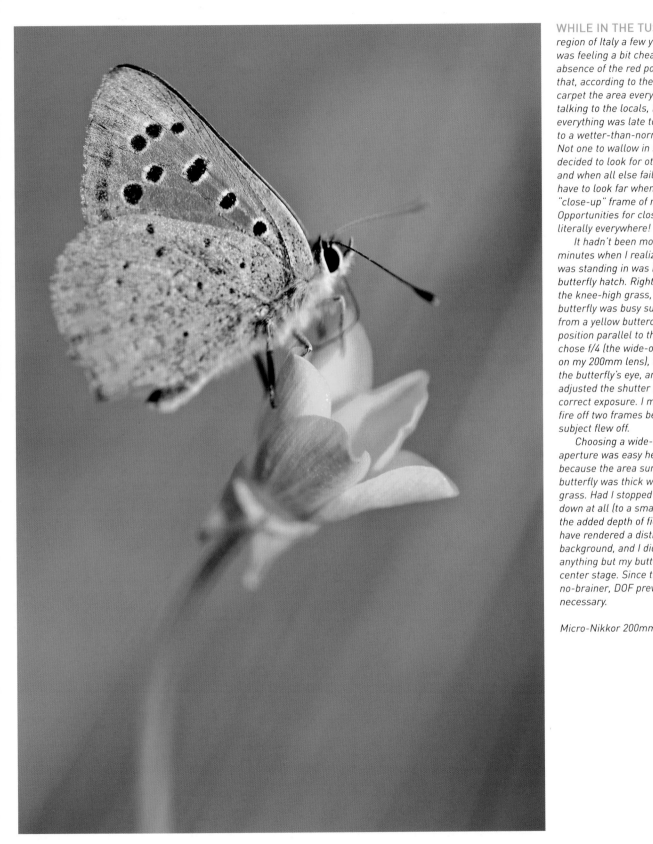

WHILE IN THE TUSCANY
*region of Italy a few years ago, I
was feeling a bit cheated by the
absence of the red poppy fields
that, according to the guidebooks,
carpet the area every spring. In
talking to the locals, I learned that
everything was late to bloom due
to a wetter-than-normal winter.
Not one to wallow in self-pity, I
decided to look for other subjects,
and when all else fails, I never
have to look far when I fall into my
"close-up" frame of mind.
Opportunities for close-ups are
literally everywhere!*

*It hadn't been more than a few
minutes when I realized the field I
was standing in was home to a
butterfly hatch. Right before me in
the knee-high grass, a single
butterfly was busy sucking nectar
from a yellow buttercup. From a
position parallel to the subject, I
chose f/4 (the wide-open aperture
on my 200mm lens), focused on
the butterfly's eye, and quickly
adjusted the shutter speed to a
correct exposure. I managed to
fire off two frames before my
subject flew off.*

*Choosing a wide-open
aperture was easy here, chiefly
because the area surrounding the
butterfly was thick with knee-high
grass. Had I stopped the lens
down at all (to a small aperture),
the added depth of field would
have rendered a distracting
background, and I didn't want
anything but my butterfly to be
center stage. Since this was a
no-brainer, DOF preview wasn't
necessary.*

Micro-Nikkor 200mm lens, f/4

Specular Highlights

N ADDITION to the very narrow depth of field for which close-up work is known, there is another close-up and macro phenomenon that most photographers either don't know about or, at the very least, fail to exploit often enough. I'm referring to what are called *specular highlights*. These are most often seen as out-of-focus hexagonal shapes in either your background or foreground when shooting close-ups of subjects surrounded by bright highlights. A single dew-laden blade of grass surrounded by other dew-laden blades of grass that are all brightly lit up by the early-morning backlight is a perfect example of a subject that will yield specular highlights.

Specular highlights occur because any single or multiple light source that's a part of your overall composition and is *not* in focus will assume the shape of the aperture. So, if your aperture is wide open, the specular highlights will be pretty close to round. If, however, your aperture is more closed down, the specular highlights will have more of a hexagonal shape, mirroring the shape of a smaller aperture opening.

WITH YOUR MACRO LENS *or a focal length of between 40mm and 80mm, and in combination with a 25mm or 36mm extension tube, you'll be quick to discover that when you focus on a single dew-covered blade of grass, each of those dewdrops functions like a tiny fish-eye lens. The surrounding landscape is recorded within each droplet. And if that fascinating discovery doesn't quite get your attention, then surely all of those "diamonds" surrounding your one in-focus blade of grass will! You can't help but notice them. These are the specular highlights, which are not quite round in the image opposite because they are taking on the shape of the aperture (which also was not perfectly round for this shot). All of these out-of-focus "drops of light" in front of and behind the focused subject are the reason why most of my students describe a morning of shooting backlit dewdrops as a "rich experience."*

To get this shot while on vacation with my family in Iowa a few years back, I scooted around freely, inch by inch, left and right, shooting a blade of grass here, a blade of grass there, each time resting my camera firmly on a small beanbag-type support as I made the exposure. For most of the images I made that morning in my wife's aunt and uncle's front yard, I shot between f/11 and f16, making a conscious effort to keep the camera and lens parallel to whichever lone blade of grass I was shooting. This assured me the maximum sharpness while still offering up an array of specular highlights.

Micro-Nikkor 70–180mm lens, f/13 for 1/40 sec.

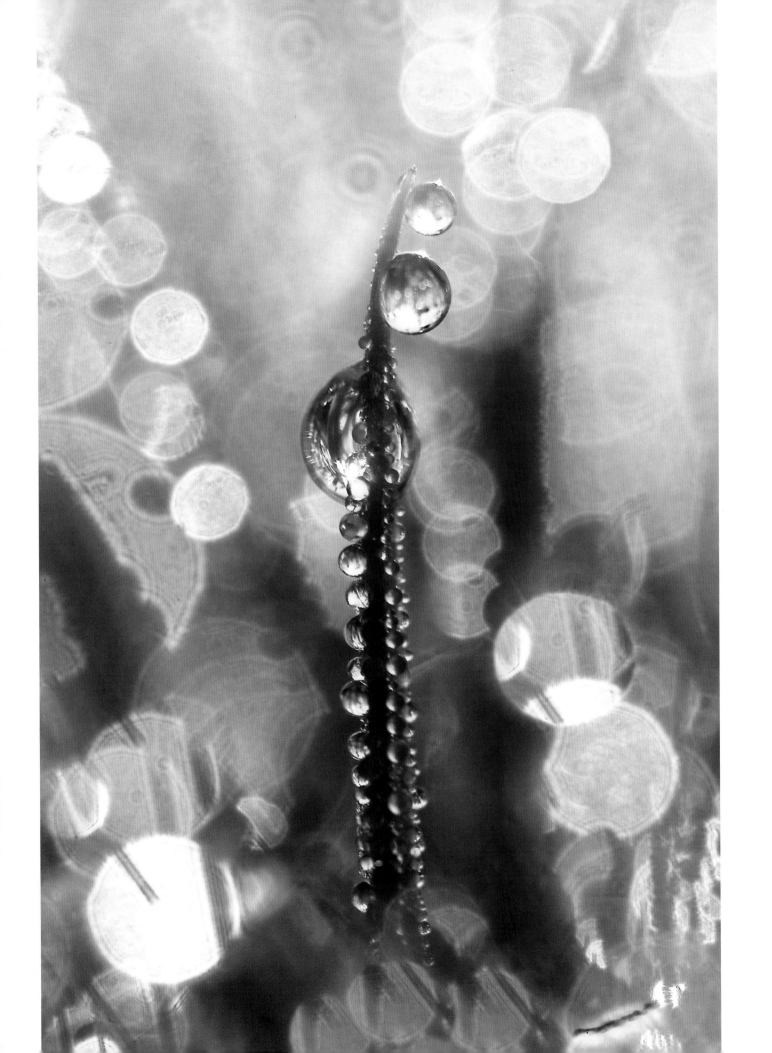

WHEN I MADE THIS IMAGE as evening approached, it was clear I wasn't going to see the sunset in Tampa Bay, Florida. A big storm was heading my way. I chose to wait out the approaching thunderstorm in the safety of my rental van, thinking perhaps that if it cleared out quickly I still might have a chance at sunset. As the storm unleashed its fury, I took note of the powerful rain falling on the windshield and the urban yet stormy landscape beyond. With my Nikkor 35–70mm lens set to a 35mm focal length and its related macro setting, I was able to frame up a "wide-angle" shot that captured, close-up, the texture of the rain running down the windshield glass and the stormy background landscape behind.

At the same time, I noticed the traffic signal with its two red lights and quickly switched lenses, opting for my Micro-Nikkor 60mm. I then began to focus even closer on the rain-drenched windshield, choosing a point of view that included mainly the two traffic lights. As with more traditional specular highlights, when up close, these once small and distant lights changed into two completely out-of-focus red circles that contrasted nicely with the close-up, in-focus rain splatter on the windshield. And because I wanted these traffic lights to record as circular in shape, I needed to keep the aperture wide open, since it's only at a wide-open (and most circular) aperture that an out-of-focus spot of light will record as a circle (rather than a hexagon) on your CCD or film.

Of course, as you have probably already figured out, I am always looking for unusual, nontraditional subjects—hence, these atypical specular highlights. If you want to capture highlights that are more traditional, other than Christmas lights or the Las Vegas Strip, I don't know of a better subject for yielding a multitude of specular highlights than macro shots of dew-covered backlit blades of grass or spiderwebs shortly after sunrise (as on pages 107 and 111).

Above: Nikkor 35–70mm lens at 35mm; right: Micro-Nikkor 60mm lens, f/2.8, Aperture Priority mode

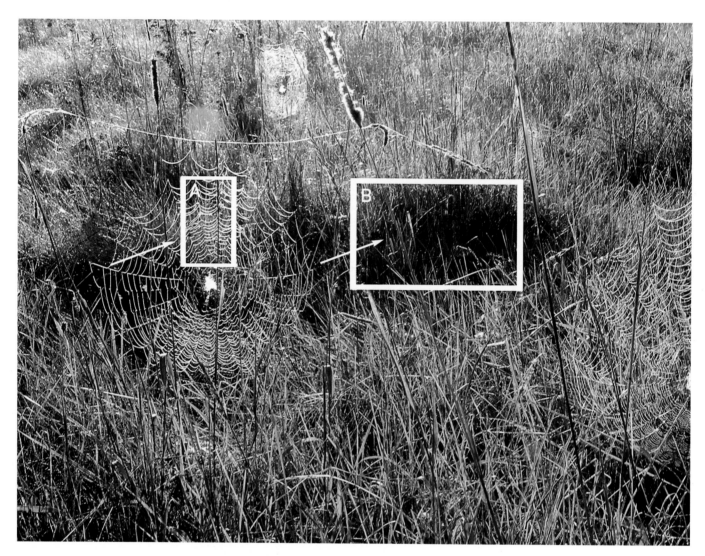

IF DIAMONDS AREN'T EXACTLY YOUR THING, *how about pearls? As I rounded a corner on a country road in Oregon's Willamette Valley, I came upon a large field of dew-covered spiderwebs easily spotted against the backlight of sunrise. Once again, my ABS performed flawlessly as I quickly eased the car off onto the shoulder of the road and leapt into action with my camera and tripod.*

Once that sun comes up, it doesn't take long for the dew to dry up, so time is of the essence. I was quick to set up a composition that had me shooting at an angle to one of the many large webs in the field. Since I wanted to record a "string of pearls" surrounded by other out-of-focus strings of pearls, I set my aperture at wide open: f/2.8. With my focus thus limited to but a few strands of web, the out-of-focus strands recorded as circular specular highlights.

And did you notice the varied sizes of the specular highlight droplets? This is due to how close or how far each drop is from the plane of focus. The farther the dewdrops (the highlights) are from the plane of focus, the larger and more diffused they will become.

In addition, take note of the boxed areas marked A and B on the image above. Box A shows the section of spiderweb on which I was focused. Box B is an area of shadow in the grasses behind and to the right of my spiderweb. In setting up my shot of the web itself, I made a deliberate choice to compose against that shadowed background area. I set my exposure for the much brighter backlit dewdrops, which in turn created a severe underexposure of that background, resulting in it recording as almost black. Just as in the jewelry stores, my pearls are showcased on a "piece of black velvet," too!

Micro-Nikkor 105mm lens, f/2.8

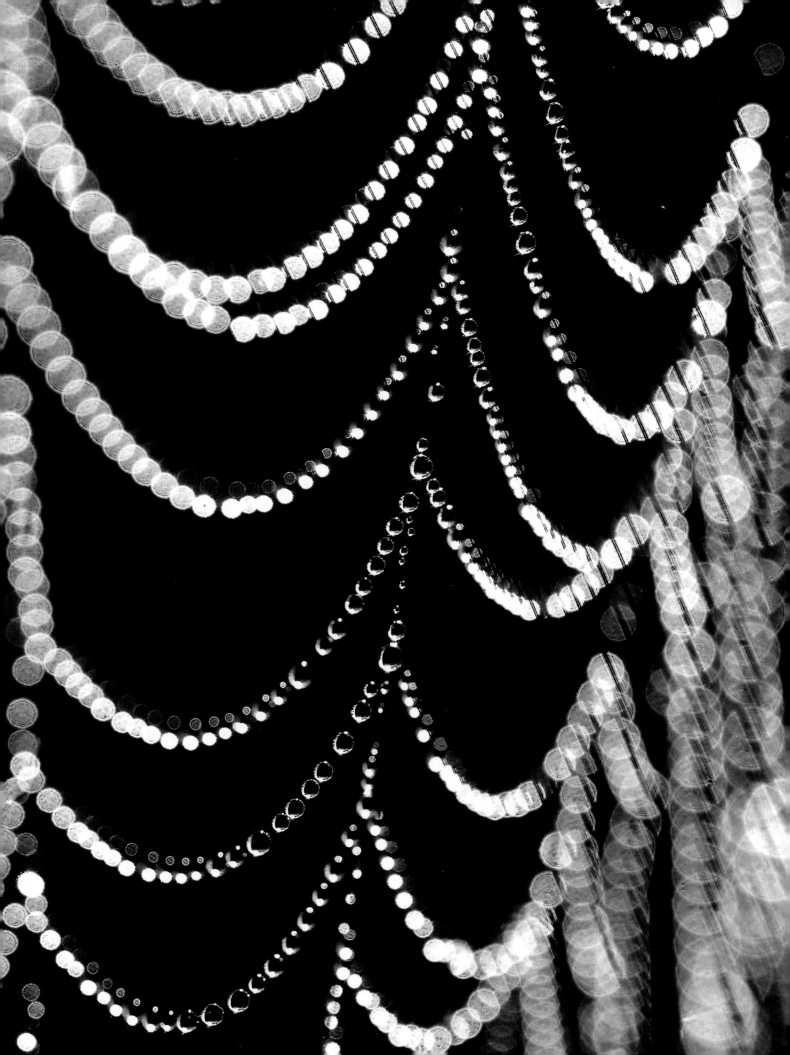

Sunrise, Sunset

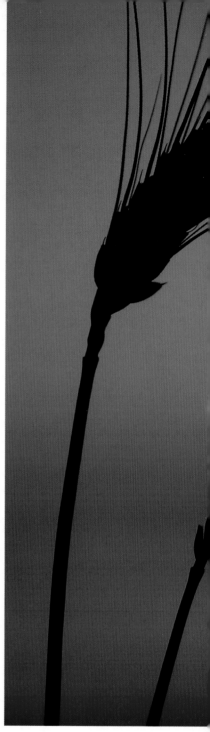

 O I KNOW I DON'T HAVE TO twist your arm to photograph a sunset, but how about a sunrise? Of course most photographers have no qualms when it comes to shooting a sunset, but suggest that they shoot a sunrise and the groans can be heard from coast to coast! If you can get in the habit of shooting *both* sunrises and sunsets, you will double your production of great work; it's that simple. If you get in the habit of also shooting simple yet effective compositions of a subject against an out-of-focus spot of light, you'll *quadruple* your production of winning images. It is during the first few minutes of sunrise or the last few minutes of sunset that you have the opportunity to shoot directly into the light and record that single out-of-focus ball. And as with many macro subjects, you'll make use of shallow depth of field and wide-open apertures.

I WAS IN THIS WHEAT FIELD *when the sun started to rise. I had already picked my three stalks of wheat and was holding them in my left hand. With my camera on tripod, and with the addition of an FLW filter (a deep magenta color that I often favor for sunrises and sunsets), I began to focus on the three stalks of wheat, which I held directly out in front of the lens and in line with the sunrise on the distant horizon. Immediately, I saw an out-of-focus ball of yellow light, which was a welcomed contrast to the silhouetted stalks of wheat. To ensure that the sun recorded as a circular (not hexagonal) shape, I set my aperture wide open to f/2.8. All that remained was to adjust my shutter speed until a correct exposure was indicated.*

Micro-Nikkor 60mm lens, f/2.8

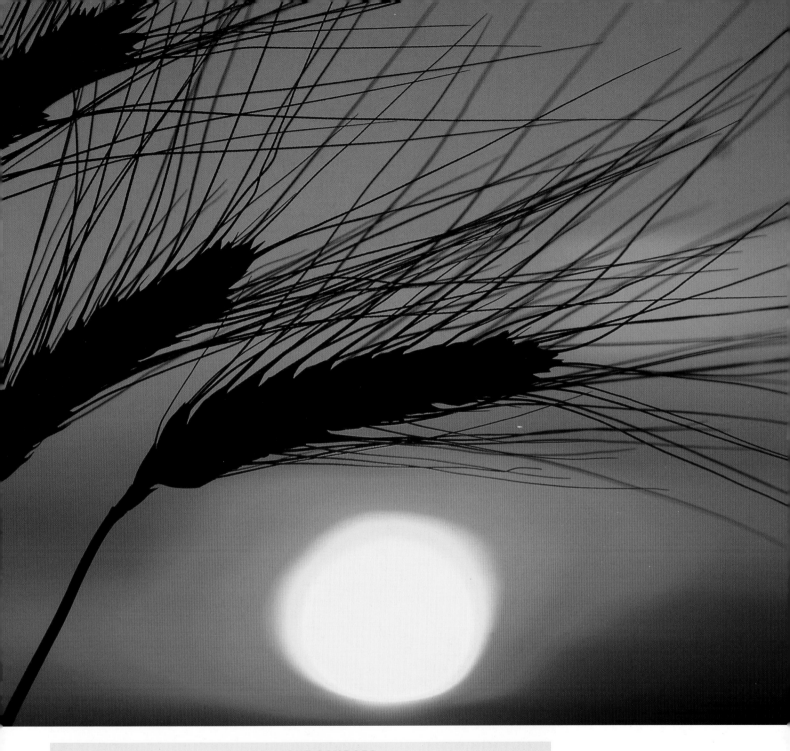

OTHER LIGHT SOURCES

The sun is *not* the only light source you can use for this idea of shooting a subject against a round background light. *Any* out-of-focus light source will perform in the same manner: flashlights, matches, porch lights, headlights, taillights, bright sunlight reflecting off of rivers and streams, even Christmas lights.

To better familiarize yourself with this optical phenomenon, try the same exercise that I have my students do. You'll need a macro lens or a zoom lens in combination with an extension tube on your camera. Get a flashlight, place your camera on one end of a table, and dim the room lights. Turn the flashlight on, and lay it down on the other end of the table, pointing toward the camera. Get a fork and place it on its side about 3 to 4 inches from the lens. Focus on the tines of the fork. What do you notice in your viewfinder? You should see the perfectly focused tines against an out-of-focus ball of light. As with specular highlights, if you want to record that ball of light as circular, you *must* set your aperture to wide open; if, on the other hand, you wish to record hexagonal shapes, you can use any other aperture than wide open.

SHOOT THE "MOON": A GOOD USE FOR WHITE BALANCE

I haven't discussed the issue of white balance (WB) as yet, nor do I intend to make it an important part of this book since, in my view, the issue of WB is very overrated and does not merit the thorough discussion it once might have. Most, if not all, shooters have come to realize the value and importance of shooting raw files. So, most shooters know that they can tweak—if not change dramatically—their WB in postprocessing. The bottom line for me is this: I opt for the Cloudy WB setting in the camera, as I like a bit more color in my images and the Cloudy setting adds warmth. However, if after loading my work into the computer I feel an image here or there needs to be a bit cooler (or perhaps a bit warmer), I can always tweak the WB at that time.

In addition, when I'm out shooting city scenes at dusk, I will first shoot several exposures with my WB set to Cloudy and then several more with it set to Tungsten. Tungsten WB is much cooler, much bluer, than Cloudy WB. Plus, most city lights are closer in their natural color (white) to the Tungsten WB setting than they are to Cloudy, which often renders these same city lights a yellow-orange.

With all this—plus out-of-focus circles of light—in mind, the idea of changing my WB from Cloudy to Tungsten occurred to me when I was recently photographing the sunrise through a dew-laden dandelion. In the first example (below), it's clear that this is an out-of-focus ball of light shot either at sunrise or sunset. We come to that conclusion based on the warmth of the light. Yet, when I switched to Tungsten WB, a much cooler light was recorded. Without waiting hours, I managed to shoot the "moon."

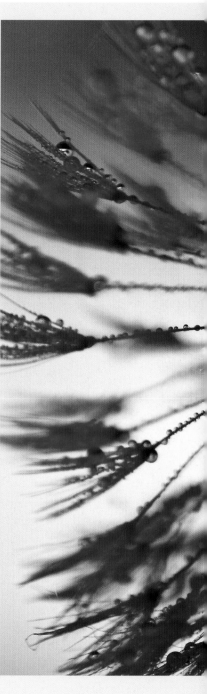

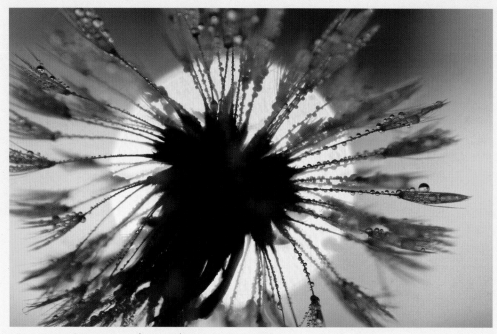

Micro-Nikkor 105mm lens, f/2.8 for 1/1000 sec., Cloudy WB

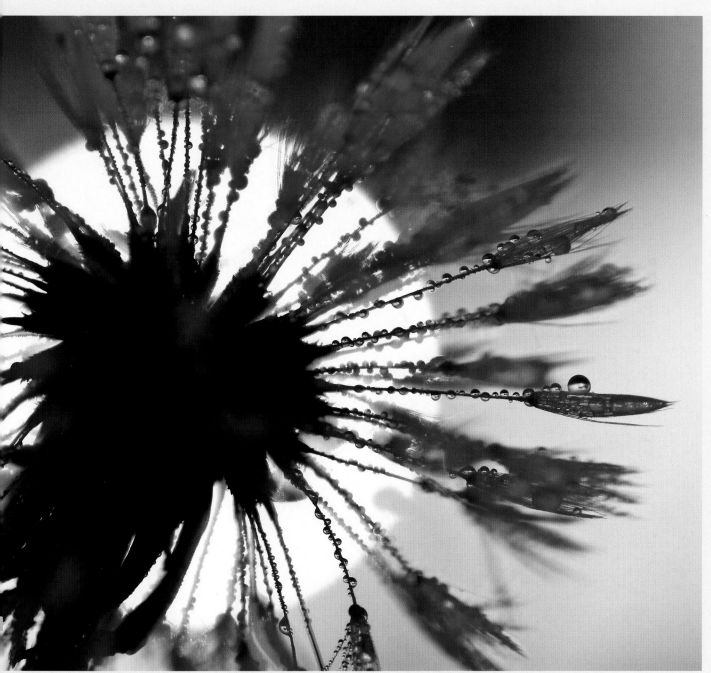

Micro-Nikkor 105mm lens, f/2.8 for 1/1000 sec., Tungsten WB

CLOSE-UP TIPS

Foreground and Background Framing

RAMING YOUR SUBJECT with other elements within the composition is one of the most called-upon techniques in photography. It's an effective and creative approach, and when applied to close-up photography, the frame, more often than not, is an out-of-focus foreground sometimes accompanied by an out-of-focus background. When your in-focus subject is surrounded by out-of-focus tones and shapes, its visual weight is further enhanced and elevated to an almost regal stature.

When you wish to employ this wonderful technique, it is absolutely essential that you call upon depth-of-field preview again; and here, perhaps more than in any other situation, you'll discover just how important it is to really pay attention to what is going on inside the viewfinder as you adjust the aperture up or down in an effort to create the most fine-tuned image possible.

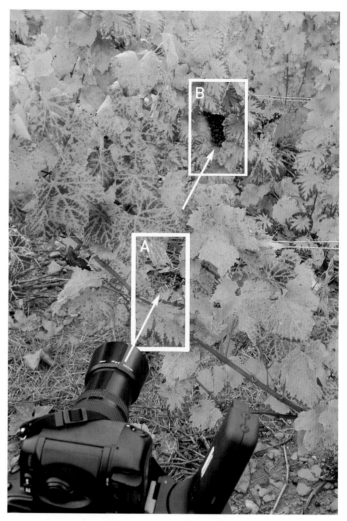

BEAUJOLAIS IS A FAMOUS *wine region in the southeast of France. For me it is the Tuscany of France, not so much for the wine but for the photographic opportunities, with its numerous rustic and old villages set amongst a terrain of large hilltops and valleys. And although the grape harvest takes place near the end of September, there can still be found forgotten grape clusters on the vine when the colors of autumn set in near the end of October.*

So, with my tripod-mounted camera and 75–300mm lens, I took a position in one vineyard row (location A, above), shooting a grape cluster in the next (location B). I made certain to choose a point of view that allowed me to shoot through foreground autumn-colored leaves in the row directly before me. These leaves became my out-of-focus foreground frame that called even further attention to the grape cluster hanging just 5 feet away. With the addition of one 12mm extension tube placed between my camera and lens, I was able to focus closer than what this lens normally allowed, and when combined with the right aperture choice (f/6.3, confirmed by the use of the DOF preview button), a cluster of grapes that captures the romance and appeal of French wine was the result.

75–300mm lens, 12mm extension tube, f/6.3 for 1/30 sec.

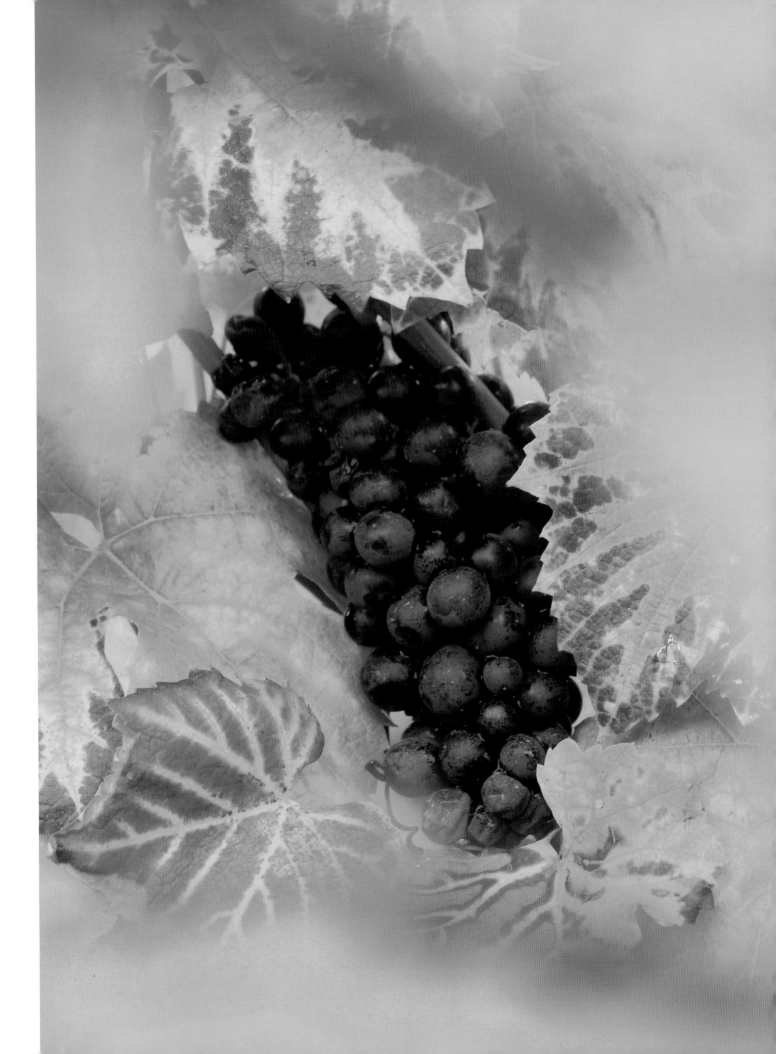

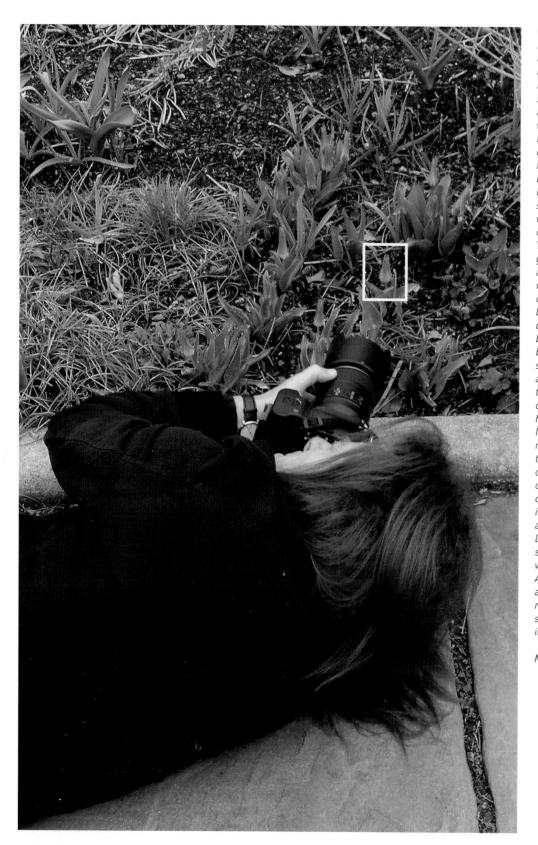

OUT-OF-FOCUS FRAMING *is certainly not limited to grape clusters on vines, and it's certainly not limited to using long telephoto lenses in the 200–400mm range. You can accomplish this selective focusing with a short or medium macro lens just as easily, and the only difference is that the out-of-focus foreground will, in all likelihood, be within an inch or two of your lens as it frames the distant subject. That was the situation when, anxious for some evidence of spring, I found myself in New York's Central Park in the flower gardens at around 104th Street and Fifth Avenue. A few trees were blooming and so were a few of the tulips, and in the spirit of beggars can't be choosers, I lay down beside one small group of blooming tulips, convinced that before I left I would have something that said "spring has arrived." I was also happy to find these tulips with the remnants of the rain that had fallen a few hours earlier. With my Micro-Nikkor 105mm lens, I moved in really close to what would be the two foreground tulips in my composition and used them as out-of-focus frames that would call attention to the "distant" in-focus tulip behind. With my aperture at f/11, I pressed the DOF preview button and began stopping down from f/11 toward wide open in 1/3-stop increments. At f/7.1 I felt I had just the right amount of depth of field. All that remained was to adjust my shutter speed until 1/80 sec. indicated a correct exposure.*

Micro-Nikkor 105mm lens, f/7.1

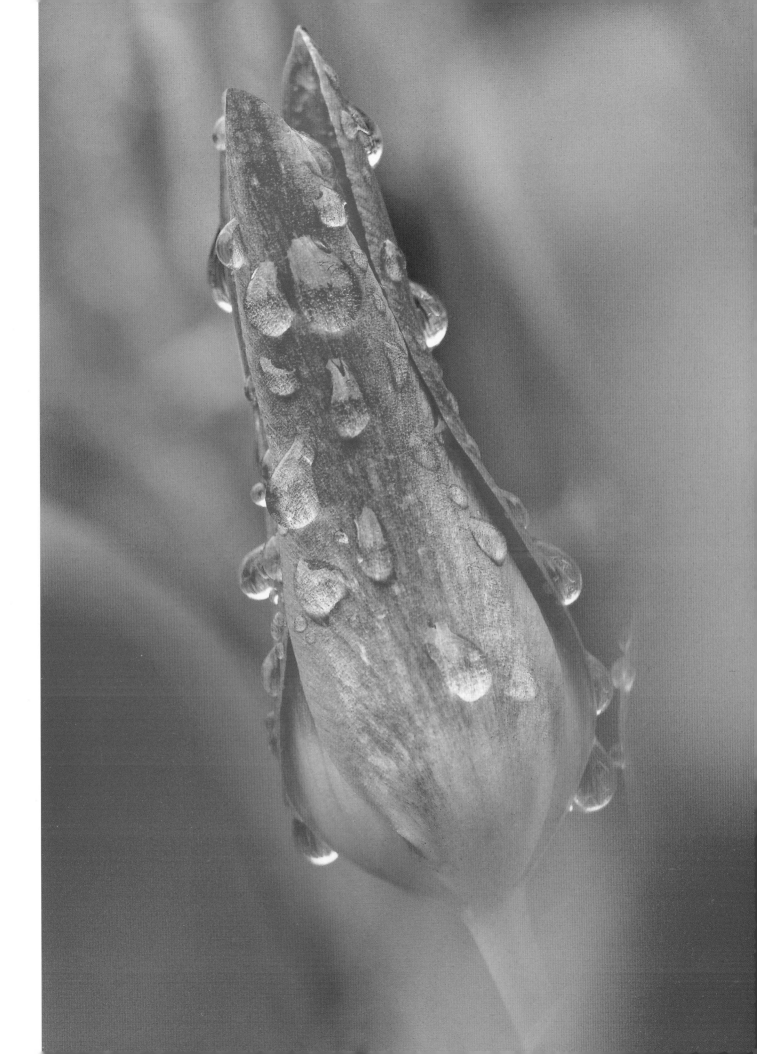

LEARNING TO SEE and compose the right out-of-focus background is a constant goal of mine. I'm forever challenging myself to look for new ways to introduce this element into my work to accentuate and call further attention to my in-focus subject. One of the neatest tricks I've learned, particularly with flowers, is to find the perfect flower and choose a point of view that shows this flower against another flower in the background. The distance between the two flowers is important to note, as I only want the foreground flower to record as sharp while the flower behind is blurry. To do this, the right lens choice is critical.

In this example, although it may not be apparent, the background hibiscus flower is about 18 inches behind the one that is the main subject. When I started to compose the scene, the two blooms were not aligned (left), but with just a slight shift in my point of view, I got them lined up perfectly (below). With my camera and 200–400mm lens and 36mm extension tube, I was able to easily zero in on the foreground flower, and with the lens set to f/5.6, I was able to limit the depth of field to the first flower and render the background flower an out-of-focus complement of color and shape. If I had shot this same image at f/16 or f/22, I would have recorded two flowers "walking all over each other," due to the increase in depth of field. The eye would have deemed the resulting composition too undefined and chaotic.

200–400mm lens at 340mm, 36mm extension tube, f/5.6

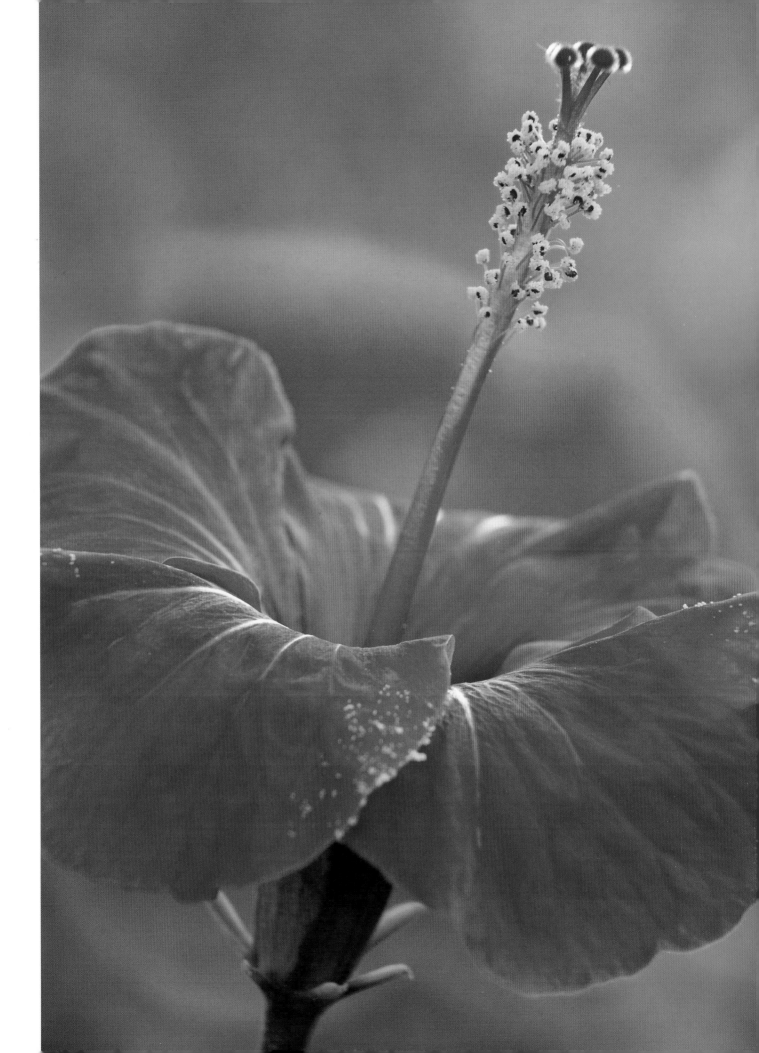

Really Filling the Frame

YOU CAN'T FULLY experience or feel an intimate, close-up encounter unless the subject is right before you, if not "in your face." A close-up or macro image will never fully inspire the awe and appreciation you want unless you are close, truly close. Despite the purchase of a macro lens or extension tubes or a close-up filter or a 2X teleconverter, most macro/close-up beginners still come up short. Why? Because they fail to see—really *see*—that their subject is not touching (or almost touching) the edges of the frame. When your subject finally touches (or almost touches) the edges of the frame, the close-up encounter can finally begin, and from there, if you so choose, it can become even more intimate by you simply moving in even closer, assuming of course you have the necessary equipment to do so.

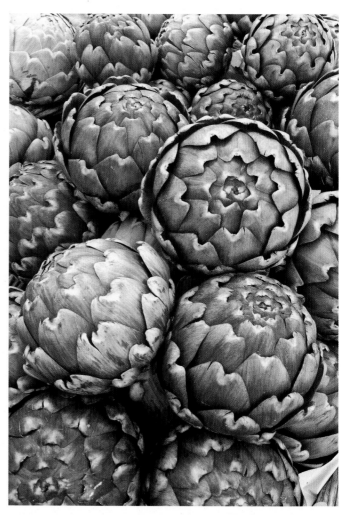

GAPS, HOLES, BUMPS, ESCAPES, AND EXITS *are words I often use to describe the compositional problems I see when doing the weekly student assignment critiques at my online school. More often than not, the solution for fixing holes and bumps is simply to get a wee bit closer and/or make a very minor shift in point of view, either up, down, left, or right.*

Note the upper left and lower right corners in the first example of this frame-filling image of artichokes that I took at an outdoor market with my Leica D-Lux 3 in Macro mode. Do you see what I call the bumps that disrupt the otherwise even flow of tone and texture running throughout the rest of the photograph? In the upper left, there's a tonal shift with the lone light-green artichoke, and in the lower right is seen a bit of the wrapping paper lining the large basket the artichokes are in. It is these two disruptions, these bumps in the road, that take an otherwise smooth, pleasing melody and turn it into something a bit off-key. Again, the simple solution: I just moved in a bit closer, and voilà—the consistent and pleasing melody of this composition of texture, shapes, and pattern rings clear, without any interruptions.

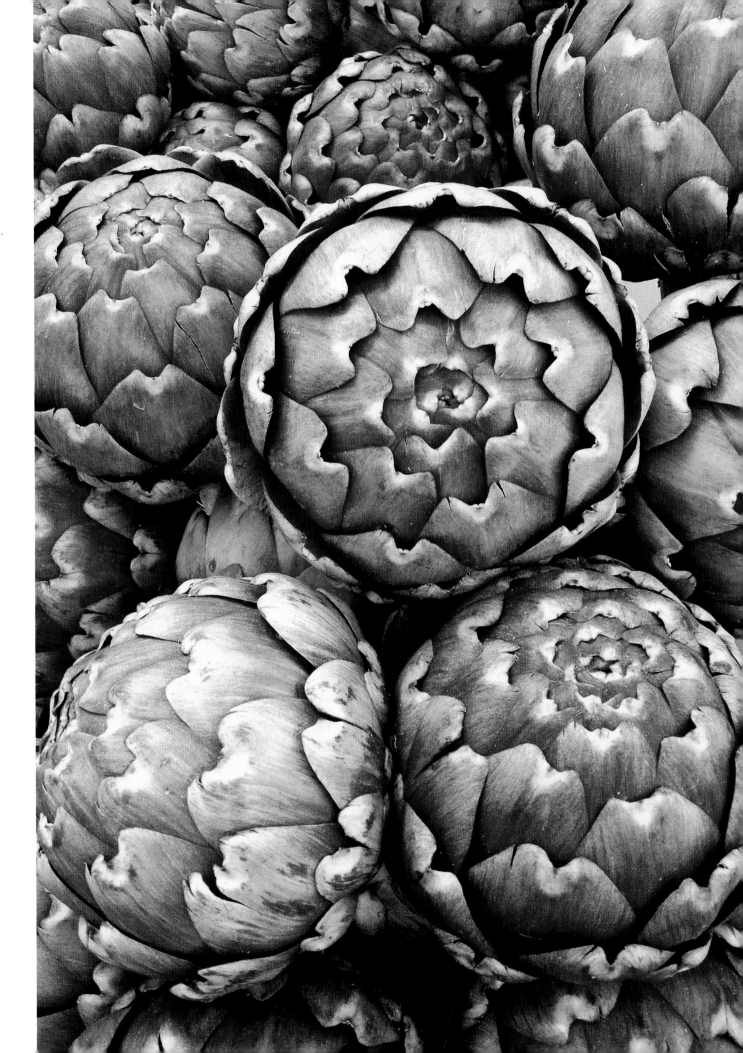

Horizontal vs. Vertical

ECAUSE OF CAMERA DESIGN, it's only natural that most of us initially end up shooting all of our subjects inside a horizontal frame. When you consider design, plus the way all cameras are displayed in ads and on store shelves (i.e., horizontally), it's easy to appreciate why this is. The seduction of "horizontalitis" is so severe that, on average, 90 percent of the amateur photographer's pictures are horizontal. In one extreme example of "horizontalitis" I once had a student ask me if it was worth the money to buy a camera that shot vertical compositions. Yikes!

As most of you have discovered, your camera—the one that has served you well with so many horizontal compositions—does, in fact, shoot vertical compositions, too; however, I know you'd be the first to admit that most of your compositions are still shot inside the horizontal frame. So, why would you ever want to shoot verticals? To bring a feeling of dignity to a naturally vertical subject (i.e., a single flower on a stem), that's why! Dignity, strength, and power are the emotions evoked by the vertical line. Since we favor the horizontal, though, photographers manage to squash, squeeze, and push down the obvious vertical subject in order to make it fit inside the horizontal frame. The biggest danger in doing this, of course, is that you have to back away farther from the subject to make it fit inside the squatter picture area. And even though you made it "fit," you are now left with "clutter openings" on both the right and left sides of the frame. The easiest solution is to turn the camera to its vertical position. Voilà, the clutter is gone!

EARLY TO BED *and early to rise makes a young man healthy and wise. Yeah, right. At least, that's the response from many of my students who, when charged with getting up at the crack of dawn, more often than not vote for more sleep. Well, that's fine with me, since I can then have all of those wonderful dew-covered spiderwebs that appear in meadows from coast to coast all to myself!*

On one such morning, while driving into the morning sunrise, a large field of backlit spiderwebs caught my attention, and not surprisingly, I was the only one around with a camera. It was one of those ideal spiderweb mornings, as the air was dead calm. As anyone who has ever photographed spiderwebs knows, even the slightest breeze can test the patience of Job. And as I've also discovered, the farther back I can be when shooting a spiderweb, the better—since even my own breath and body movements can cause a slight "breeze." Since my magnifications will be quite big and my shutter speeds quite slow, these subtle disturbances in the air will look a hurricane in the viewfinder, and no amount of sharpening in Photoshop can take an image of a blurry spiderweb and make it sharp.

So, having very carefully moved my tripod so that my point of view was as close to parallel to the web as possible, I set my aperture to f/16 and confirmed through depth-of-field preview that there were no distractions of contrast in the background that would call attention away from the web. I adjusted my shutter speed until 1/30 sec. indicated a correct exposure and fired off several horizontal frames. But I wasn't done yet. I had to make a vertical composition (see page 129).

Micro-Nikkor 200mm lens, f/16 for 1/30 sec.

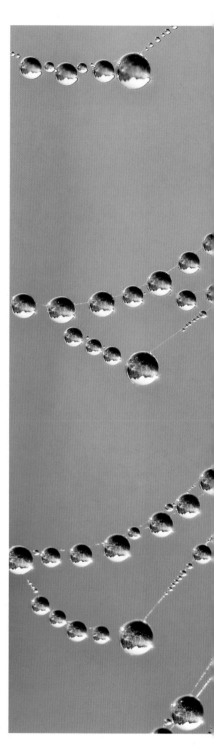

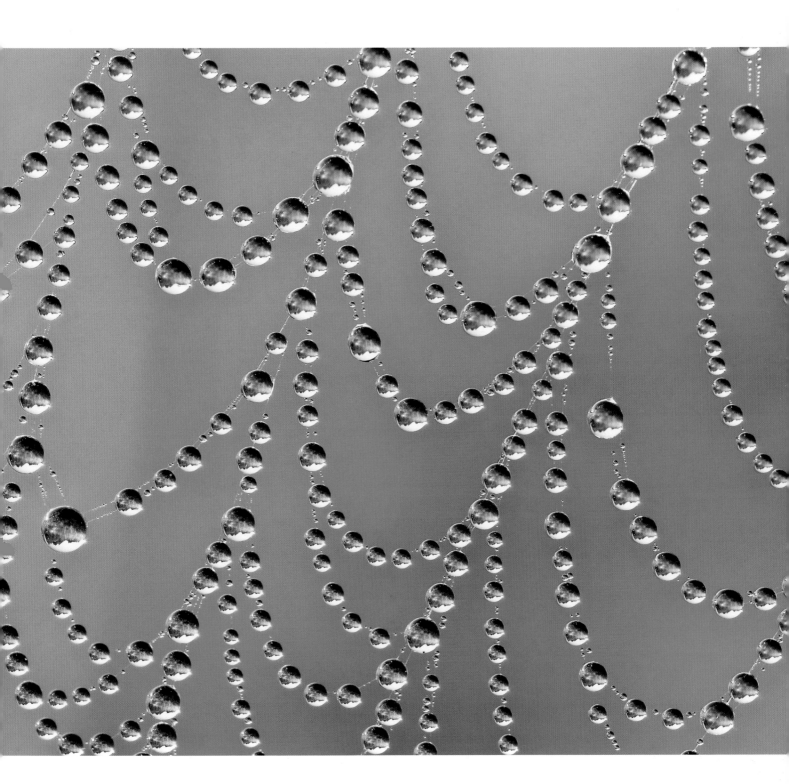

Students in my on-location workshops often ask, "What time is the best to shoot a vertical?" My answer is always the same: "Right after the horizontal!" Not all of the time—but most of the time—you can compose each and every subject in either the horizontal or vertical format. It may take some moving around, shifting your point of view, moving closer, backing up, or even changing a lens. But the benefits of shooting your subject in both formats are obvious. The biggest benefit is that you won't see a loss in image quality when working digitally. Let me explain: When you shoot a vertical subject in a horizontal format and then crop it to a vertical in postprocessing, you end up cropping into the scene to "pull out" your vertical shot. In doing so, you end up throwing away a lot of pixels, and with pixel loss comes a loss in image quality, assuming, of course, this cropped vertical is going to become an 8 x 10–inch or 11 x 14–inch print.

When you make a conscious effort to do your cropping in-camera (more often than not by a combination of moving in closer and left or right, and rotating the camera to the vertical position), you will end up with far more pixels (since you won't be cropping any out later); this translates into bigger enlargements simply because you're using the entire area of the frame. Plus, making a sincere commitment to do your "cropping" in-camera will enable you to spend less time on the computer afterward, giving you more time to shoot. Additionally, should the day come when you're ready to take your work to the marketplace, you'll be more than ready: Should a client express interest in one of your horizontals and then ask if it is available in the vertical format, you can meet the demand and, thirty days later, deposit that check for your first magazine cover!

CROPPING <u>OUT</u> OF CAMERA

There is perhaps nothing more frustrating than realizing—*after* the photographic opportunity has long since passed—that you failed to get close enough or that you didn't see the obvious vertical composition or that you didn't notice your framing of the subject was, in fact, somewhat crooked. Not a problem, you say, since you've discovered that you can crop and correct many of these flaws with the aid of software programs. In Photoshop, you just have to go to the Crop tool, and just like that, you've cut out the distracting stuff on the left or created that vertical composition from the weaker horizontal one or, better still, you simply cropped into the image really close to fool everyone into thinking that you really did record a life-size image of that honeybee!

The ease of cropping with software programs is, no doubt, in part behind many photographers' somewhat lackadaisical attitudes toward achieving effective compositions *in camera*. These photographers often reason that, what the heck, they'll just crop it later on the computer. But there's a downside to all of this postprocessing cropping. Despite how thrilled you might be with the results of your crop on the computer screen, cropping into any image has a price: more noise and a loss of sharpness. And when you crop out more than 10 or perhaps 20 percent, that price becomes even more evident. When you crop into your image, you're not only throwing away some of the pixels that make up that image but, and even more important, you're asking the pixels that remain to do the impossible—to stretch out, to expand to make up for the loss of the pixels you just threw away. Let's assume you want to make an 8 x 12–inch print. If you throw away 20 percent of the original pixels, you are now asking the remaining 80 percent to stretch out, to expand so that you can maintain your 8 x 12–inch image size. When pixels stretch, they do it by offering up a lot of noise and losing some of their snappy color. So, I always suggest trying to get things right in-camera.

REMEMBERING THAT *the best time to shoot a vertical is after a horizontal, I changed my orientation after taking the image on page 127. Going from horizontal to vertical is a snap with the Micro-Nikkor 200mm simply because the lens has a tripod collar, thus allowing me to loosen the collar and simply spin the camera to a vertical position without having to physically move the tripod or reposition the tripod head.*

Micro-Nikkor 200mm lens, f/16 for 1/30 sec.

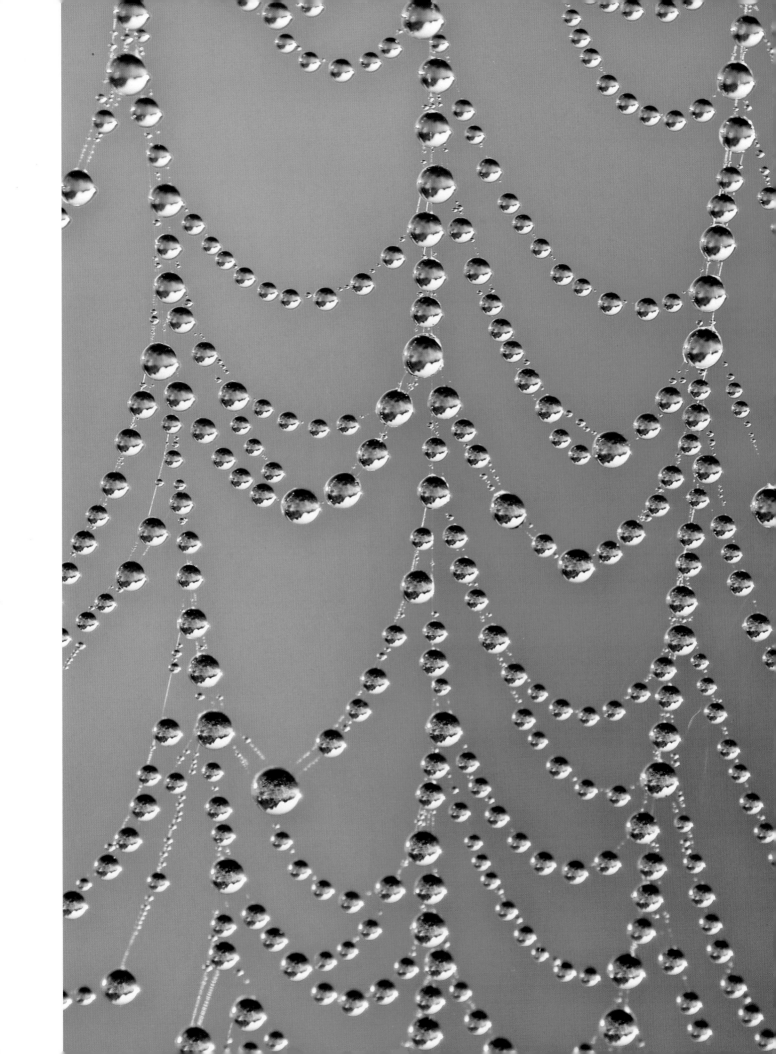

Texture Up Close

HE MORE YOU FIND yourself exploring the world of close-up photography, the more you will discover the role that texture often plays in much of your work. Texture in and of itself can certainly *be* the shot: a frame-filling image of sidelit rough tree bark or soft rose petals, for example. But texture can also create a tremendously supportive background. One of the best exercises I know for familiarizing yourself with texture and the role it plays in close-up photography is to spend an hour with a single subject—such as the bloom of one yellow daisy, a golf ball, a bottle cap, or a stalk of wheat—placing it on various background textures and filling the frame with both.

ALTHOUGH THERE WAS *considerable cloud cover, it didn't prevent me from spending an hour with a small feather and various textures found along Oregon's coast. There's a popular belief among a lot of shooters out there that textures should only be photographed when sidelit by the low-angled light of early morning or late afternoon. Obviously, I couldn't disagree more. It's true that when a texture is sidelit, it has a greater sense of depth (due solely to the combination of light and shadow), but even without sidelight, you can still find numerous texture-filled opportunities.*

In all four of these shots on the next four pages, I made a deliberate choice to shoot at the critical aperture of f/11, since depth of field was not a primary concern. At every turn, it seemed I found a new and different texture on which to place my lone feather, including sand and rock on these two pages and burnt wood and foliage on the following two. In each shot, I placed the feather on a subtle diagonal. The diagonal line, much like the feather, conjures up feelings of movement and speed, and when combined with each of the four textures, the feather evokes a different emotional response. In each case, with my tripod, 200mm lens, and aperture of f/11, I simply adjusted my shutter speed until the camera meter indicated a correct exposure; not surprisingly, since the light levels never changed in that one hour, all four images called for the same exposure of 1/30 sec.

All photos: Micro-Nikkor 200mm lens, f/11 for 1/30 sec.

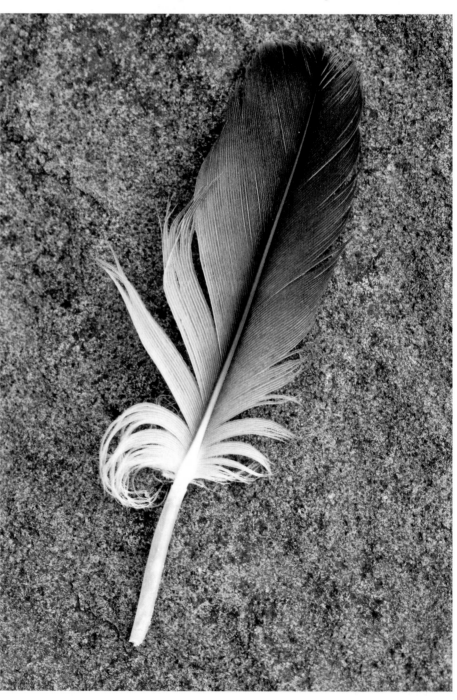

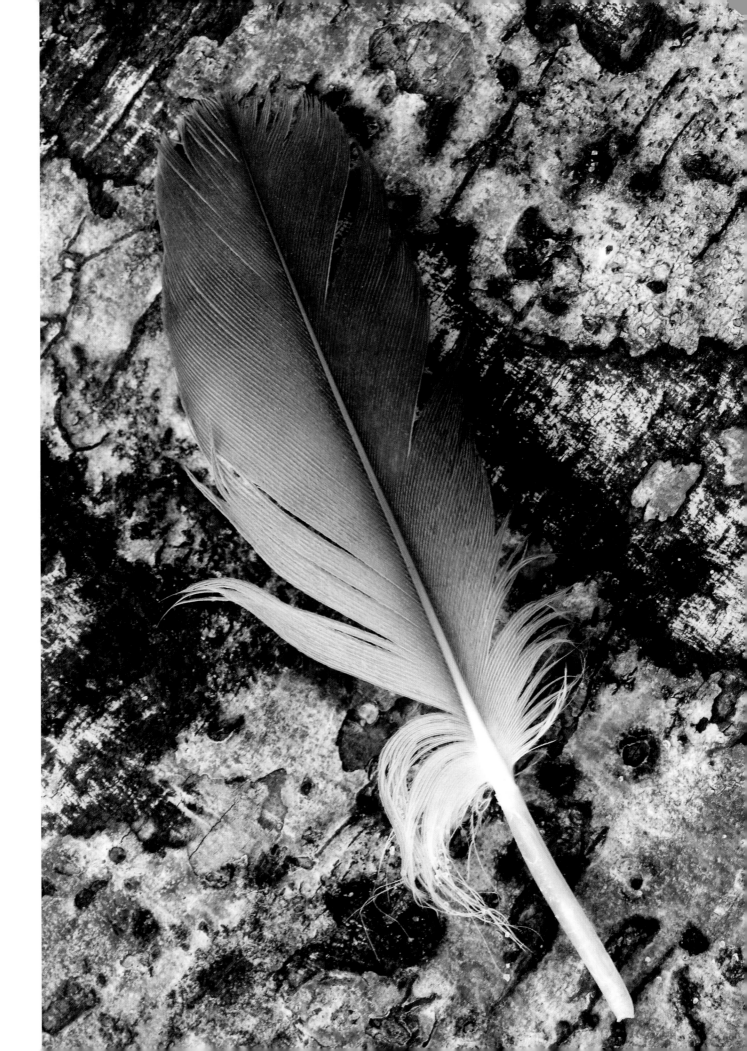

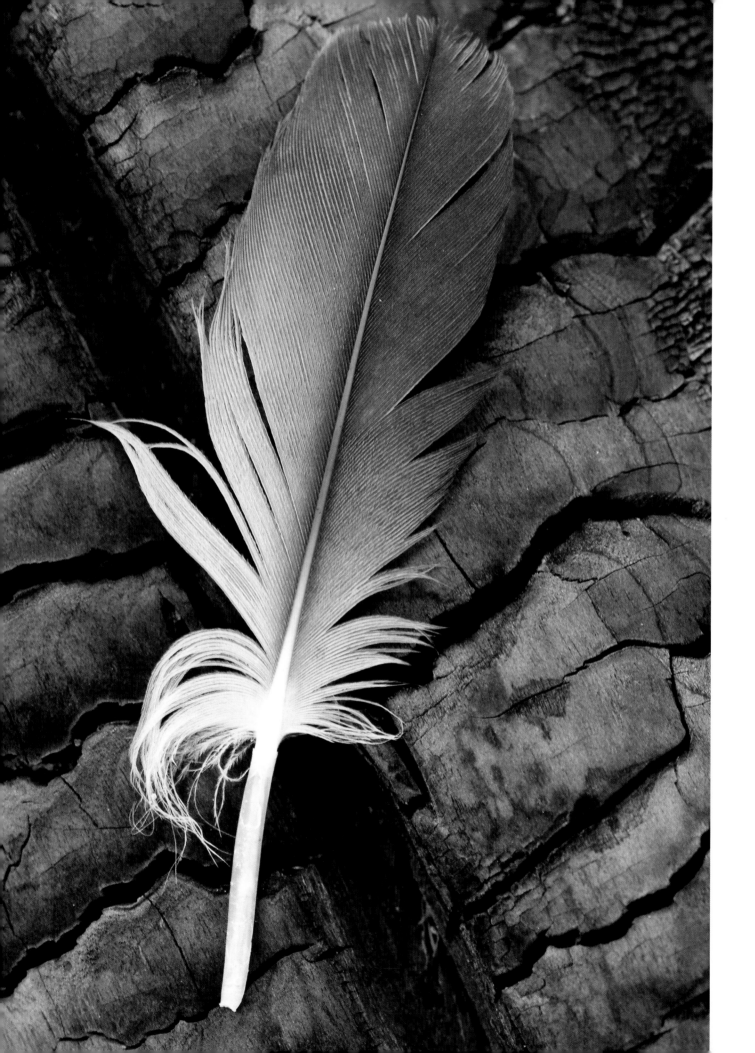

I OFTEN FIND MYSELF

shooting simple compositions of roadside textures—namely, the wild grasses that line many a ditch on country roads throughout the world in the summer months. You should keep in mind that if you aren't finding inspiring camera-ready subjects, you can always rearrange things, within reason. That's what I did a few years back when the students in a workshop I was leading in Tuscany expressed a lack of vision on one particular morning. I suggested that we simply shoot close-up shots of textures, and because we were near a roadside ditch, I was quick to find not only a few stalks of wild wheat but also a few chamomile flower blooms. We placed a few stalks of wheat on the ground, topping them off with a single chamomile blossom. It's a really simple yet very effective and powerful composition, and its power is due to texture. Get to know texture, and you will soon get to know a host of new and exciting close-up opportunities.

Note that I did use a tripod and also made it a point to fill the frame edge to edge, top to bottom with the wild wheat, choosing to place the flower near the left third of the composition. I used the critical aperture of f/11 and merely adjusted my shutter speed until 1/100 sec. indicated a -2/3 exposure (since, as mentioned previously, green needs to be metered at -2/3 if it is to be recorded as a correct exposure).

Micro-Nikkor 105mm lens, f/11 for 1/100 sec.

ALTERNATIVE SUBJECTS

For both amateurs and professionals, close-up photography continues to enjoy great popularity. While such obvious subjects as flowers, butterflies, and insects are ideal here, so are the more unusual subjects. In my online courses, I've noticed more and more of my students turning their close-up gear toward the industrial world and the abstract—and coming away with some truly compelling imagery.

TYPICAL OF MOST ABANDONED
industrial sites, you will almost always find rusting metal, and this site in Brooklyn was no exception. What was once, I'm sure, a painted and well-maintained freight-delivery door had succumbed to the ravages of time. The rusting metal, combined with the colorful remnants of a passing graffiti artist, made for a compelling image of texture. With my camera mounted on tripod and set to Aperture Priority mode, I chose the critical aperture of f/11 and the camera selected a shutter speed of 1/30 sec. I then fired off several frames, one of which you see here. Again, it's an image whose success lies primarily in its ability to appeal to your sense of touch. Such is the power of texture-filled compositions.

*Micro-Nikkor 200mm lens,
f/11 for 1/30 sec.*

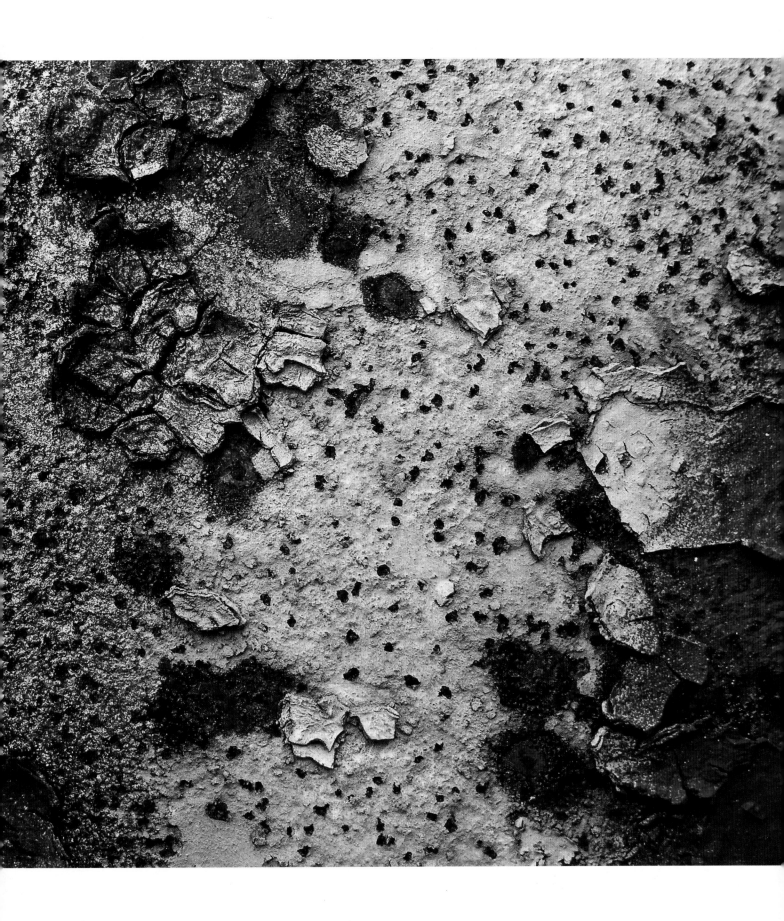

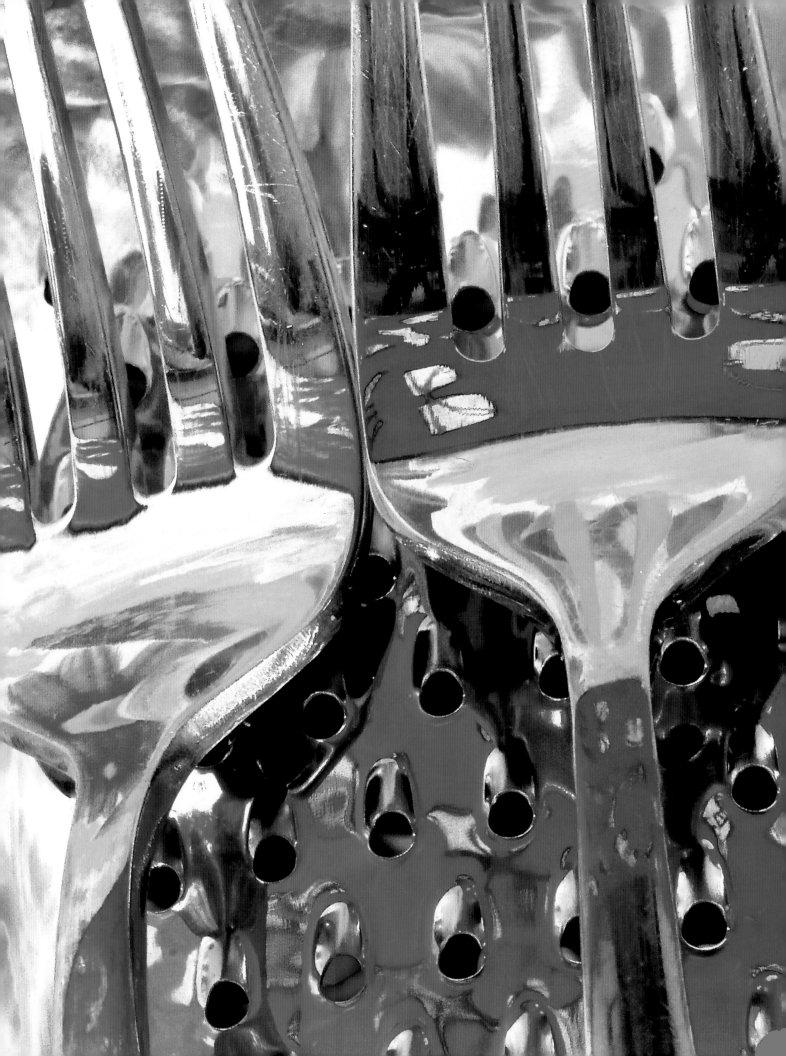

UP CLOSE INDOORS

The Home Studio Setup

ONTRARY TO popular belief—and to the potential disgust of naturists (but not nudists!) everywhere—some of the greatest close-up photographs can be made right inside your own home. Some of the benefits? You don't have to travel far, and you're gentler on the earth since you're not trekking around leaving your real—or your carbon—footprints everywhere. Your home is loaded with items that make great close-up subjects. Additionally, as long as you're willing to bring the more portable "outside" subjects—such as flowers—inside (who would be opposed to that?), you can spend weeks, months, even years shooting some terrific close-up photographs without ever venturing outside with your camera.

All you need is an area roughly 2 feet by 2 feet near a large window. The space should accommodate a small "shooting table." The advantages of this indoor close-up "studio" are many, and perhaps the best one is that you'll never have to deal with the wind; as most close-up shooters report, it's the wind that you'll be fighting the most when working up close in the great outdoors.

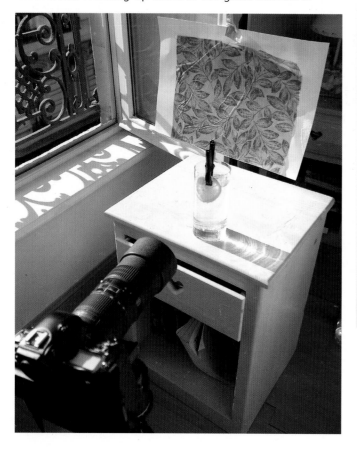

A SIMPLE LEMON SLICE *can make a bold statement of color and texture when seen up close. Note the use of the green wrapping paper in the background: Since depth of field is so shallow when shooting close-ups, I was able to add this background, which I knew would be out of focus enough to emulate grass—as if to suggest that this image was made outdoors. Additionally, I used sparkling water, not tap water, and with each and every shot (I made a total of sixteen attempts), I would also add a few dashes of salt to create even more fizzing in the water.*

Nikkor 70–180mm lens, f/22 for 1/8 sec.

The Kitchen

 ITCHEN ITEMS can make for interesting abstract close-up subjects. And, a small wooden chopping block in the kitchen can quickly become a miniature studio. Positioned near a south-facing window, there's plenty of available light to practice "kitchen art."

Obviously the idea of kitchen art isn't limited to the cheese grater you see in the images here, as any metallic surface will perform equally well when shot close-up. Consider spoons, forks, knives, measuring cups, bowls, pots, pans, kettles, skillets, corkscrews, garlic presses, whisks, and eggbeaters, to name just a few. Kitchens aren't just for cooking food, but in fact provide any number of recipes for photographic fine art.

WITH MY CAMERA *and lens mounted on tripod, I was soon filling my frame with a very simple graphic composition of three salad forks placed on bright orange wrapping paper. With my focal length set to 180mm, I chose an aperture near wide open (f/5.6) to render shallow depth of field. The resulting selective focus emphasized the forks without revealing the details in the colorful wrapping paper.*

Micro-Nikkor 70–180mm lens at 180mm, f/5.6 for 1/90 sec.

KITCHEN ART *in this case was a cheese grater transformed into a colorful abstract composition. It's a simple idea that, in addition to the grater, requires only the use of one or two pieces of colorful gift wrap. The reflective surface of the highly polished metal picks up the colors of the two different pieces of gift wrap. I used a wide-open aperture here to render no depth of field, and selective focus is the result: Softer, less-defined reflections contrast with the sharper grater holes.*

In contrast to the version on this page, the interpretation opposite of the cheese grater was made at f/16. This much smaller aperture opening rendered massive sharpness throughout the image.

Right: Nikkor 105mm macro lens, ISO 200, f/2.8 for 1/250 sec. opposite: Nikkor 105mm macro lens, ISO 200, f/16 for 1/8 sec.

Other Rooms, Other Subjects, Other Light

ETTING CLOSE INDOORS doesn't have to be limited to the kitchen. Pay attention to the light in other areas, which might in some other way be interesting. Do you have a shag rug? Consider looking at it as you would your front lawn. Instead of finding dew-covered blades of grass, you might find a ketchup-laced piece of carpet. How about a close-up of the Venetian blinds or a crystal vase or some of those often-seen "faces" that appear in many linoleum tiles? And, of course, there are always those wonderful still lifes of your kids' broken yet colorful crayons, along with the Slinky, especially when in its half-circle position. Take any number of these objects and place them on a small table. If you have some windows in the house that provide diffused light and others that let in direct light, you'll quickly see how both lighting conditions offer up their own special qualities, either softening the image (diffused light) or creating bold contrast (frontlight or sidelight).

If you choose use an ordinary house lamp (tungsten light) as your light source for close-ups, set your white balance (WB) to Tungsten to record daylight images without the ordinary yellow/orange cast that's often the result of shooting under tungsten light. If you feel compelled to shoot with a flash, *do not* attempt close-up shots with an ordinary on-camera flash; rather, you must resort to the use of a ring flash (see page 84). However, due to the often metallic, glossy, or semi-matte finish that so many household products possess, I *would not* recommend the use of flash, simply because it's quite difficult to avoid the sheen that often records on the subject from the flash itself.

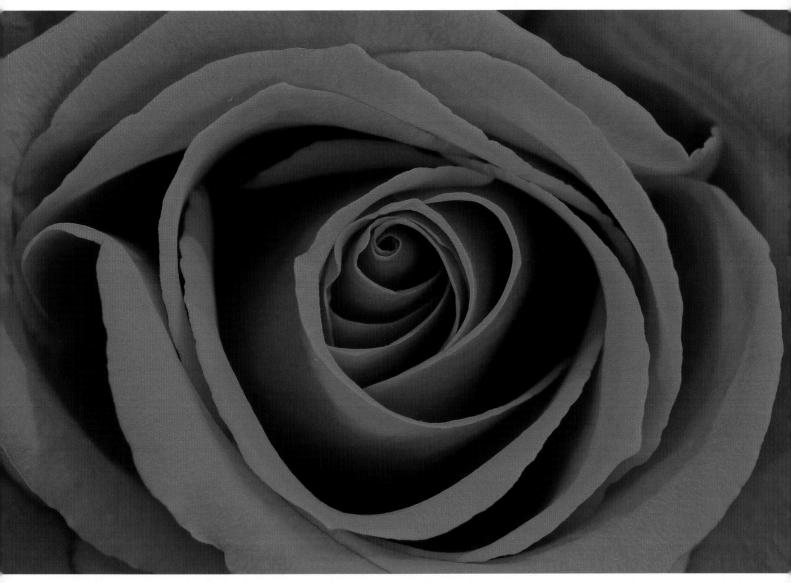

IF NOTHING ELSE, *this image is definitive proof that it doesn't take much more than a nearby window to create a compelling composition of a red rose, and again, all without the delays and frustrations often caused by the wind. I positioned this long-stem red rose standing in vase near a window in a rear storage room of our apartment. (And, just a side note: It's also where our cat chooses to spend a great deal of his time.) With my camera mounted on tripod, I chose a viewpoint that would find me shooting straight down on the rose, close enough to fill the entire frame. Since depth of field was a concern (I wanted to get sharpness from the top petals down into the folds), I set my aperture to f/22 and then adjusted the shutter speed until 1/8 sec. indicated a correct exposure. I then set the camera's self-timer delay to 5 seconds, and 5 seconds after tripping the shutter release, the exposure was made. A simple shot for sure, but no doubt a rose of lasting beauty.*

105mm lens, f/22 for 1/8 sec.

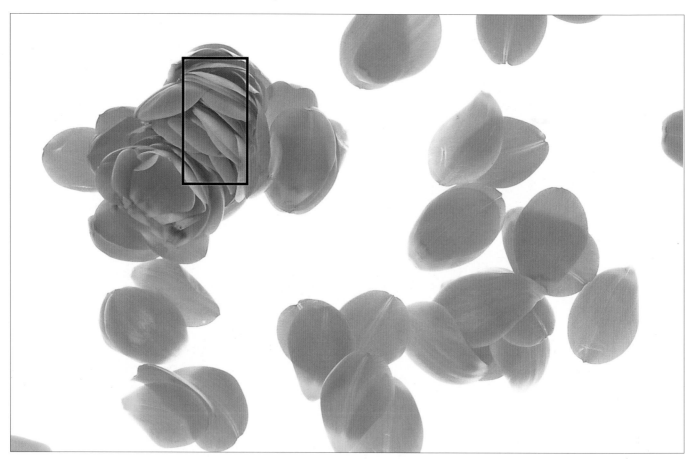

ALTHOUGH I'VE BEEN SHOOTING for more than thirty years, I never seem to tire of photographing flowers; however, I will confess that I'm finding it far more challenging today, if only because I would prefer to create fresh compositions that set my flower shots apart from the masses. I'm not always successful, but when I feel I have come up with something new, I'm quick to share it. Just recently, I bought a dozen bright orange tulips at the outdoor market, and once they began to open up and bloom, I tore each petal off each stem. Before long I had several stacks of petals spread out on white poster board. The multiple curvilinear lines of these stacked petals presented the opportunity to shoot a macro shot that would be steeped in sensual feelings, since it is the same curvilinear line that is reminiscent of the human form.

With my Nikon D300 camera and Micro-Nikkor 105mm lens mounted on my tripod, I focused as close as my lens would allow, which, in this case, took me beyond life size due to the camera's 1.5X multiplier that compensates for the smaller image area than what's found with a 35mm film camera. Before setting my exposure, I wanted to add some fill light to the scene, and one of the reasons I chose to place the flower petals on white board is because white is highly reflective. With the addition of a second piece of white poster board propped up at an angle of about 60 degrees right next to the first one, I was able to throw the reflected light coming off of the bottom board back onto the awaiting petals. I chose an aperture of f/32 (to cover every nook and cranny with sharpness) and simply adjusted the shutter speed until the camera's meter indicated 1/2 sec. for the correct exposure. Due to this really slow shutter speed, I engaged the camera's mirror lock-up feature and set the camera's self-timer to fire 5 seconds later after tripping the shutter release. The composition, to some, looks like an orange rose or a camellia but, as you now know, is nothing more than a "manufactured" shot of stacked tulip petals.

Nikon D300, Micro-Nikkor 105mm lens, f/32 for 1/2 sec.

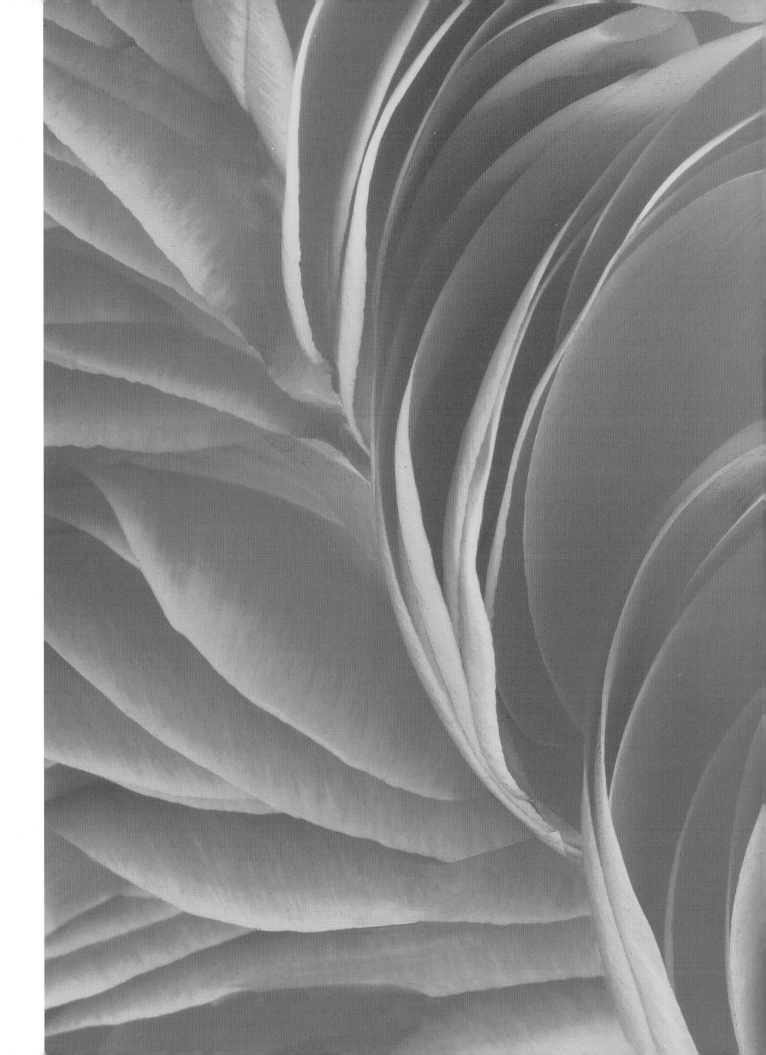

The "Dewdrop" as Mini Fish-Eye Lens

NE OF MY MOST fascinating discoveries in the world of close-up photography was made long ago: Dewdrops can act as mini fish-eye lenses. I made this discovery after waking early one morning and seeing one of the heaviest blankets of ground fog I had ever seen on my farm. I headed out the door to the large backyard flower garden and came upon three huge dew-covered spiderwebs. It was one of those rare moments when not only were the dewdrops large but the air was dead calm, too. As I made quick work with my Micro-Nikkor 105mm lens, I noticed with great delight a fish-eye view of my flower garden within each of the individual drops of dew, and thus began a love affair with dewdrops the world over. And, since you can generate your own droplets at home, this is an idea that's not limited to outdoor work or by the need for specific weather conditions.

SINCE IT'S EASY to make your own "dewdrops," from the moment I discovered the mini fish-eye effect, the Oregon winters never seemed as long. I have since adopted as a piece of "my equipment," one particular bedside table that has two pieces of glass (the main surface and a shelf below) on which I am able to create countless droplet compositions.

The process goes something like this: With a large syringe, I place individual drops of clear massage oil in a somewhat random fashion atop the upper glass surface of the table (the box in the image below). I've found that Johnson's Baby Oil is too thin and the drops spread out and go flat; but others report that Karo syrup works quite well due to its thickness. So, based on the principles of close-up photography, when I focus on these "dewdrops," whatever I place on the lower shelf will record inside each of these "fish-eye lenses," as I like to refer to the droplets.

The idea here was, of course, to create an image of rain, and what I chose to do to further support this was really quite simple, so simple, in fact, that I found myself saying, "Duh!" when it finally occurred to me what was needed. I looked through my file images of clouds and skies and made an 8 x 10–inch print of one. I then came upon a shot of a simple red umbrella that was part of an ad in the local newspaper, cut it out, and placed it on my clouds-and-sky print. Sure enough, as soon as I placed this on the lower shelf, I was soon immersed in recording one of the more exciting close-up photos I had made in some time.

With this idea in mind, why not consider doing the same thing with the theme It's Raining Cats and Dogs? Make an 8 x 10-inch print of one of your own sky/cloud compositions and then make a number of really small prints of your cat and dog. Cut these out, lay them on the sky print, and you now have a great shot of it raining cats and dogs!

f/11 for 1/125 sec.

ONE OF THE GREAT THINGS *about making discoveries in the world of close-up photography is that other discoveries are soon to follow— one thing leads to another. After spending the better part of a day shooting varied subjects with my massage oil "dewdrops" on my glass table, I got out the bottle of Windex and sprayed the table down, ready to clean it off; but then I noticed the interaction between the Windex and the oil, and that's all it took to get my camera back into position. I quickly grabbed my daughter's large collection of colored pencils and placed them on the lower glass shelf, as I knew this random setup would provide multiple tones of background color. Within minutes I was once again immersed in a close-up world of "dewdrops" and the liquid effects generated from combining an ammonia-based liquid with massage oil.*

The first image (opposite) was taken within minutes of spraying much of the table with the Windex; this accounts for the many bubbles seen floating atop the once-clear droplets of massage oil. The second image (above) was the result of having made several swipes across the table with a paper towel and having left behind a thin layer of massage

oil. When I again sprayed the Windex across the top of this thin layer of massage oil, more bubbles developed. At this point, I moved in much closer, as close as I could focus, in fact—which, once again, meant that I was able to record images that were 1.5X life size due to the smaller sensor size of the Nikon D300. Among the many photographs I made at this 1.5X size, this one in particular stood out as one of my favorites, and I now use it as a screen saver on my Mac. You'll notice that, unlike the previous image, the background colors are not nearly as defined, and this has everything to do with my distance. Remember, the closer I focus, the farther away and less defined my background becomes, and that is, of course, the case here. The background of colored pencils may be easier to see in the first image, because my distance from the subject is greater. But again, because I was focused much closer in the second photograph, those same pencils are rendered as a wash of out-of-focus tones and hues.

Opposite: Nikon D300, Micro-Nikkor lens, f/11 for 1/250 sec.; above: Nikon D300, Micro-Nikkor lens, f/11 for 1/90 sec.

APPENDICES

Appendix A: VR and IS Lenses Exposed

SO THE QUESTION IS, "Do VR and IS lenses live up to their promises?" What is a VR or an IS lens? VR (vibration reduction) or IS (image stabilization) lenses are lenses that counteract the normal camera shake that often occurs when handholding your camera and lens. In effect, with one of these lenses, it's like having a built-in gyroscope. When you find yourself shooting, say, images of your friend's wedding and you've had one too many glasses of champagne, a VR or IS lens will move in the opposite direction of any camera movements to counterbalance your shake, resulting hopefully in an in-focus picture. There is a switch on the side of these lenses that you must have in the On position when handholding your camera in order for VR or IS to work.

A word of *extreme caution*: Read the instructions that came with the lens first, but most of the time, the On/Off switch found on the lens barrel of most VR and IS lenses should be switched off when you're using these lenses and a tripod. Since the VR or IS lens responds to movement/camera shake, and since either is highly unlikely with a tripod, the VR or IS function will still act as if camera shake is present and introduce a countershake when you take the picture. This means that an image that would normally be tack sharp when taken on a tripod will actually be blurry! Yikes! This has happened to a number of students, and in a few cases, they didn't notice the blur until returning to their hotel rooms following an evening of shooting cityscapes (photo-ops that, in all likelihood, they would not have again anytime soon). I've also heard similar stories from readers of my other books who made this discovery too late, having already shot those once-in-a-lifetime photo-ops while on vacation.

The promise made by the VR and IS lenses is simple: You will be able to *handhold* the lens and camera at as many as four shutter speeds slower than what are normally considered safe handholding shutter speeds. And what is *normally* considered a safe shutter speed for handholding? Whatever lens is in use, it's a safe bet that you can record tack-sharp handheld images at the closest shutter speed to the lens's longest focal length. So for example, an 18–70mm street zoom can be safely handheld at shutter speeds of 1/60 sec. and above (60 being closest to 70), while a 70–200mm telephoto zoom can be safely handheld at shutter speeds of 1/200 sec. and above, and so on. If your lens has VR or IS, manufac-turers promise you can safely handhold at shutter speeds up to four times *below* the normally accepted shutter speed range. So, that same 70–200mm VR lens can be safely handheld at shutter speeds down to 1/15 sec., while the 18–70mm IS can be safely handheld at shutter speeds down to 1/4 sec. Don't you believe it!

In test after test after test, most VR and IS lenses do deliver on the promise of handholding at slower shutter speeds—but no more than *two* times slower than the accepted norm. So with that 70–200mm, you will, in all likelihood, be able to shoot handheld at shutter speeds of 1/50 sec. Nikon's Micro-Nikkor 105mm with VR has left many unsuspecting photographers a bit miffed as they quickly discover VR (or IS in Canon's case) is virtually useless when shooting close-ups. It's something to think twice about if you've been looking forward to buying and shooting with a VR or IS macro lens. To be sure I'm not misinterpreted, the VR or IS found on a 100mm or 105mm macro lens does indeed work—but only when your working distances are at least 8 to 10 feet and greater. Keep in mind that both of these lenses are great for portraits, and therefore, the VR or IS can come in really handy as you move about, handholding the camera and lens, while shooting portraits at the company picnic or family reunion.

So, how do you increase your depth of field without giving up that faster shutter speed? Since VR doesn't work when shooting close-ups, is there any way to get around the constant use of a tripod? What's a shooter to do? Every digital single-lens reflex has built-in VR, but you just don't know it. Okay, that's not quite true, but it's close. It's not called VR but rather DTSU (pronounced dit-su), and for DTSU to perform flawlessly, you must also be shooting in raw format. With your ISO set to 200 (or 125 or 100 if your camera allows it), you simply head out the door and into the garden and start shooting those amazing flower close-ups *without* your tripod. Let's assume it's the perfect day for flowers (bright, overcast, diffuse light), and you're using your 70–200mm lens along with a small extension tube, say the 36mm Kenko tube. You're quick to discover that the best you can do in the depth-of-field arena is *f*/11, since *f*/11 offers a shutter speed of around 1/160 sec., which is a shutter speed that's right on the border of being a safe tripodless speed. Trouble is, you've already taken three different shots of flowers that each could have benefited from even more depth of field; you chose not to stop the lens down any further to *f*/16 or

f/22 because it would force a shutter speed that would be too slow to handhold. It's times like this when you call upon DTSU, and like I said, this little feature is already built in to every digital single-lens reflex.

So, as you frame up that lone flower and with your aperture now set to f/22, you see that a correct exposure is indicated at 1/40 sec. Of course, you can't possibly shoot at that shutter speed without camera blur, so instead, shoot a DTSU—in other words, a deliberate 2-stop underexposure. This would be f/22 at 1/160 sec., and as you've already discovered, you can safely handhold your camera and 70–200mm lens at 1/160 sec. At the end of the day, you simply load the images into the computer and those 2-stop underexposures are ready to be adjusted in Photoshop by simply moving the exposure slider over from left to right, correcting what was a "dark" histogram. The result: your tack-sharp image with the added depth of field you had hoped for, all correctly exposed.

I *do not* suggest that you could just as easily change your ISO from 200 to 800 and achieve the same thing, because you can't. Yes, you'll get the same exposure (f/22 at 1/160 sec.), but you will also introduce more noise, more grain. Also, *do not* try to shoot any DTSU with an ISO beyond the lowest ISO setting that your camera offers (for example, 100, 125, or 200). If you try this with ISO 400 or 800, for example, it will not be a clean image. Due to an anomaly in raw processing, any higher ISO than the lowest will actually produce far more noise than what you ordinarily see when shooting at these same higher ISOs and not deliberately underexposing.

Appendix B: Macro Magnification Ratios

 WILL BE FIRST to admit that much of the science of photography alludes me. I'm fully aware of the numerous conversations that take place in photo chat rooms worldwide in which science and mechanics are discussed in great detail, conversations that I rarely participate in and even rarer still understand. I'm a visionary first, and once I approach the viewfinder, I'm focused on one thing: making a compelling image. And, for the most part, making that compelling image relies on the following basic fundamentals: a knowledge of exposure, a vision that matches up with my lenses, and a willingness to entertain various points of view and consider the various compositional choices. Do I really care what the actual size of my subject is in real life? Heck, I've known what size honeybees, dragonflies, butterflies, houseflies, spiders, ants, and even worms were long before I picked up a camera! The same is true for most flowers, fruits, vegetables, wheat stalks, and feathers. When I see a bee in a photograph taken by one of my students, my first reaction is *not*, "Gee, just how big was that honeybee?" I can tell how big it is just by looking at other elements in the picture. My first reaction, almost without fail, is, "Wow! Just how close were you?" or "It's too bad you didn't (or couldn't) get closer."

The only photographers who really need to be at all concerned with magnification ratios are those who work in the science-related fields. Sure, I can see why it's important to know the magnification ratio when shooting a newly discovered frog in the Amazon rain forest or photographing blood splatter at a crime scene, but this book is *not* about science. Rather, it's about the *art* of the close-up. This isn't to say there can be no "art" when shooting frogs or blood splatters, but what I'm saying is that, for the most part, a close-up photographer's primary concern is in making a compelling image. If, by chance, he or she does so at magnifications greater than 1X, then technically that's a macro image. But at the end of the day, is that really all that important? As I've been telling my students for years, if it looks good, if it's compelling, if it generates a gasp from the viewer, then as far as I'm concerned, it's a worthy close-up photograph! Of course, it's important to know how I or another photographer made the shot. Did I use a telephoto with extension tubes or a 200mm macro or a wide-angle lens and the Canon 500D close-up lens? But in more than thirty years of shooting, no one has yet to ask me what the magnification ratio of that ant or bee or butterfly was. Sure, with the images I only recently started to make with my Canon 65mm macro lens, I may be asked this question a few times in the coming years, but the first reaction, if I did my job right, should be, "Wow! How did you do that?" Maybe (and I still insist this is only a remote chance), just maybe, someone will say, "What is the magnification ratio of that?"

Now that my position about magnification ratios is clear, I will add this: Invest the time needed to understand how your lenses "see." This includes your macro, if you own one. What are their minimum focusing distances? Four feet, two feet, three inches? What are the minimum focusing distances when combined with a single 25mm extension tube, with two 25mm extension tubes, with a close-up filter added, when the lens is attached to a bellows, when the lens is combined with a 2X teleconverter and 50mm of extension tubes, and so on? I can't answer these questions for you since I don't know what kind of camera you own or what kind of lenses and other equipment you have. But *you* should know this ahead of time, before you head out to the pond and find yourself standing at its edge staring down a large bullfrog. Quick, what lens and combination of extension tubes makes the most sense for shooting that bullfrog?

Again, I can't be as specific to your situation as I want, but the following setups are meant to be a rough guide into the world of close-up photography. This information is based on *my camera gear*, and unless you have the same exact system, you will need to invest a bit of time in making your own chart. The good news is you won't really need the data for long, assuming you go out and practice with your gear. Developing a vision for close-up photography is no different than learning how to drive a car. You get in the "driver's seat," look out that "windshield" of your camera (better known as a viewfinder), and "see" where the varied combinations of your lenses and related accessories can take you.